Thomas H. Carpenter
is the Charles J. Ping Professor of
Humanities and director of the Ping Institute
for the Teaching of Humanities at Ohio University. He
was awarded a masters in Theology from Harvard, and
after earning his D. Phil. in Classical Archaeology at the
University of Oxford, worked for four years as chief
researcher at the Beazley Archive at the Ashmolean
Museum, Oxford. Professor Carpenter's other books
include *Mythology, Greek and Roman*; *Dionysian Imagery
in Archaic Greek Art*; and *Dionysian Imagery
in Fifth Century Athens*.

Thames & Hudson world of art

This famous series provides the
widest available range of illustrated books
on art in all its aspects.

To find out about all our publications,
including other titles in the World of Art series,
please visit
thamesandhudsonusa.com.

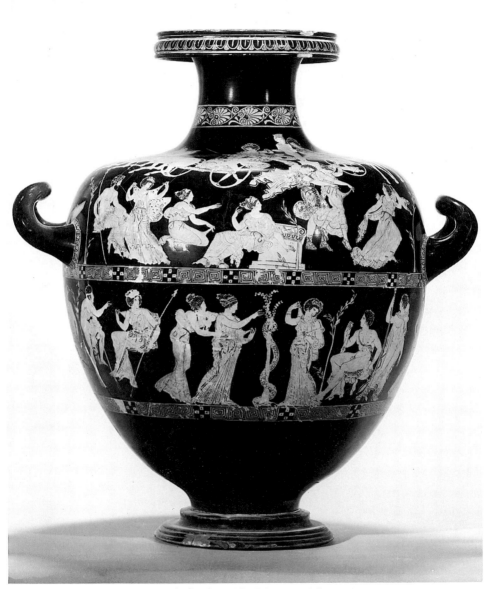

Hydria by the Meidias Painter. *c*.410. See *213*

THOMAS H. CARPENTER

ART
AND MYTH
IN ANCIENT
GREECE

a handbook

370 illustrations

Thames & Hudson world of art

For Lynne

Art and Myth in Ancient Greece © 1991
Thames & Hudson Ltd, London

First published in 1991 in paperback in the
United States of America by Thames & Hudson Inc.,
500 Fifth Avenue, New York, New York 10110

www.thamesandhudsonusa.com

Reprinted 2018

Library of Congress Catalog Card Number 88-51326

ISBN 978-0-500-20236-4

Printed and bound in China through Asia Pacific Offset Ltd

CONTENTS

PREFACE

During the past century many theories have been proposed for the interpretation of Greek myths; however, the reader will quickly notice that none of them is mentioned here. This is in part because even a summary review of the theories is far beyond the scope of this small book, and in part because the focus here is on identification rather than on interpretation.

The primary purpose of this book is to help readers identify scenes from myth in Archaic and Classical Greek art while at the same time showing that the depictions often need to be seen in a developmental context to be understood. My intention has been to provide a dependable groundwork on which further studies can be built since it is my firm conviction that interpretation can only follow careful examination, identification, determination of a chronological context, and recognition of patterns of development (when they exist).

Questions of what specific meaning certain myths may have had for a particular polis, or for Greeks in general, will certainly occur to readers as will questions as to why a particular scene was put on a vase or shield band or temple pediment, or why it was depicted one way and not another. These are important questions, and it is my hope that observations here may give some basis for seeking answers to them. References for each chapter under 'Further Reading' point to recent analyses and interpretations.

Chapter One

INTRODUCTION

Most surveys of Greek mythology are, quite rightly, based on literary sources, since these are the principal repositories of ancient myths. Some surveys include the occasional ancient sculpture or painted vase as illustrations, some use a mixture of ancient, renaissance and modern art, and still others use new works specifically created for them, but in few cases is the reason behind the choice of illustrations or the connection between them and the text at all clear. The scenes float in a kind of a-historical limbo.

In fact, ancient Greek art is also a rich source for the knowledge of myths and one that can be studied in its own right. The way a story is shown may develop and change over a period of time so that a depiction of a myth from 580 B C will probably be very different in content (as well as in form) from a depiction of the same myth in 400 B C. Sometimes a story is shown for which no literary source survives, sometimes the details of the story shown are quite different from those in literary versions, and sometimes life is given to a story known only in a late and abbreviated form.

This book is an introductory survey of myth as it appears in surviving ancient Greek visual arts created between about 700 and 323 B C. Though some familiarity with the Homeric epics and Greek tragedies is assumed the book is intended for the interested layman as well as for the student of classics or of myth. It begins with a brief survey of the types of ancient sources that have come down to us and continues with an examination in some depth of the development in art of two myths as a demonstration of a method for such studies. The largest part of the book, however, is a survey of the development of some of the more important myths (a word used here to encompass heroic legends as well as stories of the gods). At the end of the book is a bibliography of further reading for each chapter.

The focus is ancient Greek narrative art – depictions of scenes that tell stories. Thus, portraits of the gods are only of interest as they define attributes by which a deity may be recognized in narrative scenes, and, as a result, few non-architectural free-standing sculptures and few coins are included here since often they simply repeat (and perhaps refine) a type established much earlier on. By Greek art not only the art of the Greek Aegean – East Greece, the islands, the mainland and the Peloponnese – is meant, but also the work of Greek artists or their followers in the West – particularly South Italy (Magna Graecia) and Sicily.

A starting point of 700 BC is chosen because this is roughly the date when the first certain depictions of myth appear in Greek art, on Attic vases. An end point of 323 BC is chosen in part because the death of Alexander traditionally marks the end of the Classical period, and in part because it is toward the end of the 4th century that Attic vases painted with narrative scenes, one of our most important sources, finally ceased to be produced.

The traditional terms Geometric, Archaic, Classical and Hellenistic are used here as names for historical periods and stages in the development in Greek art. Geometric refers to the period from about 900 to 700 BC when Greek art began to be revitalized after the stagnation of the 'dark ages' that followed the destruction of the Mycenaean world. The art of this period, mostly painted vases and small bronzes, is characterized by the use of geometric forms of decoration (as opposed to free forms). Stylized human figures in narrative scenes appear on vases by about 750 BC, but scenes from myth do not occur before the end of the century. Trade with the East developed during the late 8th century and the influence of eastern forms and styles is clear in Greek art of the 7th century – the term 'orientalizing' is often used to describe the new developments through which geometric forms give way to more natural ones and fantastic figures and shapes proliferate. The 6th century was a time of consolidation and prosperity in Greece, and the term Archaic is used to describe the art of this period. This was, without any question, the most creative period for the depiction of myths in art, and many of the conventions established then carried on into later times. The sack of the Acropolis in Athens by the Persians in 480 BC and the subsequent destruction of the Persian fleet by the Athenians traditionally marks the end of the Archaic period and the beginning of the Classical, when Greek art reached its full and powerful maturity. The term Hellenistic, then, is used to describe the history and art of the Greek world from the death of Alexander in 323 on into the 1st century BC. The great social and political changes during the Hellenistic period are paralleled by great changes in the way myths were understood and depicted, but these changes are beyond the scope of this book and will be more appropriately treated in another study.

The depiction of myth in the visual arts uses a 'language' quite different from literary languages, and it is a language that must be learned through careful observation. Each element of the depiction must be examined and seen in relation to all of the other elements before the intention of the work can be fully understood. Nothing takes the place of careful looking, but beyond that, there are conventions that must be learned which form a kind of shorthand by which a gesture or an object or even the direction an individual is facing can have a particular meaning, often quite different from the meaning we might impose on them based only on our own experience. Furthermore, the relation between the form and the subject also has an effect on the language – the focus of the sculptor preparing a pedimental group of the battle of the gods and giants for a public building such as a temple is obviously different in many ways from that of a vase-

painter putting the same subject on the inside of a drinking cup to be sold to a private individual.

A general survey of the major types of ancient narrative art available to us, with an attempt to put them in some chronological context, is a logical starting point for this study. Then, as individual objects are presented later on, the specific problems of their 'language' will be discussed in more detail.

To start, it is worth stating the obvious points that the depictions of myth that have survived represent only a small fraction of those that were made, and that any statement we make about the earliest or latest scene or image could be contradicted tomorrow by a new discovery. Even more significant is the virtual disappearance of whole art forms. During the 5th and 4th centuries wall-paintings in public places were certainly a major form for the depiction of myth, but almost none have survived, and our knowledge of the most famous comes only from occasional references to them by a few later writers, and perhaps from pale reflections of parts of a few on some painted vases. Of course, almost all traces of woven fabrics have vanished, yet we know from depictions on vases and from literary sources that figure-scenes often appeared on them. Likewise, most carvings in wood and ivory have turned to dust. Very few objects of gold or silver have come down to us from antiquity because of the value of the metals themselves, which was far greater in the eyes of some than were the forms in which they were cast. So too, most ancient bronze sculptures were melted down for re-use and a great many marble works were burnt in lime kilns for mortar.

For descriptions of works of art now lost, two ancient authors are of particular importance. Pliny the Elder, a Roman rhetorician and historian, wrote his *Natural History* around the middle of the 1st century A D. In it he discusses many ancient artists and in so doing mentions titles for many of their works – thus we know the subjects depicted if not the details of the works themselves. About a century later Pausanias, a Greek geographer, perhaps from Lydia, travelled extensively in Greece and wrote a detailed account of what he saw in his *Description of Greece*. Much of the book is devoted to history and topography of the sites visited, but Pausanias was clearly fascinated by religion and art, and he describes many depictions of myth and legend in great detail. For our purposes, Pausanias' descriptions are the more valuable.

Paintings on vases are, in many ways, the richest source for ancient depictions of myth and legend. This is in part because of the large number of surviving vase-paintings (or parts of vase-paintings) and in part because of the creativity of some of the painters using the form. While in most ancient civilizations painting on pottery is relatively unimportant and is rarely a medium for narrative scenes – in Greece, particularly during the Archaic and Early Classical periods, it attracted significant talent and developed alongside sculpture and wall-painting as an art in its own right. The survival of so many painted vases – though still only a small fraction of those made – is due to several factors. Of considerable importance are the durability of the material and its inherent valuelessness. It

cannot be melted down and under most conditions it does not decay. Even when a vase is broken into many pieces it can be put back together again and the depiction on it examined, yet the fragments are otherwise worthless. Another factor is the value put on painted vases by non-Greeks – particularly the Etruscans – who often treated them as treasured objects and put them in their tombs where they remained in relatively good condition, of little interest to ancient tomb robbers. Also, the popularity of the vases in foreign markets encouraged the growth of the pottery 'industry', which certainly increased the quantity produced if not always the quality.

Narrative scenes first appear around 750 BC on Attic vases and figured scenes continue to be the primary interest of Attic vase-painters from then on into the 4th century. During the 7th century, Corinth was the foremost producer of pottery in Greece, exporting great quantities to both the East and West. Though a narrative or figured style did exist in Corinth throughout this period (and even in the 6th century) the Corinthian style was primarily ornamental, with animal friezes, and the quantity of figured vases produced was always relatively small.

The 7th century was the period of experimentation for Attic potters and virtually none of their wares were exported beyond the Greek islands. Towards the end of the century, however, a technique called black-figure, borrowed from Corinth where it had been perfected, became the standard for Attic pottery and was to remain so for at least a century. With their black-figure vases decorated with narrative scenes rather than with ornamental animal friezes, Attic potters had captured the export market from Corinth by the middle of the 6th century.

For the black-figure technique a silhouette figure is painted on to an unfired vase and details are incised with a sharp tool so that after the vase is fired they remain the light color of the clay while the figure is black. Red and white paints are occasionally used, though sparingly, for some details.

Around 530 BC Attic vase-painters invented a new technique called red-figure. It is literally the reverse of black-figure. The figure is reserved, that is, it is left the color of the clay while the background is painted black. Where details were incised in black-figure, here they are indicated with painted lines the thickness of which can be regulated by the density of the glaze. Some of the earliest vases in the new technique with a black-figure scene on one side and a red-figure scene on the other are called bilingual vases. By the beginning of the 5th century red-figure was the dominant technique and remained so on into the 4th century.

While Corinth and Athens were the most important producers of painted pottery during the first half of the 6th century, the vases of a third region, Laconia, are also important for the study of myths in Greek art. Laconian potters borrowed the black-figure technique from Corinth toward the end of the 7th century, but it was not until about 580 that narrative scenes began to appear on their vases. Then, for more than fifty years a school of Laconian figured

painting flourished, and exports reached the East and West. By 520, however, probably due to competition from Athens, the Laconian figured style had all but vanished.

Other centers, such as Boeotia, Euboea, Rhodes, Chios and some of the East Greek cities produced some figure decorated pottery during the 6th century. Also, of some importance for our purposes are two black-figure styles probably produced in Italy during the last third of the century. So-called 'Chalcidian' vases show a strong Attic influence, and while inscriptions on them are in the alphabet of Chalkis on the island of Euboea, it is likely that they were made in Italy. Caeretan hydriai show strong East Greek influences, but they were in all likelihood made in or near Caere (modern Cervetri) in Etruria. By the 5th century Athens had captured the market in painted vases and was virtually the only Greek producer of them. However, after the middle of that century schools of red-figure pottery appear in the Greek colonies of South Italy and Sicily, probably started by Attic immigrants, and continue to produce vases on through the 4th century, primarily for local consumption.

Several schools of South Italian vase-painting have been identified. The earliest, called Lucanian, seems to have started in Metaponto around 440, and then during the 420s another school, called Apulian, was established at Taranto. Other schools developed in Sicily at the end of the 5th century and are connected with schools that developed in Campania, and particularly at Paestum.

There is an important difference between most Attic and South Italian depictions of myth. Few Attic vase-paintings of mythological scenes can be called illustrations of literary texts. Most South Italian depictions of myth, on the other hand, are quite explicitly depictions of Greek theater productions, showing a moment, or moments, from a drama much as a poster outside a theater or cinema does today.

Small framed reliefs hammered in strips of bronze often used to attach the arm loop to a round hoplite shield are another important non-Attic source for depictions of myths. Many of these shield bands, as they are called, are decorated with a series of figured relief panels. The earliest of these bands dates from the end of the 7th century and some may have been produced as late as the 5th. By far the greatest number of them have been found at Olympia where they were probably attached to shields put there as dedications. It is likely they were made somewhere on the Peloponnese.

Olympia was the site of another dedication very important for the study of myths in Greek art – a large chest made of cedar wood decorated with figured scenes, some inlaid with gold and ivory and some carved from the wood itself. Though no trace of the actual chest survives, Pausanias (5.17.5ff) gives such a detailed description of it that most of the myths depicted can be identified, and scholars have been able to make a plausible reconstruction of it. Pausanias connects the chest with the tyrant Kypselos who ruled at Corinth during the third quarter of the 7th century, and while the actual age of the chest is a moot

point, the inscriptions and the nature of many of the scenes Pausanias describes, allow an early 6th-century date. Many scenes have remarkably close parallels in early 6th-century vase-paintings and small carved ivory reliefs from the middle of the 6th century may give a sense of panels carved on the chest.

During the 5th century terracotta relief plaques with mythological scenes on them were made on the island of Melos, as decorations to be attached to furniture or to chests. These Melian reliefs are clearly 'down market' versions of reliefs of ivory and precious metals, but nonetheless, the scenes depicted are often lively and original.

Engraved seals or gems are yet another non-Attic source for depictions of myth. While scenes from myth may appear on them as early as the middle of the 7th century, the period of major production starts during the second quarter of the 6th century, centered in the Greek islands, and the inspiration for much of their iconography is clearly East Greek.

Finally, sculpture is perhaps the best known, but by no means the richest, source of myth in art. Not surprisingly, narrative scenes during our period are limited almost exclusively to architectural (as opposed to free-standing) sculpture, which appears only on public buildings such as temples or treasuries for dedications from various cities at the great sanctuaries. The scenes could decorate the triangular pediments at the front and back of buildings or friezes which could comprise (in the Doric order) a series of rectangular metopes separated by ridged vertical dividers (triglyphs) or (in the Ionic order) an uninterrupted series of figures. One of the earliest depictions of myth on a Greek building is the pediment from the Temple of Artemis on Corfu dated to about 580 BC, but by the end of that century scenes from myth appear on temples and treasuries throughout the Greek world, with Athens, Delphi and Olympia having perhaps a disproportionate share of them. The sculpture from the pediments and metopes from the Temple of Zeus at Olympia (c. 460) and from the Parthenon on the Acropolis in Athens (c. 440) are milestones both in the development of Greek art and in the iconography of Greek myth.

Chapter Two

A DEMONSTRATION OF METHOD
THE RETURN OF HEPHAISTOS
TROILOS AND ACHILLES

While exploring an Etruscan tomb near Chiusi in 1844, the Italian excavator Alessandro François discovered fragments of a remarkable black-figure vase. The tomb had been robbed in antiquity, no doubt of bronze and precious metal grave goods, and the vase of mere clay (and thus worthless to ancient robbers) had been smashed outside the tomb. For the student of mythology the reassembled vase is a treasure-house of information, and it will frequently be used in the following discussion as an important reference point for the development of Archaic iconography.

The vase, which dates from soon after 570 B C, is a large volute krater – more than two feet tall – signed by the potter Ergotimos and the painter Kleitias [1]. Its body, neck and foot are decorated with six bands of figured scenes, and figures even appear on the volutes. Nearly a dozen different mythological episodes are illustrated, and inscriptions name more than 120 of the figures.

The vase serves as a convenient starting point for the examination in some detail of the iconographic development of two myths for which only scant literary sources survive – the return of Hephaistos and the pursuit and death of Troilos. Both myths are illustrated on the middle band of the body of the vase. On one side Dionysos leads Hephaistos to the assembled deities on Olympos, and on the other Achilles pursues the youth Troilos and his sister Polyxena outside the walls of Troy. Much of our knowledge for both of these myths comes from depictions of them in ancient art rather than from literary sources.

At the center of the frieze on one side of the vase Aphrodite faces Dionysos [2]. He approaches from the right leading the crippled god Hephaistos on a mule followed by horse-human hybrids labelled 'silens' and women labelled 'nymphs'. Aphrodite stands in front of Zeus and Hera who are seated on thrones, and behind them are Athena, Ares, Artemis, Poseidon (?) and Hermes. In short, Dionysos is leading Hephaistos to an assembly of Olympians, but it is not at all clear why.

Pausanias gives part of the answer (1.20.3). While describing a sanctuary of Dionysos in Athens he mentions a painting of 'Dionysos taking Hephaistos up to heaven' and goes on to summarize the myth:

. . . there is a Greek legend that Hera threw Hephaistos out when he was born, and he spitefully sent her a present of a golden throne with invisible cords that tied her up when she sat on it. Hephaistos refused to listen to any of the gods about this, until Dionysos who was on good terms with him, made him drunk and brought him up to heaven.

A later summary gives a similar account adding only the details that Ares tried to bring Hephaistos back but was repulsed by burning torches and that Hera showed her gratitude by convincing the Olympians to include Dionysos in their number. From these summaries we also know that fragments of verse from early in the 6th century by the poet Alcaeus of Lesbos were part of a poem on this subject. We also know that the myth was the subject of plays in the 5th century.

If we return to the scene on the François Vase, many details now make sense. Hephaistos' deformity, that led to his mother throwing him from Olympos, is indicated by his feet turned in opposite directions. The silen playing pipes and the nymph with small cymbals, together with the rowdy behavior of one silen carrying a nymph, suggest a revel that must have preceded the return. Dionysos' role as an uncouth outsider is suggested by his bushy beard, closer to those of the silens than to those of Zeus or even Hephaistos.

Hera sits on her throne, presumably bound by invisible cords. Ares sits dejectedly on a block, his head bowed, his spear point down on the ground, indicating his failure to bring Hephaistos back. Athena stands looking at him and pointing with her two hands in opposite directions as if to say, you failed while this barbarian succeeded. Aphrodite's role remains something of a mystery, but some scholars have suggested that she may have been offered by Zeus as a kind of bribe and that Dionysos, winning her, somehow transferred her to Hephaistos who is, in some myths, her husband. In short, we do not know why she is there.

The depiction of the myth on the François Vase is the most complete in addition to being one of the earliest. But before looking at later versions, we should look at a scene said to be the Return on a Corinthian amphoriskos from soon after 600 [3]. A beardless youth with twisted feet sits on a mule and raises a drinking horn to his mouth. He is accompanied by a woman and three naked men – one with a cup, one with a vine and one with an oinochoe. In front of the mule is a tree and two grotesque, phallic men. It would seem, particularly with the François Vase in mind, that a drunken cripple on a mule could be no one but Hephaistos. But this is not necessarily the case. Figures with twisted or misshapen feet often appear on contemporary Corinthian vases – often drinking – and on some of them two or more cripples appear in the same scene. It is not clear what these crippled figures represent, but surely they are not 'Hephaistoi'! Also, if the scene on the amphoriskos is the Return, it is difficult to understand who the woman accompanying the procession might be. This is not to say that the scene is not the Return, only that the identification is by no means certain.

The complete scene with the procession and the waiting deities appears on an Attic neck-amphora a decade after the François Vase (where Hephaistos is a naked youth) [4] but for the most part it is replaced with abbreviated versions focusing on the procession. On an Attic column krater from about 550 by Lydos, the procession fills a continuous frieze encircling a vase [5]. Hephaistos rides a mule on one side of the vase and Dionysos walks on the other, but the

gods are nearly lost amongst the seventeen silens or satyrs with pipes, wine-skins, bunches of grapes and a snake, and the nine women who dance and revel with them.

These figures are similar to those labelled silens and nymphs by Kleitias and deserve a brief digression. The biped horse-human hybrids on vases are often called satyrs and, in fact, the two words 'satyr' and 'silen' seem to have been interchangeable at least by the 4th century when Plato, in his *Symposium*, could have Alcibiades use both to describe Socrates. Silenos was a particular satyr, known for his wisdom and was captured by King Midas. On an Attic cup made by Ergotimos, the potter of the François Vase, where the capture of Silenos is depicted, he has essentially the same form as Lydos' satyrs [6]. Most Attic satyrs have human legs and feet, a few have horse legs; human legs ending in hooves are usually seen as an East Greek characteristic [7].

Satyrs are regular companions of Dionysos on Attic and South Italian vases, though their iconography probably predates his. On most black-figure vases their companions are nymphs – jolly dancing girls, familiars of the countryside [8] – but toward the end of the 6th century they are transformed into maenads, the daemonic votaries of the god [9].

Some black-figure scenes become even more abbreviated and show only Hephaistos on the mule with satyrs accompanying him, and in these scenes he often carries an axe as an attribute since his deformity is almost never shown on Attic vases (aside from the François Vase). Later painters who enjoy the joke of the deity on an aroused mule seem, at times, to forget the origin of the scene and put Dionysos or even a maenad on a mule. This eventually becomes a generic scene with no particular meaning.

Another scene with Dionysos may also be an abbreviation for the full Return. On many black-figure vases from the second and third quarters of the 6th century, Dionysos stands facing a woman [10]. Though she has often been called Ariadne, she is never named and there is a clear iconographic parallel on the François Vase that would allow her to be Aphrodite. In that case, the abbreviated version could have had symbolic meaning showing the connection between the gifts of love and wine known in ancient literature. For example, Solon could write: 'Dear to me now are the works of Aphrodite and Dionysos and of the Muses, works which make good cheer for man.' This symbolic or poetic role could be the explanation for Aphrodite's central position on the François Vase.

Outside Attica during the 6th century, the Return appears only occasionally and takes various forms. On a Laconian cup from the middle of the century a crippled Hephaistos with a drinking horn rides a mule side-saddle and is followed by a naked man with a wine-skin on his back [11]. Dionysos is not a part of this scene. (Other crippled figures do not appear in Laconian art, so there is no reason to doubt that this is Hephaistos.) The Return is also the subject of what were probably quite similar scenes on two Caeretan hydriai. On the better preserved, a youthful Hephaistos with crippled feet rides a galloping mule

toward Dionysos accompanied by a maenad with a snake and a satyr (with hooves) playing pipes [12].

Pausanias also tells us (3.17.3) that 'Hephaistos releasing his mother from bonds' was depicted in a bronze relief on an Archaic Temple of Athena at Sparta and (3.18.16) that 'the legendary binding of Hera by Hephaistos' was depicted on the throne by Bathykles at Amyklai, also Archaic. Though we have no idea what these scenes may have shown, it would seem unlikely from Pausanias' brief titles that they depicted the procession as we know it on vases.

The Return continues to be a popular subject with Attic red-figure vase-painters. In many scenes there is little change as a youth or bearded man rides a randy mule, and satyrs accompany them. Attributes are regularly included. Hephaistos carries an axe or now sometimes tongs. As on the Kleophrades Painter's lively calyx krater, a satyr sometimes carries a bellows [13]. Sometimes the god wears a rounded workman's hat which in later art becomes one of his canonical attributes.

A new version also appears early in the 5th century with both gods walking. This innovation was probably inspired by satyr plays on the subject, since on at least two vases a satyr wears the shorts used by actors to hold on an artificial phallos and tail [14]. In both versions of the procession the seated Hera is sometimes included [15]. Then, before the end of the 5th century, the subject ceases to appear on Attic vases, and no later versions of it survive in any medium.

The bawdy elements of the Return, as we know them from the François Vase, were toned down during the 5th century and the absence of the myth from Attic vase-paintings after about 420 is in part the result of changing tastes in Attica. The vigorous (at times outrageous) scenes had little place in the sentimental repertory of the 4th-century Attic vase-painter.

Fragments of two plays about the Return survive, one from the end of the 6th or beginning of the 5th century by the Sicilian dramatist Epicharmos, and the other a satyr play from later in the 5th century by the Eretrian dramatist Achaios. The surviving fragments of both tell only of a feast – presumably the feast at which Dionysos made Hephaistos drunk – rather than of a procession.

Several depictions of Hephaistos feasting (or about to feast) with Dionysos survive on Attic vases from the late 6th down to the early 4th century and must depict part of the myth of the Return. On a black-figure hydria by the Lysippides Painter from about 520, Hephaistos with his axe approaches a kline on which Dionysos reclines while a satyr entertains him with his kithara and Hermes and satyrs and maenads encourage the festivities [16]. The *kline*, or couch, is the traditional furniture for a symposium or feast where one reclines leaning on the left elbow to eat and drink (a tradition borrowed by the Greeks from the East in the 7th century). A table with food on it stands beside the kline and here a vine growing up by the couch suggests that the festivities are out of doors.

It is also possible that fragments of a pediment from a late 6th-century temple

on Corfu may depict this feast [17]. There, Dionysos (?) with a drinking horn reclines on a couch with a naked youth who holds a cup and wears a cloth hat much like the one often worn by Hephaistos. As mentioned earlier, the god is sometimes shown as a youth even on early vases.

On one side of a red-figure volute krater by Polion from about 420, a small satyr helps Hephaistos up from a couch on which Dionysos also reclines while to the far left of the scene Hera sits scowling [18]. A satyr with a torch and tongs marches from the kline toward Hera, suggesting the usual procession, while other satyrs and maenads sit and converse. Time and space have been compressed, as they often are in Archaic vase-paintings, to give us several elements of the story at once.

Finally, one of the last depictions of any part of the story of the Return is on an Apulian amphora from the late 4th century [19]. A comic little Hephaistos with his axe over his shoulder stands in front of a seated Hera and seems to lecture the assembled deities including Athena, Zeus, Aphrodite and Ares. A small Eros hovers in front of Hera. The intent behind most depictions of the Return is surely humorous, but here the humour has moved into the burlesque. Obviously there is no iconographic connection between this and any of the Attic scenes.

At the center of the same band on the other side of the François Vase a youth on horseback labelled 'Troilos' gallops to the right with a riderless horse beside him as a man (much of him is missing, but greaves show that he is a warrior) runs after him with what must be a spear [20]. This is the most detailed version of another popular scene on Attic vases for which the literary sources have not survived. But where the subject of the Return is comic, the subject here is tragic.

Homer mentions Troilos only once (Iliad 24.257) and then in passing as one of the sons Priam lost. He uses the epithet 'horse-loving' to describe him. From Proclus' summary of the epic poems we know that a story about the death of Troilos at the hands of Achilles was included in the Cypria, one of the lost books of the Trojan cycle, and that this was also the subject of a lost play by Sophocles. The event took place soon after the siege of Troy had begun. Later sources add the details that Troilos was said by some to be the son of Apollo rather than of Priam, and that the murder took place at the sanctuary of Apollo. Two different motives are suggested for the murder: that Achilles was in love with Troilos and killed him when he rejected his advances, or, more likely, that there was a legend that Troy could not be taken once Troilos reached the age of twenty, and thus Achilles was obliged to kill him. The romance of Troilos and Cressida told by Chaucer and Shakespeare is a medieval fabrication with no ancient source whatsoever.

Though the surviving literary details are few, they do allow us to make some sense of the Troilos scene on the François Vase which, with other depictions, gives a clearer idea of the myth itself. The scene here is framed by two buildings, a fountain house to the left and the walls of Troy to the right. The warrior

chasing Troilos is Achilles and the fallen vase (labelled *hydria*, or water jar) beneath the galloping horses has obviously been dropped by Polyxena, Troilos' sister, who runs in front of him showing that they had been at the fountain and are fleeing toward home. Priam, the King of Troy and father of Troilos, rests on a seat (helpfully labelled *thakos*, or seat) in front of the walls while Antenor, his counsellor, rushes toward him gesticulating, warning him of the threat to Troilos and perhaps, in turn, to Troy. From a door in the wall Hektor and Polites, brothers of Troilos, emerge fully armed in an attempt to save him, but we know they will be too late.

Behind Achilles, Athena, his protectress, and Thetis, his mother urge him on, while Hermes the neutral messenger/reporter of the gods prepares to follow. A woman labelled Rhodia stands by the fountain-house gesturing, presumably calling the attention of the Trojan youth still filling a water jar. From the far left Apollo moves into the scene reminding us that Troilos, sometimes said to be his son, is killed in his sanctuary, and that later the god is instrumental in the death of Achilles. In his depiction, Kleitias is not interested in the relation between time, space and action, but, like most Archaic artists, leaves them for the viewer to provide.

Depictions of other episodes from the Troilos myth also appear in ancient art – Achilles lying in ambush, the murder of Troilos in the Sanctuary of Apollo and the fight over his body. Though there is, of course, some overlap in representations of the various episodes, we should look at each of them individually.

The earliest certain depiction of Achilles lying in ambush is on a Corinthian black-figure flask made a decade or two before the François Vase *[21]*. A bearded Troilos leads two horses toward a fountain at which Polyxena fills a jug. Achilles, fully armed, crouches behind a tree at the back of the fountain. A woman walks away with a full jug, and Priam and another man stand to the left watching. Unusual in this version of the ambush are the beard on Troilos and the presence of Priam, but in other ways it is similar to many later Attic depictions on black-figure vases.

In almost all Attic depictions of the ambush, Troilos has two horses (he usually rides one and leads another) which he has presumably taken to the fountain for water, in most Polyxena is present and a bird often sits on the fountain (rarely a fountain-house) *[22]*. Though birds in scenes on Archaic vases need not always have specific meaning, the occurrence of the bird in so many depictions of this particular scene points to a special significance here. It is probably the raven of Apollo, an omen of things to come and a reminder of the god's role in the story.

The prominent role of Polyxena in so many depictions of this scene deserves some comment. She is a canonical part, not an extra, and on some vases she even appears to the exclusion of Troilos. But just why she is there is not clear. We know, again from Proclus that in another of the lost books of the Trojan cycle, the *Ilioupersis*, Polyxena was sacrificed at the tomb of Achilles after the fall of

Troy. A particularly brutal depiction of the event appears on a mid-6th-century Attic vase where Neoptolemos, the son of Achilles, cuts her throat *[23]*. Later painters chose, more characteristically, to show her being led to the tomb *[24]* and Pausanias (1.22.6) tells that it was the subject of a wall-painting in the Sanctuary of Aigeus in Athens. In his *Hecuba*, Euripides tells that the spirit of Achilles demanded the sacrifice and in another lost play, Sophocles told the same story, but it is not at all clear why he made the demand. Some have suggested that Achilles had fallen in love with her and point to her regular appearance in depictions of the ambush and pursuit as evidence of an early connection between them.

The ambush of Troilos also appears on a few non-Attic vases from the 6th century – Boeotian (where Troilos is bearded), Laconian *[25]*, East Greek and Chalcidian. It may also be the subject of a mid-6th-century pedimental sculpture from the Acropolis at Athens, though Troilos and his horses would not have appeared there. A crouching warrior on a metope from a 6th-century temple near Paestum may also be an abbreviation of the scene. The ambush appears on few Attic red-figure vases and then only from the middle of the 5th century.

The subject appears on South Italian vases more than a century after the last Attic vase-painting of it. On these, Polyxena does not appear and Troilos has one horse, which he sometimes waters at a fountain. In one entertaining scene, clearly intended as a parody of the myth, a dumpy Troilos has led a mule to the fountain behind which Achilles hides *[26]*. There is little or no iconographic connection between these scenes and the earlier ones.

The earliest certain depiction of the pursuit is on a Proto-corinthian aryballos from the third quarter of the 7th century where a named Achilles pursues a bearded horseman labelled Troilos *[27]*. The scene on the François Vase comes next chronologically, and the majority of later Attic versions reflect the same iconography. Troilos with two horses gallops to the right preceded by Polyxena, a water jar lies on the ground (sometimes broken) and Achilles pursues with a spear, or sometimes a sword. When the fountain is included, it is often a fountain-house as on the François Vase.

The scene is popular with Attic black-figure painters and appears on a few red-figure vases down to the middle of the 5th century (where Troilos sometimes rides to the left). On a cup by the Brygos Painter, Achilles has caught Troilos by the hair and is pulling him off his horse *[28]*. A century after the last Attic vase-painting of the subject, it appears on South Italian vases. On those, as with the ambush, Polyxena is not a part of the scene and Troilos has only one horse.

A scene on a Corinthian amphora from the middle of the 6th century is of interest here because it shows the importance of recognizing conventions *[29]*. An archer and a warrior with a spear pursue a youth on horseback who turns and shoots at them with his own bow. The fact that his horse has eight legs – is, in fact, two horses – shows that this is probably just a variation on the Troilos scene

common in Attica. On a Chalcidian krater a youth with two horses rides beside two couples labelled Paris and Helen, Hektor and Andromache. Here also, the two horses probably identify Troilos [30].

The earliest depictions of the murder of Troilos are on shield bands from the late 7th and early 6th century found at Olympia. On each a warrior with a sword prepares to kill a naked youth at an altar [31]. The latest of these, from about 590, is particularly interesting because there is a cock on the altar as well. Cocks were often given by men as love gifts to boys, so the cock in this scene may support the version of the Troilos myth that tells of Achilles' love for him.

On a Corinthian krater roughly contemporary with this shield band, Achilles holds the naked youth upside down by his feet over an altar as Trojan warriors (including Aineias and Hektor) approach from the right [32]. In several Attic black-figure vases from the middle to end of the 6th century, Achilles had beheaded Troilos and uses the head as a weapon against Hektor and other Trojan warriors who attack him [33]. The altar figures prominently in most of these. On a mid-century Chalcidian amphora, Achilles beheads Troilos at an altar.

The few Attic red-figure depictions come from late in the 6th or early in the 5th century and show little or no connection with the black-figure versions. In one, Troilos is a young helmeted warrior who falls as Achilles attacks him with a spear and Aineias rushes to his aid [34]. In another, Troilos, whose horse has just fallen, is attacked by Achilles with a sword.

The murder is the subject of an Apulian amphora from the middle of the 4th century. Troilos kneels with his arms outstretched, begging for mercy, as Achilles grabs him by the hair about to behead him with his sword. Athena stands to the side calmly watching. This moment before death is also shown on contemporary small bronze reliefs from mirrors, both Attic and South Italian [35].

Before concluding the discussion of the Troilos myth, another story that parallels it in many ways should be briefly considered – the death of Astyanax, the son of Hektor. Like the Troilos myth, it was told in poems from the epic cycle which have not survived, and our primary knowledge of it comes from ancient art. Proclus, in his summary of the *Ilioupersis*, tells that Astyanax was killed by Odysseus during the sack of Troy, but another source tells that in the *Little Iliad* Neoptolemos threw him from the walls of Troy during its sack.

In Attic vase-painting depictions of the death of Astyanax as part of the *Ilioupersis* are popular from before the middle of the 6th century down to the middle of the 5th. The three central figures in these scenes are Neoptolemos, Priam and Astyanax [36]. Neoptolemos usually holds Astyanax by the foot, slung over his shoulder about to fling him down on Priam who lies, falls back, or sits on an altar. The parallel with the Troilos scene of a youth killed at an altar by a warrior is obvious – but the means of death are different. The similarity between some Attic scenes with Astyanax and the Troilos scene on the Corinthian krater mentioned above [32] has often been noted.

Beyond even these parallels, the two myths do seem to have been conflated in the minds of some Attic painters. So, on a black-figure lekythos a warrior prepares to throw a decapitated head (rather than a body) at an old man seated at an altar [37]. On a contemporary hydria the warrior swings the body by the foot, but on the altar to the right is a tripod, and the old man crouches to the left. Athena watches horses gallop in from the far left. It is easy to see how the conventions for the two murders could become mixed in the minds of vase-painters, and it would be unwise to try to read much significance into the conflation.

The myth of Troilos and Achilles, then, appears in Greek art over nearly three centuries – the end of the 7th to the end of the 4th. The remarkable similarities in some of the Attic imagery over several generations must be, in part, the result of a well-established iconographic tradition, but elements of the imagery may also have depended on a common literary source. The fallen hydria beneath Troilos' galloping horses on many vases was probably an image passed on from painter to painter, while the convention of Troilos' two horses more likely has a literary source. The source of the conflation of the Astyanax and Troilos myths was probably the mind of a vase-painter rather than that of a poet, but one suspects that poets or dramatists might have inspired the variations in different red-figure depictions of the death of Troilos.

We know that the myth was part of the epic cycle and the subject of at least one play, but without its survival in art it would be a lifeless footnote for us. Even with the depictions, though, we do not know with certainty the central point of the story – the motive for the murder.

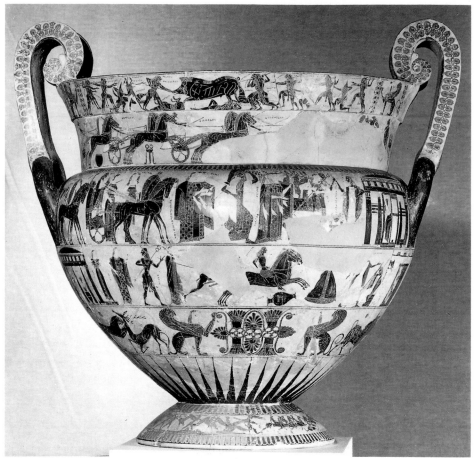

1 'François Vase'. Attic black-figure volute-krater from Chiusi, signed by the potter Ergotimos and the painter Kleitias. Side A. *c.* 570. 66 cm

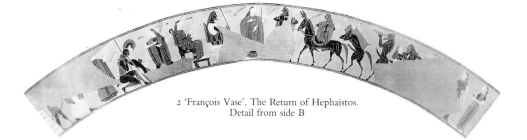

2 'François Vase'. The Return of Hephaistos.
Detail from side B

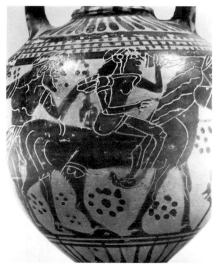

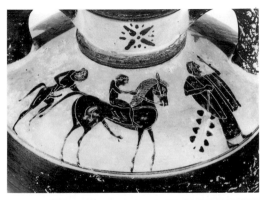

3 Corinthian amphoriskos. The Return of
Hephaistos(?) Early 6th Century. 11.5 cm

4 (*right*) Attic black-figure neck-amphora. The
Return of Hephaistos. A, Dionysos with an ivy
sprig precedes a young Hephaistos on an
ithyphallic mule followed by a satyr. B, Deities
welcome them. Hera is seated and Aphrodite is
probably the other woman, from the evidence of
the François Vase. Zeus must be one of the men,
though none of the gods has an attribute. The star
on the neck is simply a decorative device,
unrelated to the scene. *c.* 560. 37 cm

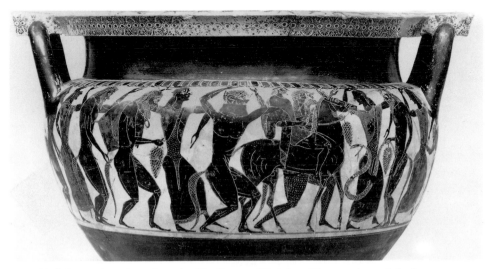

5 Attic black-figure column-krater by Lydos. The Return of Hephaistos. The procession encircles the vase.
Dionysos walks on one side while Hephaistos rides his mule on the other. Dancing satyrs and nymphs accompany
them with snakes and grapes and wine-skins. *c.* 550. 56.5 cm.

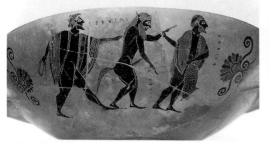

6 Attic black-figure cup from Aegina, signed by the potter Ergotimos. The Capture of Silenos. The captors carry the rope and wine-skin they used to catch Silenos as they lead him away to Midas. *c.* 560

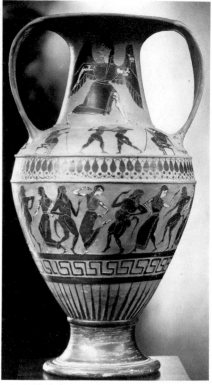

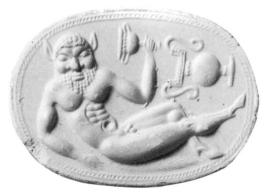

7 Agate scarab. Satyr with hooves, an East Greek characteristic, reclines, holding a cup in one hand. An elaborate vase is shown on its side above his legs. *c.* 530. L. 2.2 cm

8 Attic black-figure neck-amphora, signed by the potter Nikosthenes. Neck, winged woman (Iris or Nike?). Shoulder, athletes boxing between judges. Body, dancing satyrs and nymphs. *c.* 530

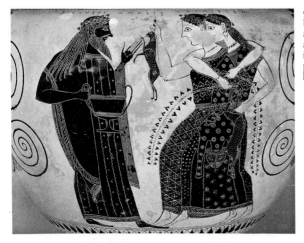

9 Attic black-figure neck-amphora signed by the potter Amasis. Two maenads approach Dionysos with gifts of a hare and a stag. They wear jewellery and carry ivy sprigs, and one of them sports a panther-skin. Dionysos, holding a kantharos, greets them. *c.* 530. 32.5 cm

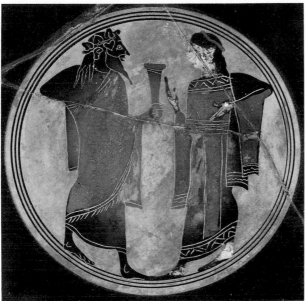

10 Attic black-figure cup by the Heidelberg P., from Greece. Dionysos with an unnamed woman. The iconographic parallel on the François Vase allows her to be identified as Aphrodite, but she has also been called Ariadne. *c.* 550

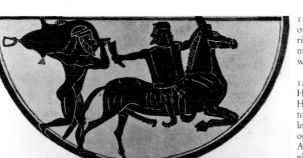

11 Laconian cup from Rhodes. Return of Hephaistos. The crippled Hephaistos rides an ithyphallic mule as a naked man fills his drinking horn from a wine-skin. *c.* 560

12 Caeretan hydria. Return of Hephaistos. A young crippled Hephaistos rides a galloping mule toward Dionysos who wears a leopard-skin and holds a kantharos in one hand, a small leopard in the other. A maenad with a snake and a satyr playing pipes (note his hooves) follow. *c.* 530. 41 cm

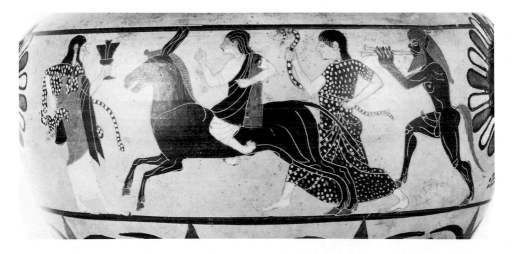

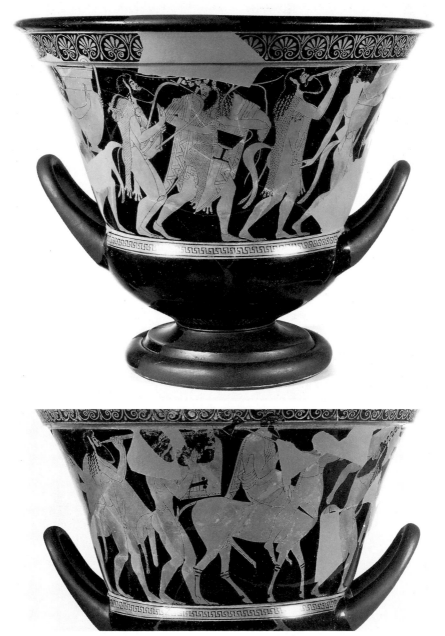

13 Attic red-figure calyx-krater by the Kleophrades P. Return of Hephaistos. A, Dionysos with leopard-skin, vine branch and kantharos, with satyrs wearing similar skins playing pipes and lyre and carrying a wine-skin and a volute-krater. B, Hephaistos with an axe on an ithyphallic mule with satyrs playing kithara and pipes and carrying bellows and a pointed storage amphora. *c.* 490. 43.8 cm

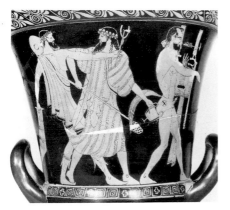

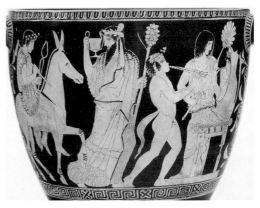

14 Attic red-figure calyx-krater by the Altamura P. Return of Hephaistos. The satyr playing a kithara is an actor in disguise who wears shorts to which an artificial phallos and tail are attached. Hephaistos wears tall actors' boots. The scene seems to have been inspired by a satyr play. c. 460. 39.7 cm

15 Attic red-figure skyphos. Return of Hephaistos. A young satyr playing pipes leads the procession of Dionysos with thyrsos and kantharos and a young Hephaistos on a mule toward Hera who sits tied to her seat by invisible fetters as an attendant (Hebe?) fans her. c. 430. 30 cm

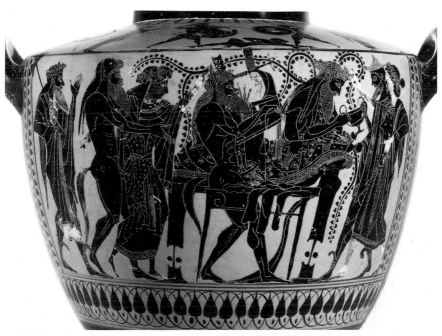

16 Attic black-figure hydria. Dionysos reclines on a kline while a satyr entertains him with a kithara and a feast awaits on the table beside him. Hermes and a nymph (?) are at the head of the couch, a satyr and a nymph at the foot. A surprised Hephaistos with an axe over his shoulder enters the scene from the left. This must be the beginning of the feast before the Return. c. 520. 47 cm

17 Limestone pediment from Corfu, discovered by A. Choremis in 1973. Dionysos and Hephaistos(?) feasting. Late 6th Century. 2.73 × 1.3 m

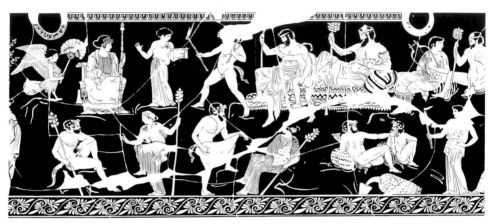

18 (*above*) Attic red-figure volute-krater by Polion, from Spina. Return of Hephaistos. A satyr helps the drunken Hephaistos up from the kline he shares with Dionysos while Hera, holding her sceptre, awaits his return. Here a siren with arms (unusual in Attic art) fans her. Note the compression of time and space in this narrative scene. *c.* 420

19 (*right*) Apulian red-figure amphora from Arpinova. Burlesque of the Return of Hephaistos. Late 4th Century

20 (*below*) François Vase (see *1*). Achilles pursuing Troilos. Detail from side A

21 Corinthian flask from Cleonae. Achilles lying in wait for Troilos. Achilles, wearing a Corinthian helmet and greaves and holding spears and a shield with a gorgoneion for a device hides behind a fountain with a lion-head spout at which Polyxena fills a jug. A bearded Troilos leads two horses (one light and one dark) while his father Priam and another man watch. *c.* 580

22 Attic black-figure neck-amphora. Achilles lying in wait for Troilos. Achilles, with a Boeotian shield, hides behind a fountain as Polyxena, with a hydria, and Troilos, with two horses, approach it. The bird, which the painter has emphasized by making it very large, probably has special significance here, perhaps as an omen of things to come. The florals hanging down from the corners, however, are purely decorative. *c.* 560

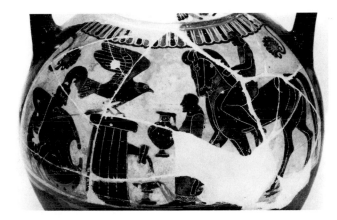

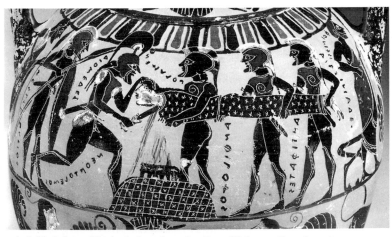

23 Attic black-figure 'Tyrrhenian' amphora. Sacrifice of Polyxena. Vases from the Tyrrhenian group seem to have been made specifically for the Etruscan market and include some particularly brutal scenes that would have appealed to Etruscan rather than Attic tastes. Here old Phoenix looks away while Neoptolemos cuts Polyxena's throat. A fire burns on an altar behind the tomb of Achilles. *c.* 560

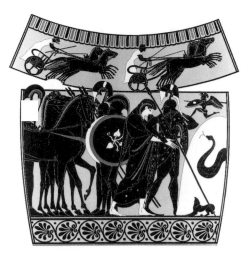

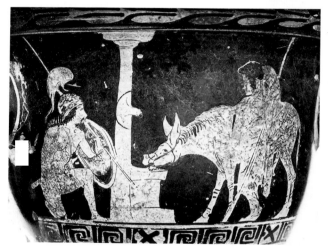

24 (*above left*) Attic black-figure hydria. Above, chariot race. Below, sacrifice of Polyxena. More in keeping with Attic tastes, Neoptolemos leads Polyxena to the tomb. An eidolon of Achilles flies above the tomb. The serpent is associated with the underworld. *c.* 500

25 (*above*) Laconian cup from Cervetri. Achilles lying in wait for Troilos. In the main field Achilles kneels by a low building on which a bird perches. In the exergue below Troilos gallops to the right toward Polyxena who stands holding jugs. The hare beneath the horse running in the opposite direction is probably included to suggest speed. *c.* 560

26 (*above*) Apulian or Boeotian red-figure bell-krater. Parody of Achilles lying in wait for Troilos where Troilos' horses have been replaced by a mule. *c.* 400

27 (*right*) Proto-corinthian aryballos. Achilles pursuing Troilos (named). The large horse toward which he rides has a goat growing from its back like a chimaera and the painter seems to have confused the Troilos story with Bellerophon and the Chimaera. Late 7th Century. 6.2 cm

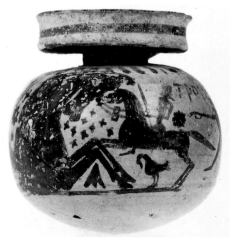

28 (*above*) Attic red-figure cup
by the Brygos P. Achilles
pursuing Troilos. Achilles
catches Troilos by the hair and
pulls him off his horse. Polyxena
rushes off to the right. The
hydria she has dropped lies
under the horses. *c.* 480

29 (*right*) Corinthian neck-
amphora from Capua. Achilles
pursuing Troilos(?) *c.* 550.
32.5 cm

30 (*below*) Chalcidian column-
krater from Vulci. Paris and
Helen, Hektor and Andromache
all named. The youth with the
two horses must be Troilos,
brother of Paris and Hektor.
c. 540. 37.9 cm

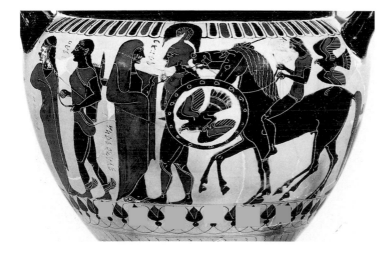

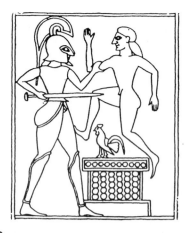

31 (*left*) Bronze relief, shield band panel from Olympia. Death of Troilos. Achilles is about to kill Troilos at an altar on which a cock stands. Cocks were often love gifts from men to boys. *c.* 580

32 (*centre*) Corinthian column-krater. Death of Troilos. Achilles holds Troilos over an altar having pulled him from his horses, which stand nearby. Trojan warriors (including Hektor and Aineias) rush toward him from the right. *c.* 580

33 (*below*) Attic black-figure 'Tyrrhenian' amphora from Pescia Romana. Death of Troilos. Achilles has beheaded Troilos beside an omphalos-shaped altar and uses his head as a weapon against Trojans (including Hektor) who challenge him. *c.* 560

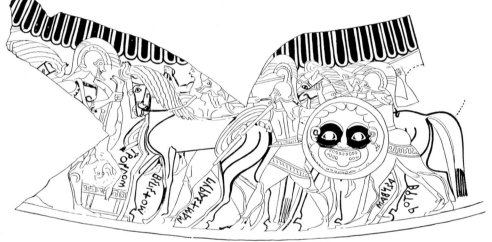

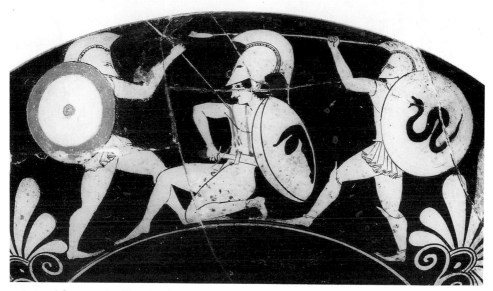

34 Attic red-figure cup by Oltos. Death of Troilos. Achilles and Aineias fight over Troilos. This is a generic scene depicting a duel, where the victor is usually the figure to the left. Only the names of Troilos and Aineias inscribed on the vase (not visible in the photo) allow an identification of the specific scene. *c.* 510

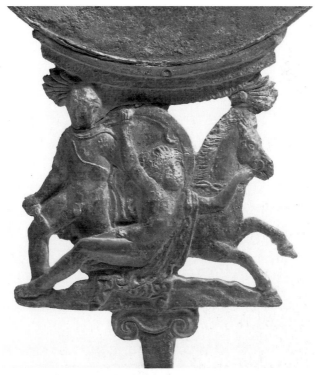

35 Tarentine bronze mirror handle. Death of Troilos. *c.* 325

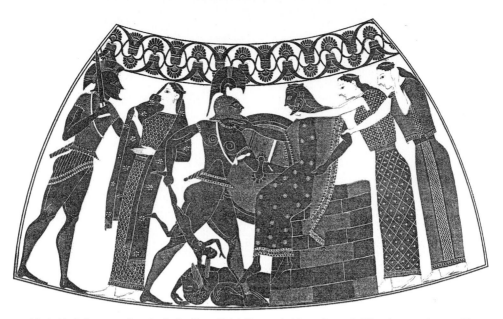

36 Attic black-figure amphora by Lydos, from Vulci. Ilioupersis. Neoptolemos, holding Astyanax by an ankle, prepares to kill Priam who sits on an altar begging for mercy. To the left, Menelaos recovers Helen. This is a good example of compression of time and space in an archaic narrative scene. *c.* 550

37 Attic black-figure lekythos. Ilioupersis. Neoptolemos is about to throw the head of Astyanax at Priam who sits on an altar begging for mercy, while a woman behind him mourns. *c.* 500

Chapter Three

PORTRAITS OF THE GODS

Relatively few figures in ancient narrative scenes are identified by inscriptions. Rather, context and attributes, such as dress, objects carried, accompanying animals and physical appearance are the usual means of identification. The identity of many heroes is clear from context, but gods and goddesses are sometimes only bystanders in heroic scenes. Thus the members of the divine family and their entourage need to be introduced here with their attributes.

In the main band encircling the François Vase a procession of deities approaches the house of Peleus to celebrate his marriage to Thetis [1]. Almost exactly the same scene appears on an Attic black-figure dinos from a decade or so earlier signed by the painter Sophilos [38], and fragments of another dinos from the Acropolis show that he painted the scene more than once. These are the first 'family portraits' of the gods and goddesses in Greek art. Since almost all of the figures are named in both Sophilos' and Kleitias' depictions of the wedding of Peleus and Thetis, these scenes serve as appropriate starting points for our introductions. The myth of the wedding itself is discussed in Chapter 9.

An obvious distinction is made on both vases between the lesser figures who walk and the grander ones who ride in chariots. At the front of each procession is a group of those on foot, the chariots follow, and at the very end are Hephaistos on his mule and the fish-bodied Okeanos. Various figures on foot accompany the chariots as well.

Iris leads the procession in her role as herald or messenger [39]. She is the female counterpart of Hermes and shares some of his attributes. Both of them regularly carry a *kerykeion*, or herald's staff. In early art it is shown as a cleft stick, then as a staff with an open figure of eight at the top; later it sometimes ends in facing snake-heads, and in Roman art it becomes the caduceus. On Sophilos' vase, Iris wears boots with wings at the front which are also often worn by Hermes in Archaic art. Boots depicted on black-figure vases often have a flap at the front quite similar in shape to these wings; however, they should only be called wings when the feathers are clearly indicated as they are here. Iris only rarely appears in 6th-century art, but she does appear on 5th- and 4th-century Attic and South Italian red-figure vases where she sometimes has wings on her back and can easily be confused with Nike (Victory) [40]. She also appears on the west pediment of the Parthenon attending Poseidon and perhaps as the winged attendant of Hera on the east frieze.

On both vases, a group of women without attributes follow on foot not far behind Iris. On the François Vase they are Hestia, Chariklo and Demeter. For Sophilos they are Hestia, Demeter, Chariklo and Leto.

These are two rare appearances of Hestia in ancient art. She has little mythology and almost no iconography. Likewise, it is one of the few appearances of Chariklo, the wife of the centaur Chiron, and she, too, has no attributes. He, on the other hand, is easily recognized. On the François Vase he walks with Iris, on Sophilos' vase he is a bit further back in the procession, but on both he carries a branch over his shoulder with animals hanging from it. He is a civilized centaur and wears a *chitoniskos* (a short tunic) on his wholly human body which is attached at the rump to the chest and hind legs of a horse. Unlike other centaurs, he often wears a cloak of some sort and his front legs are sometimes human. He is discussed in Chapter 9 as Achilles' tutor.

The inclusion of Demeter in this group of minor figures is, at first thought, surprising since she is certainly a major deity in Classical Athens. Before the middle of the 6th century, however, she only occasionally appears in Greek art, and then only in groups of deities on Attic vases. From the late 6th century she appears more and more frequently on Attic vases with her daughter Persephone (Kore) and with the Eleusinian prince, Triptolemos, who sits on his wheeled throne about to leave on his mission to teach agriculture to mortals, a subject which continues to be popular in Athens through the 5th century [41], and in South Italy on through the 4th. Since vase-painters seldom indicate a woman's age, it is often difficult to distinguish Demeter from her daughter in these scenes. On the 5th-century vases they both often hold torches and wear crowns, on some they hold sceptres and stalks of grain. In a famous mid-5th-century relief from Eleusis, Demeter has a sceptre, Persephone a torch [42], while on the east frieze of the Parthenon it is Demeter seated between Dionysos and Ares who holds the torch [43].

Demeter may also be the goddess holding torches in depictions of deities accompanying a wedded pair in a chariot, a scene that appears on Attic black-figure vases during the second half of the 6th century. However, it is not safe to assume that all women with torches are Demeter or Persephone. On an Attic red-figure krater from shortly after the middle of the 5th century, Hekate holds torches as Hermes leads Persephone from the underworld to Demeter who holds a sceptre [44].

Demeter is named as the goddess without attributes who mounts a chariot on an Attic black-figure hydria from *c.* 525, and on a slightly earlier amphora she holds stalks of grain as she mounts a chariot in the presence of Triptolemos and others. Unnamed goddesses often mount chariots on Attic vases from the last quarter of the 6th century, but it is not safe to name them without the presence of an attribute or an inscription.

Demeter's appearance in art of the 6th and 5th centuries is limited almost exclusively to Attica and her popularity as a subject after the middle of the 6th

century is certainly connected with the increased importance of the Eleusinian mysteries in Athens, fostered by the tyrant Peisistratos. But for both Sophilos and Kleitias, she is not yet a goddess deserving special attention.

Leto, the fourth in the group of women without attributes on Sophilos' vase, is not part of the group in Kleitias' version. In fact, Leto does not appear anywhere in what survives of the procession on the François Vase, though she may well have ridden in a missing chariot with Apollo. He was surely included and Hermes rides with his mother Maia, rather than with Apollo on Sophilos' vase.

Leto never has attributes. Thus, she can only be recognized by an inscription or through her association with her children, Apollo and Artemis. She may sometimes be the goddess mounting a chariot in the presence of Apollo and Artemis. She is certainly the woman between Apollo with his kithara and Artemis with her bow on the mid-6th-century metope from Selinus [45] and she is probably one of the two women who often flank the god with his kithara on a large number of Attic vases from the second half of the 6th through the 5th century [46]. Unless Artemis carries her bow, it is not possible to distinguish her from her mother in these scenes.

One of the few myths in which Leto plays a significant, if passive, role is the death of Tityos. Though there are several versions of the story, the one illustrated in ancient art is always the same. Tityos was a monstrous son of Gaia (Earth) by Zeus. On seeing Leto he was overcome by desire and tried to rape her. As he carried her off she called to her children for help and they killed him. Odysseus later sees the huge body of Tityos stretched out in the underworld where an eagle attacks his liver. One of the earliest depictions of the story is on metopes from Paestum dated to the middle of the 6th century. On one metope Tityos, waving a club, carries off Leto, on another Apollo and Artemis pursue with drawn bows. The myth is also the subject of several Attic black-figure vases roughly contemporary with the metopes, where Gaia is shown trying to save her son. The myth is the subject on a Caeretan hydria from the last quarter of the 6th century and on a few Attic red-figure vases from the first half of the 5th [47].

On both vases, Dionysos walks alone behind the group of women. He is an outsider, as we have already seen in the Return of Hephaistos frieze. On both, he carries a branch of a grape vine, but on the François Vase he also carries a large amphora on his shoulder. These clearly identify him as the god associated with wine, but they are not his canonical attributes in Archaic and Classical art. The cult of Dionysos only became an important one in Athens around the middle of the 6th century, probably as a result of policies of Peisistratos, and both vases must pre-date that development.

Dionysos is one of the most frequent subjects on Attic vases from the middle of the 6th century on through the 4th, though the vast majority of the scenes have no clear narrative content. His attributes are a drinking vessel (a drinking horn or a *kantharos*) and an ivy-wreath. Satyrs and nymphs or maenads are his

regular companions, as discussed in Chapter 2, and the ithyphallic mule is his mount. From late in the 6th century the *thyrsos*, a long fennel stalk crowned with ivy-leaves, is often carried by maenads and sometimes by the god himself. Snakes and panthers sometimes accompany him.

In Attic vase-paintings from the 6th and most of the 5th centuries, Dionysos is bearded and is almost always clothed in a chiton and himation *[48]*. Then suddenly around 430 a new, beardless Dionysos appears and this half-naked, effeminate youth is the god who usually appears in 4th-century art *[49]*.

The early iconography of Dionysos is probably an invention of Attic vase-painters. He rarely appears on Corinthian vases, though he did appear on the Chest of Kypselos, bearded and fully clothed reclining in a cave. He never appears on Laconian vases; the earliest East Greek depictions of him are later than the earliest Attic and give him similar attributes. He appears on a few Chalcidian vases and, as already shown, in the Return of Hephaistos on Caeretan hydriai. The beardless Dionysos with Ariadne is popular with South Italian vase-painters throughout the 4th century.

Around 530, a coinage was produced at Naxos in Sicily with the bearded, ivy-wreathed head of Dionysos on the obverse *[50]* and a grape cluster on the reverse, which was later replaced by a squatting satyr. As in vase-painting, the traditional bearded head is replaced by a beardless one by around 400 *[51]*. A bearded Dionysos reclining on the back of a mule becomes the coin type of Mende in northern Greece before the middle of the 5th century and is replaced in the 4th by the head of the beardless god. However, the head of Dionysos adopted during the last quarter of the 5th century as the coin type of Thebes, Thasos and Sybirita on Crete, is the traditional bearded one.

Representations of Dionysos in sculpture, though not numerous, follow the same course as those on vases and coins. One of the earliest is probably a colossal unfinished statue of a bearded figure still in a quarry on Naxos dating to the middle of the 6th century and a bearded head from Ikaria survives from the end of the century *[52]*. Some Attic seated figures, now headless, may represent Dionysos – one of them from Ikaria certainly does, and another seated on a panther-skin might. He is one of the twelve Olympians on the east frieze of the Parthenon where he is seated, naked to the waist and beardless. He fought a giant on one of the metopes, and he may be the naked reclining figure on the east pediment *[53]*. At least by the second half of the 4th century a similar figure on the Lysikrates monument in Athens certainly is Dionysos.

Sophilos includes Hebe, Themis and three nymphs in the group walking ahead of the chariots, Kleitias includes three Horai. On both vases groups of women on foot accompany the chariots. On the dinos those named are the Charites, Muses and Moirai, on the François Vase they are the Muses (named Kalliope, Ourania, Euterpe, Kleio, Melpomene, Stesichore, Erato and Polymnis) and Moirai.

Nymphs, as already mentioned in Chapter 2, accompany Dionysos on some

6th-century vases. They may also be the women accompanying various goddesses on red-figure vases, but their nature in art is as vaguely defined as it is in literature. Muses are probably the women who stand with Apollo as he plays his kithara on Attic vases (when there are more than two or when they hold musical instruments). They appear on Attic vases after the middle of the 5th century in their contest with the Thracian Thamyras [139]. Though some of them occasionally appear together with various musical instruments and scrolls on Attic and South Italian red-figure vases, the assignment of specific functions to them did not occur until well after the Classical period.

The Horai (Seasons) may be the women who sometimes accompany Aphrodite on Attic red-figure vases, and Pausanias (5.11.7) tells that they appeared on Pheidias' throne for his Zeus at Olympia along with the Charites (Graces). Neither group, however, has attributes. The Moirai (Fates) have little or no iconography during our period, nor does Themis, the mother of both the Moirai and Horai.

Hebe appears as the wife of Herakles on an early 6th-century Corinthian aryballos [233], on a few Attic black- and red-figure vases from the middle of the 6th century to after the middle of the 5th, and on at least one South Italian vase [234]. In a different role she is probably the girl attending Hera or Zeus on many Attic red-figure vases from the 5th century, but she has no regular attributes to make her identity clear.

The major part of both of the processions is made up of deities in chariots. On both vases Zeus and Hera ride in the first chariot, Poseidon and Amphitrite in the second, Ares and Aphrodite in the third. Sophilos gives none of these figures attributes. Kleitias hides the occupants of the second and third chariots under a handle, but he gives Zeus an elegant thunderbolt and sceptre.

In Greek art Zeus is almost always depicted as a bearded adult. The one notable exception to this may be on the west pediment of the Temple of Artemis on Corfu, which is roughly contemporary with Sophilos' dinos – there Zeus (if he is Zeus) is a naked, beardless youth attacking a Giant or a Titan with his thunderbolt [95]. But on shield bands in Olympia from the same period, a bearded Zeus attacks a serpent-legged Typhon with the thunderbolt [96]. Though the shape of this weapon may vary – sometimes ornate and flower-like, sometimes a simple missile – it is his most common attribute in Archaic and Early Classical art [54]. Later he sometimes holds a long sceptre as well or instead of the bolt, particularly when he is pursuing a beloved. He is sometimes shown with an eagle, and the eagle alternates with the thunderbolt and the figure of Zeus as a coin type for Elis, where Olympia is located [55].

Several metamorphoses of Zeus are depicted in ancient art. As a bull he carries Europa on his back over the sea to Crete as early as the second half of the 7th century on a fragment of a relief amphora. A similar scene appears on mid-6th-century metopes from Delphi and Selinus [57], on Caeretan hydriai, on a few Attic black-figure vases from the end of the 6th century, on gems [56] and on

many Attic and South Italian red-figure vases on into the 4th century. As a swan he seduces Leda, though the earliest depiction of this encounter was a statue from about 400 (of which copies survive) where Leda gently shelters the bird *[58]*. The more erotic versions of the subject do not appear before the end of the Classical period.

As an eagle Zeus is shown on Apulian red-figure vases from early in the 4th century carrying off Thalia, daughter of Hephaistos. She becomes the mother of the Sicilian twins, the Palikoi, a myth which was the subject of a play by Aeschylus.

The Roman poet Ovid (43 B C–A D 17) tells that Zeus changed himself into an eagle to abduct the Trojan prince Ganymede, but this metamorphosis does not appear in earlier literature. Pliny (34.79) mentions a bronze by the Athenian sculptor Leochares (c. 350 B C), of which marble copies survive, that showed an eagle carrying Ganymede, but Pliny implies that the bird was only an agent of Zeus. Similar scenes are depicted on Hellenistic jewellery and mirrors. On some 4th-century Apulian vases Ganymede is pursued by, or carried by, a swan as his tutor looks on helplessly. An anthropomorphic Zeus carries the young Ganymede in a terracotta sculpture from Olympia *c.* 470 *[59]*, and a similar Zeus pursues or carries the youth on Attic vases during the first three quarters of the 5th century.

Certainly the most famous representation of Zeus was the ivory and gold colossus made by Pheidias for the Temple of Zeus at Olympia, but almost all we know of it comes from a few written descriptions (Pausanias 5.11 being the most complete) and what are probably representations of it on Roman coins and gems, though it has recently been shown that the figure on a late 5th-century red-figure fragment from near Kerch must be derived from that work. His principal attributes there were the eagle and sceptre.

Hera, like many goddesses in Greek art (including Amphitrite) does not have regular attributes and thus must usually be identified by context. On Attic black- and red-figure vases she sometimes sits on a throne near a seated Zeus, as she does in Kleitias' Return of Hephaistos (see Chapter 2) and on the east frieze of the Parthenon. Though she sometimes holds a sceptre, it is by no means safe to assume that all women with sceptres are Hera. Likewise, she sometimes wears a *polos*, or crown, but these too can be worn by other goddesses. She is one of the three goddesses in the Judgement of Paris, but there it is often impossible to distinguish her from Aphrodite (see Chapter 9).

Poseidon, like his brother Zeus, is usually shown as a bearded adult. In fact, depictions of them are so similar that it is often only the presence of an attribute that allows the one to be distinguished from the other, as the controversy over the identity of an over life-sized bronze of a bearded male found off Cape Artemision illustrates *[60]*. That sculpture is complete except for the object it was holding, which could have been a thunderbolt or a trident. In some Archaic vase-paintings Poseidon also carries a fish *[61]*.

Poseidon appears on many of the 6th-century painted plaques found near the Corinthian shrine dedicated to him at Penteskouphia (and very occasionally on Corinthian vases), on Attic black- and red-figure vases, and on South Italian vases from the 4th century. Throughout, the image of the god changes little. The god about to throw his trident is the coin type on the obverse of coins from Poseidonia from about 525 through to the middle of the 4th century. The only significant change in the type is the appearance of a beardless Poseidon on some coins after the middle of the 5th century, but these are produced side by side with coins showing the traditional bearded god [62].

Poseidon rides a horse on some plaques from Penteskouphia from the mid-6th century, on coins of Potidaea from the end of the 6th century and then on at least one South Italian vase from the end of the 5th. He rides a hippocamp (horse-fish hybrid) on a Laconian cup from mid-6th century and on a few Attic vases, mostly black-figure, he rides a hippocamp or a hippalektryon (horse-cock hybrid) [63]. On one Attic black-figure vase he rides a bull.

The contest between Athena and Poseidon for Attica was the subject of the west pediment of the Parthenon and, on an Attic red-figure cup from the end of the 5th century, he is shown striking a rock with his trident, perhaps recalling that myth. On the east frieze of the Parthenon he sits beside Apollo.

Amphitrite is the consort of Poseidon as Hera is of Zeus, and she is shown with him on plaques from Penteskouphia contemporary with the depictions of the wedding of Peleus by Sophilos and Kleitias, but she has little mythology or iconography. She sometimes carries a fish but can only certainly be identified when she is named. Of the many women Poseidon is shown pursuing on Attic red-figure vases from the middle of the 5th century, the Danaid Amymone can be identified by her hydria [64]. It refers to a story in which Poseidon rescues her from satyrs who had attacked her at a fountain or spring only to seduce her himself. She first appears on Attic vases, c. 460, where she is pursued by Poseidon or attacked by satyrs, and these scenes may have been inspired by Aeschylus' satyr play, Amymone. On later Attic and South Italian vases she is shown seated or standing with Poseidon, sometimes in the presence of satyrs.

Ares is the archetypal warrior and little more. Only inscriptions or context allow him to be distinguished from the thousands of other warriors who appear in all periods of Greek art. He occasionally appears on Attic black- and red-figure vases as a bystander with other Olympians, but the only popular myth illustrated in ancient art in which he plays a key role is the fight between his son, the brigand Kyknos, and Herakles.

According the the earliest surviving literary version of the myth, The Shield of Herakles, Kyknos provoked the anger of Apollo by waylaying pilgrims on their way to Delphi. Encouraged by Apollo, Herakles confronted Kyknos and killed him in the ensuing battle. Enraged at the death of his son, Ares attacked Herakles, but through the intervention of Athena could not injure him and was, instead, wounded himself.

Most of the depictions of this myth are on Attic vases from the second half of the 6th century. On one of the earliest and most detailed, c. 550, all the participants are named. Herakles and Ares stand facing each other over the body of Kyknos. Each has raised his spear, ready to attack, but Zeus comes between his two sons trying to stop the fight. Behind Herakles, Athena stands with her spear poised ready to help him. Chariots frame the scene. Variations on this scheme appear on several Attic vases [65]. On a roughly contemporary Corinthian fragment, part of a named Kyknos survives beside a building, perhaps representing a sanctuary of Apollo where the fight was said to have taken place.

On other Attic vases Herakles is shown fighting Kyknos while the two of them are flanked by Athena and Ares. On a metope from the Treasury of the Athenians at Delphi (c. 500) Herakles and Kyknos fight alone, a scene that also appears on a few Attic vases and on a Chalcidian amphora. Pausanias (3.18.10) also tells that this was the subject of a relief on the throne by Bathykles at Amyklai near Sparta from the end of the 6th century. The subject seldom appears in any form after the first quarter of the 5th century.

One of the earliest depictions of Ares is on a fragment of an amphora from Naxos of the mid-7th century [66] where, as on the François Vase, he rides in a chariot with Aphrodite, who is sometimes said to be his wife. The two were probably shown together on the Chest of Kypselos, and they appear in some Attic red-figure depictions of the assembled deities. On a Lucanian vase from the 4th century, Aphrodite sits holding his helmet while Ares, a naked youth, stands beside her holding his shield and her mirror. Eros flies above them. Ares is usually bearded on Attic black- and red-figure vases, but statues of him by Alkamenes and Skopas, known only through ancient descriptions and Roman copies, were of a beardless god.

Aphrodite occasionally appears in scenes with other gods on 6th-century Attic black-figure vases and on red-figure vases from the first half of the 5th, but her great period of popularity in Greek arts starts after the middle of the 5th century. Sometimes she holds a sceptre, a flower, or later a mirror, but none of these is by itself sufficient to identify her. She is shown riding a swan or a goose on Attic [67] and then South Italian vases from the beginning of the 5th century on through the 4th, and this is also the subject of terracotta statuettes, bronze reliefs and gems.

Aphrodite is clothed in Archaic and Classical art before the 4th century. Praxiteles' statue of her at Cnidos was one of the first and certainly the most famous depiction of the naked goddess, and established a new vision of her [68], but even during the 4th century she is usually clothed in vase-paintings. The principal myth of Aphrodite depicted in ancient art is her birth which is discussed in the following chapter.

The procession of deities includes four more chariots on the François Vase, but they are so badly damaged only a few of the occupants are recognizable. There

are only two more chariots in Sophilos' scene and both are well preserved. Apollo and Hermes ride in the first [69], Athena and Artemis in the second.

While Hermes drives the chariot, a beardless Apollo in a long chiton stands beside him playing his kithara. This is just the Apollo who appears most often in ancient art. Occasionally he is bearded in Archaic art, such as on a Melian amphora from about 650 and on the Troilos frieze of the François Vase, but in Classical and later art he is always beardless and often naked, the epitome of young male beauty.

The kithara, sometimes the lyre, is his most common attribute. He plays a lyre on the Melian vase just mentioned, a kithara on a bronze cuirass found at Olympia from later in the 7th century, on a shield band from the mid-6th, and on dozens of black-figure vases where he is part of a divine entourage. On both black- and red-figure vases he often appears playing his kithara between Artemis and Leto or with the Muses [45, 46]. These scenes have no specific narrative content but represent the gentle and reasonable god for whom the byword is 'nothing in excess'.

The other side of his nature, death and destruction – Apollo the far-shooter – is symbolized by another common attribute, the bow, which he shares with his sister Artemis. Free-standing sculptures of Apollo with his bow appear at least by the mid-6th century and continue to appear throughout our period. The Apollo Belvedere [70], a copy of a 4th-century bronze, is one of the best known examples. In most depictions of the death of Tityos, Apollo and Artemis use their bows, as they do when they slaughter the children of Niobe, the woman who foolishly boasted of her progeny at Leto's expense. This myth is depicted on an Attic black-figure amphora from about 550, but the next occurrence of it does not appear for nearly a century when it appears in a scene on a red-figure krater certainly influenced by wall-painting [71]. The myth was the subject of a frieze on Pheidias' throne of Zeus at Olympia, of which copies of parts have been identified. Sculpture from what was probably a pedimental group of the dying Niobids survives from the mid-5th century, and in the 4th century the myth is a subject of South Italian vases.

The tripod and the fawn are two more important Apollonian attributes that appear in ancient art. The tripod is associated with the god's oracle at Delphi and most often appears in depictions of Herakles' attempt to steal it. The meaning of the myth is not clear since surviving literary sources are late and contradictory, but it seems that Herakles tried to steal the tripod so that he could set up his own oracle. Presumably some offense at Delphi provoked his actions. The earliest depiction of the myth is on a late 8th-century bronze tripod-leg from Olympia [72]. It is the subject of a mid-6th-century metope from Paestum and the east pediment of the Siphnian treasury at Delphi, but its greatest popularity is on Attic black- and red-figure vases during the last quarter of the 6th century and first quarter of the 5th [73]. On the vases, Artemis often aids Apollo while Herakles' patron, Athena, stands behind him. This is, in fact, one of the most

common Heraklean scenes on Attic vases. From late in the 6th century it is the subject of shield bands, a Chalcidian skyphos and Boeotian black-figure vases, and from the 4th century it is the subject on a few Lucanian and Apulian vases.

A parallel scene appears on a few Attic vases from the second half of the 6th century (and perhaps on a few earlier shield bands) in which Apollo and Herakles fight over a deer [74]. The deer is usually associated with Artemis and this struggle, like the struggle over the tripod, has no surviving literary source. It seems to be distinct, however, from Herakles' pursuit of the Kerynian hind discussed in Chapter 6.

Artemis holding her bow rides in the next chariot on Sophilos' vase while Athena drives. As we have seen, Artemis often appears with Apollo and shares with him the bow and fawn as attributes. However, in the earliest representations of her in ancient art, she appears as the Potnia Theron (mistress of animals) a role mentioned by Homer (*Iliad* 21.470). In this form she is usually a winged figure who stands with her arms at her sides and with a large bird or an animal hanging from each hand. Though the form itself may go back to Minoan and Mycenaean art, Artemis as Potnia first appears in the 7th century on Boeotian, Melian and Corinthian vases, and ivory plaques from Sparta and gold and bronze reliefs. During the 6th century, she appears in this form on Attic black-figure vases as well. She stands on both handles of the François Vase, once holding two lions, once a panther and a stag [75].

The torch is another attribute sometimes carried by Artemis, but, as already mentioned, it is by no means restricted to her. During the last quarter of the 6th century, she occasionally appears with her torch in Attic black-figure depictions of a wedded couple in a chariot. During the 5th century, however, she quite frequently has a torch in many different scenes on red-figure vases and in sculpted reliefs.

Hermes drives the chariot in which his elder half-brother Apollo rides [69]. He is bearded and wears a chitoniskos and hat. The top of a wing on one of his boots is just visible and his kerykeion rests on the front of the chariot box. In the Wedding frieze on the François Vase he drives his mother Maia, rather than Apollo, and there he is a much more dignified figure dressed in an elegant chiton and himation and holding his kerykeion. This is unusual, though not unique, dress for him, and in the Troilos frieze on the same vase he wears his more common chitoniskos, which, in later works, is replaced by a chlamys [44].

The kerykeion is Hermes' most obvious attribute, and is, as mentioned earlier, one that he shares with Iris [76]. He is rarely shown without it; however, there are scenes where a mortal messenger carries one, a reminder that whoever may carry it, the kerykeion is first of all a herald's staff [302].

Sophilos' depictions of Hermes in the Wedding procession and elsewhere are certainly some of the earliest of the god. At approximately the same time, however, a similar Hermes appears on middle Corinthian vases and this is the

Hermes in the Ransom of Hektor on a mid-6th-century shield band from Olympia [317], and facing Zeus on a Laconian cup. He is almost always bearded on Attic black-figure vases, but after the middle of the 5th century he regularly appears on red-figure vases as a beardless youth and sometimes wears a winged helmet as well as winged boots [44]. This is the Hermes adopted by early Apulian painters.

Hermes is one of the most common mythological figures on Attic vases – particularly black-figure – and it is difficult to think of many scenes from myth in which he does not appear at one time or another, often just watching from the sidelines. In spite of his ubiquity, however, few myths are depicted in ancient art in which he plays a central role. One exception is his role in the birth of Dionysos discussed in the next chapter, another is his killing of Argos.

According to the most common version of this story Zeus seduced Io, a priestess of Hera, and when Hera became aware of this infidelity, Zeus swore it had not happened and turned Io into a cow. Hera, aware of this ploy, asked for the cow and made the many-eyed monster Argos its guardian. Zeus then sent Hermes to free Io, and to do this he had to kill Argos.

One of the earliest depictions of the death of Argos is on an Attic black-figure amphora from about 530 [77]. Hermes attacks a falling Argos, a man with a face on both sides of his head. Hera rushes to the rescue and Io, a cow, stands calmly facing away from the action. Roughly contemporary with this is a neck-amphora from the 'Northampton Group', probably made by an East Greek immigrant in Etruria. Here Argos is a large naked man with a great bushy beard and an extra eye on his chest, and Io is a bull.

The subject appears on more than a dozen Attic red-figure vases from about 500 to the mid-4th century. Hermes' weapon is usually a sword. On the earlier ones, Argos is a naked man whose body is covered with eyes, and Io is often a bull [78]. On a krater from around 430, Argos again has a face on either side of his head, but Io has become a human woman with small horns above her forehead, and this is the way she appears on a 4th-century krater. On an early Lucanian oinochoe also from about 430, Io is a cow with a woman's face.

Hermes also appears as the warder of human souls in his role in the *psychostasia* (weighing of souls) and as *psychopompos* (guide of souls). The weighing of souls first appears on an Attic black-figure dinos from about 540, and then on a lekythos from about 500, and on several red-figure vases from the first half of the 5th century [325]. As psychopompos, he leads mortals to Charon who will ferry them across the Acheron. This is a favorite subject on Attic white-ground lekythoi after about 470 [79]. On a column drum, perhaps by Skopas, from the 4th-century Temple of Artemis at Ephesos, Hermes leads a woman to, or perhaps from, a winged Thanatos (Death) [80]. On some vases he is the guide who leads Persephone back from the underworld.

On Sophilos' dinos, Athena drives her half-sister Artemis, as she may have done on the François Vase where the name of her female passenger is missing. In

neither scene is she shown with attributes. She simply appears as one of many goddesses, unusual only because she, a woman, is driving. Likewise, on the Return of Hephaistos and the Troilos friezes on the François Vase she has no attributes, nor does she on the few contemporary Corinthian vases where she appears. On a Laconian cup her only distinguishing characteristic is a *polos*, the hat already mentioned in connection with Hera and worn by many other goddesses. After about 560, however, the Athena who appears on Attic vases is usually armed, wearing her helmet and often her aegis, and carrying her spear.

The aegis is Athena's most distinctive attribute, given to her by Zeus, but its nature in visual arts differs from descriptions of it in literature. For Homer it is a goat-skin fringed with golden tassels (*Iliad* 2.447) while for vase-painters and sculptors it is fringed with snakes [*84, passim*]. At first it seems to be a plain skin, but later it is often covered with scales. After about 530, the gorgon's head may be attached to the centre of it [*73*].

An armed Athena striding forward with her spear raised ready to fight (Athena Promachos) is a common form for the goddess in Attic black-figure vase-paintings. This is the Athena who appears on Panathenaic prize amphorae from about 560 down to the end of the 4th century [*81*]. Always painted in the black-figure technique, these vases filled with prime olive oil were given as prizes at the Panathenaic games held at Athens every four years. During the $2\frac{1}{2}$ centuries they were made, there were moderate changes in the shape of the amphora, but Athena Promachos always appeared on one side between two columns with the inscription 'a prize from the games at Athens'; a depiction of the event for which the vase was awarded appeared on the other side. This same Athena Promachos is sometimes used for the statue in black-figure depictions of the rape of Kassandra [*337*], a subject discussed in Chapter 9.

Images of Athena were coin types for many cities including Athens and Corinth. A helmeted head of Athena was on the obverse of Athenian coins from the last quarter of the 6th century through our period [*82*], and an owl, a bird associated with her, was on the reverse. The head of Athena wearing a raised Corinthian helmet (with cheek plates and a nose guard) was on the reverse of the coins of Corinth during the last quarter of the 6th century and on through our period [*83*], with the winged horse Pegasos on the obverse.

Pheidias' huge chryselephantine statue of Athena Parthenos for the Parthenon, dedicated in 438, was certainly one of the best known depictions of the goddess in antiquity. Though it is lost, we have a fairly good idea of what it looked like from descriptions by Pausanias (1.24.5–7) and Pliny (36.18), among others, and from small Roman copies [*85*]. It has recently been shown that the figure of Athena on a fragment of a late 5th-century Attic krater found near Kerch must be derived from the work. She wore an ornate helmet and her aegis with the gorgon's head on it. In one hand she held a Nike, in the other a spear. Her shield rested beside her and near it a snake. On the base of the statue was a

relief showing the birth of Pandora, on her shield an Amazonomachy and Gigantomachy, on her sandals a Centauromachy.

Another side of Athena's nature is illustrated by the west pediment of the Parthenon where her contest with Poseidon was shown. She won Attica with her gift of an olive tree (against Poseidon's salt-water spring) which became a buttress of the Attic economy. It was oil from her trees that was given in the prize amphorae at the Panathenaic games. Athena was also patron of woolworking and of craftsmen and is shown in that guise on Attic red-figure vases [84]. On the Parthenon frieze it is Hephaistos, the craftsman of the gods, with whom she is paired, and her image stood with his in the Hephaisteion above the Agora.

Athena appears as an important figure in depictions of several myths to be discussed in later chapters, including her birth, the Judgement of Paris, Marsyas, and the birth of Erichthonios, but she is also shown on Attic vases as a companion of heroes. She protects Perseus while he fetches the head of Medusa, and she watches and encourages her favorite, Herakles, in hundreds of depictions of his various labours and deeds. During the 5th century she also gives Theseus her patronage (though perhaps less enthusiastically). Of mortal warriors, Achilles, Diomedes and Odysseus are her special friends.

On the François Vase, Doris and Nereus, the parents of the bride, accompany Athena's chariot, and on both vases Okeanos, the grandfather of the bride, follows the last chariot, a merman with the lower body of a fish. Most of him is missing from the François Vase, but on Sophilos' dinos he wears a chitoniskos over a human torso which is attached at the waist to an arching fish-body [86]. A single horn protrudes from his forehead, and he holds a fish in one hand, a snake in the other. His fully human wife, Tethys, accompanies him with Eileithyia, the goddess of childbirth, beside her. This is one of the few appearances of Okeanos, Tethys or Doris in ancient art. Eileithyia (sometimes two Eileithyiai) appears in depictions of the birth of Athena, but otherwise there is little iconography associated with her.

Nereus, on the other hand, poses iconographic problems that may explain his curious absence, as father of the bride, from Sophilos' depiction of the wedding procession. On several Attic black-figure vases from the first half of the 6th century, Herakles is shown wrestling with a fish-bodied Nereus (inscriptions on some make clear his identity) as he forces from him the way to the garden of the Hesperides as discussed in Chapter 6. On a mid-6th-century shield band [87] the mutations Nereus employs in his attempt to escape from Herakles are indicated by a flame on his forehead and a snake protruding from the back of his neck – on a krater by Sophilos a snake emerges from the curve of his back. After about 560 Nereus is a wholly human old man in his fight with Herakles, and this is the way he appears on Attic red-figure vases during the first half of the 5th century [203].

The absence of Nereus, the father of the bride, from the procession on the dinos is puzzling, but it may be explained by an iconographic problem. Nereus is clearly fish-bodied for Sophilos and thus all but indistinguishable from

Okeanos. For some reason – perhaps a strong literary source – Okeanos had to be included, and for reasons of design alone it would have been difficult to include two fish-bodied creatures. Later, for Kleitias, Nereus' form was wholly human and thus he could easily include him.

Hephaistos rides side-saddle on a mule at the very end of both processions *[86]*. As we have already seen, he often appears riding a mule on Attic black- and red-figure vases as he returns to Olympos with Dionysos to be reconciled with his mother, Hera. The other popular myth depicted in ancient art in which he plays an important role is the birth of Athena, discussed in the next chapter. Also discussed there are his roles in the birth of Erichthonios and the creation of Pandora.

His most common attributes are the axe or tongs and sometimes a close-fitting workman's hat (often called a *pilos*) and a sleeved tunic (*exomis*) all of which refer to his role as blacksmith. It was he who made Achilles' armour, and he is shown giving it to Thetis on Attic vases from the first quarter of the 5th century *[88]*. A similar scene probably appeared on the Chest of Kypselos. With Athena he is the patron of craftsmen – so he sits with her on the Parthenon frieze and her image stood beside his in the Hephaisteion, his temple in Athens.

Though he is a cripple, his deformity is rarely made explicit in Attic art, only hinted at. Thus he sometimes rides side-saddle on his mule, and Cicero can write of a late 5th-century sculpture of him by Alkamenes 'there is visible a slight lameness which, however, is not ugly.'

38 Attic black-figure dinos signed by
Sophilos. Top, Wedding of Peleus and
Thetis. Below, animal friezes and
lotus-palmette chains. c. 580. 71 cm
with stand

39 (below) Detail of 38. Peleus with a
kantharos in one hand stands in front
of his house and greets the arriving
deities led by Iris, who carries a
kerykeion and wears winged boots.
She is followed by Chariklo, Leto,
Dionysos, Hebe and Chiron

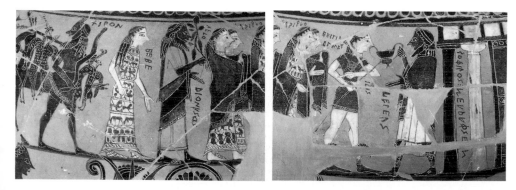

40 (*above left*) Attic red-figure lekythos by the Villa Giulia P. Iris carries her kerykeion and a writing case. She is sometimes winged in 5th-century art. *c.* 460

41 (*above*) Attic red-figure skyphos by Makron. Departure of Triptolemos. The Eleusinian prince, holding stalks of grain in one hand and a phiale in the other, sits on a wheeled throne with wings. Persephone stands in front of him with a torch and an oinochoe about to pour into his phiale. Behind her is the nymph Eleusis, and behind Triptolemos is Demeter holding a torch and stalks of grain. The bearded snake (a motif borrowed from Egypt) is a decorative device on the throne. *c.* 480. 21 cm

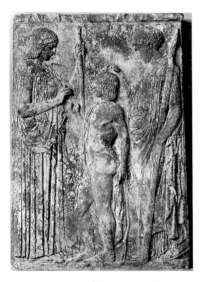

42 (*left*) Marble relief from Eleusis. Triptolemos (?) between Demeter with a sceptre and Persephone with a long torch. Demeter gives something to the youth (probably ears of corn added in gold or bronze) and the scene is probably the departure of Triptolemos. *c.* 430. 2.20 m

43 (*below*) Marble relief, East frieze from the Parthenon in Athens. Seated deities. Hermes with his hat in his lap, Dionysos, who probably held a thyrsos, Demeter with her torch, and Ares, who held a spear probably added in paint. *c.* 440. 1.05 m

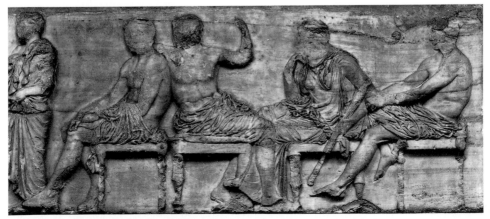

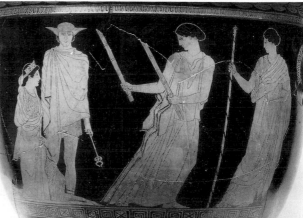

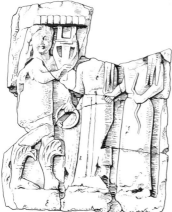

44 (*above*) Attic red-figure bell-krater. Hekate with torches leads Persephone accompanied by Hermes with his kerykeion and petasos from the underworld while Demeter, holding a sceptre, waits. Inscriptions identifiy all of the figures. *c.* 440. 41 cm

45 (*left*) Limestone relief, frieze from Selinus. Apollo, wearing winged boots and playing a kithara, moves toward Leto, who holds a wreath or crown, and Artemis, who holds her bow in one hand and probably held a painted arrow in the other. Mid-6th Century. 84 cm

46 (*below*) Attic red-figure amphora from Vulci. Leto with a flower stands behind Apollo, who plays his kithara and faces his sister, Artemis, who wears the skin of a feline and a quiver hanging at her back. A deer and a panther accompany them. *c.* 500

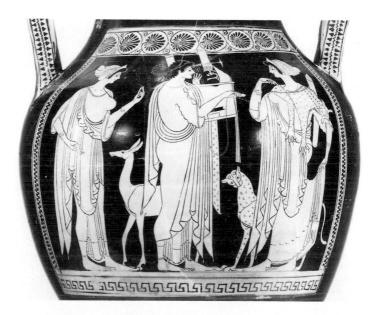

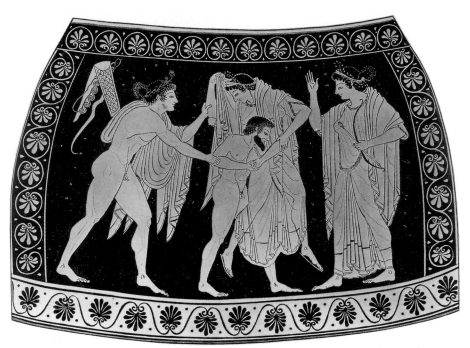

47 Attic red-figure amphora by Phintias, from Vulci. Rape of Leto. Tityos lifts Leto off the ground as Apollo tries to restrain him and Artemis gesticulates. Apollo's bow and quiver hang behind him; Artemis carries a bow and arrow. *c.* 510. 60 cm

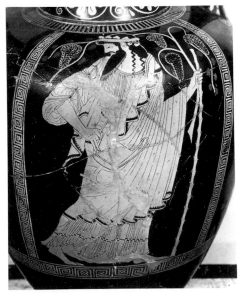

48 Attic red-figure amphora by the Eucharides P. Dionysos wears an ivy wreath and holds a kantharos, staff and grape-vine. *c.* 480. 55.8 cm

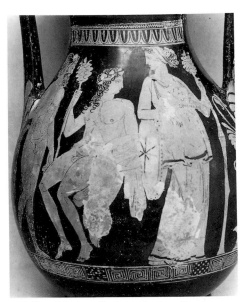

49 Attic red-figure pelike from Camiros. Dionysos with a thyrsos seated between a satyr and a maenad leaning on a tympanum and holding a thrysos. *c.* 340. 42.5 cm

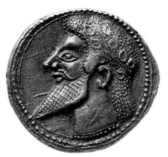

50 Silver drachma from Naxos (Sicily). Dionysos. On the reverse (not shown) a grape cluster between two leaves. *c.* 520

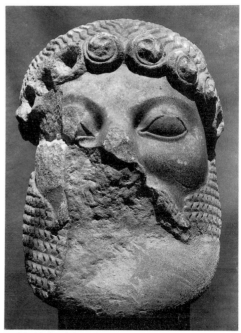

52 Marble head from Ikaria. Dionysos. *c.* 520. 41 cm

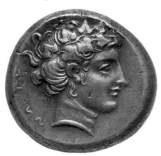

51 Silver tetradrachm from Naxos (Sicily). Dionysos. On the reverse (not shown) a satyr with a kantharos, ivy sprig and wine-skin sits on a wine-skin. *c.* 410

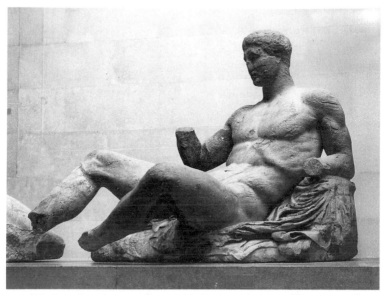

53 Marble figure from the east pediment of the Parthenon in Athens. Dionysos, seated on an animal skin, probably held a kantharos or a thyrsos. *c.* 440

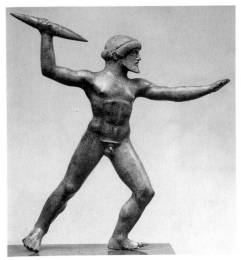

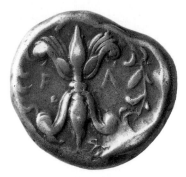

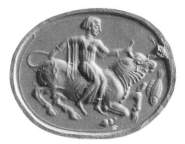

54 Bronze figurine from Dodona. Zeus throwing a thunderbolt. *c.* 470. 13.5 cm

55 (*right above*) Silver stater from Elis. Thunderbolt with laurel wreath. On the obverse (not shown) a head of Zeus. *c.* 420

56 (*right centre*) Agate gem. Rape of Europa. *c.* 480. L. 1.9 cm

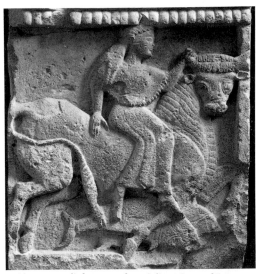

57 Limestone relief, metope from Selinus. Rape of Europa. Europa rides on a bull (a metamorphosis of Zeus) over the sea, indicated by fish, on her way to Crete. Mid-6th Century

58 Marble group. Leda and the Swan. Roman copy of an early 4th-Century Greek original. 1.32 m

59 Terracotta akroterial group from Olympia. Rape of Ganymede. Zeus carries off the Trojan prince
Ganymede, who holds a cock in one hand, a traditional love gift. *c.* 470. 1.08 m

60 Bronze figure found in the sea off Cape Artemision. Zeus with a thunderbolt or Poseidon with a trident.
c. 460. 2.09 m

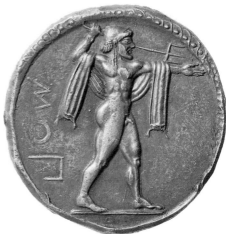

61 (*above left*) Attic red-figure cup by
Oltos. Tondo, Poseidon carrying a trident
and a fish, his usual attributes. *c.* 520

62 (*above right*) Silver stater from
Poseidonia (Paestum). Poseidon with his
trident. On the reverse (not shown) the
same figure but engraved (incuse) rather
than in relief. *c.* 510

63 (*right*) Attic black-figure (on white
ground) lekythos. Poseidon with his
trident rides a hippocamp (sea horse)
c. 490. 30.3 cm

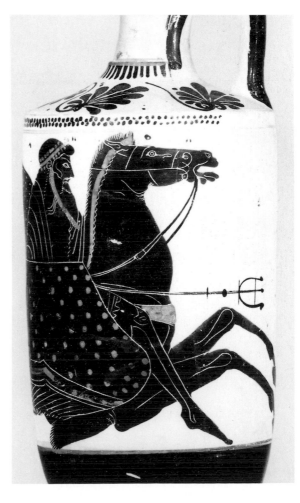

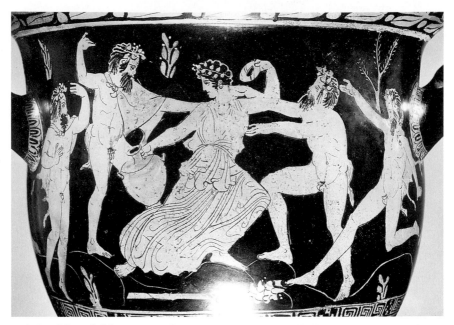

64 Attic red-figure bell-krater. Rape of Amymone. Amymone is attacked by satyrs as she goes to fill her hydria at a spring. A thyrsos lies at her feet. The scene is almost certainly inspired by a satyr play. *c.* 420. 42.2 cm

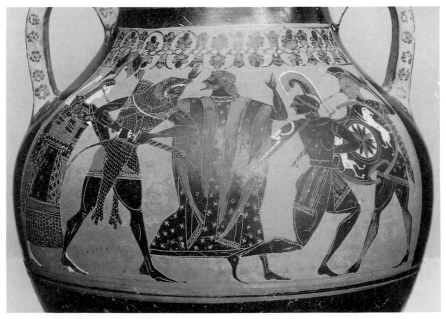

65 Attic black-figure amphora from Camiros. Herakles and Kyknos. Zeus intervenes as Herakles chases Kyknos toward Ares with Athena's support. The painter has given Ares an elegantly decorated Boeotian shield in contrast to Kyknos' normal hoplite shield (with a tripod as its device). *c.* 540. 55 cm

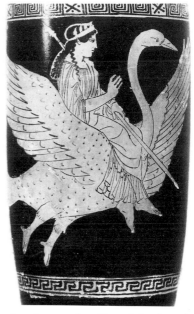

66 (*above left*) Naxian amphora fragment from Naxos. Aphrodite and Ares ride together in a chariot drawn by winged horses. Mid-7th Century

67 (*above right*) Attic red-figure lekythos by the Achilles P., from Cyprus. Aphrodite holding a sceptre rides on the back of a swan. *c*. 440. 31 cm

68 (*left*) Gold finger ring. A naked Aphrodite with a dove stands beside a pillar with her clothes on it while Eros holds up a crown in front of her. 4th Century. L. 2.1 cm

69 (*below*) Attic black-figure dinos (see *38*). Hermes and Apollo with a kithara ride in a chariot accompanied by three Muses

70 Marble figure. Apollo Belvedere. A Roman copy of a 4th-Century bronze of Apollo as archer, holding his bow in his left hand. The tree trunk and snake were added by the copyist as a support for the statue which is not necessary in bronze. 2.24 m

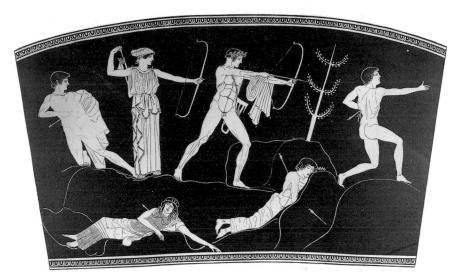

71 (*above*) Attic red-figure calyx-krater by the Niobid P., from Orvieto. Death of the Niobids. Apollo and Artemis shoot the children of Niobe. The painter has abandoned the usual single ground-line here and has placed the figures at various levels, probably in imitation of contemporary wall-painting techniques. *c.* 450. 54 cm

72 (*left*) Bronze relief, tripod leg from Olympia. The struggle for the tripod. Two men, probably Herakles and Apollo, struggle for possession of a tripod. *c.* 720. 4.6 cm

73 (*below*) Attic red-figure amphora by the Andokides P., from Vulci. The struggle for the tripod. Apollo hangs onto a leg of the tripod as Herakles marches off with it toward Athena, and Artemis stands to the side smelling a stylized flower. Note Athena's splendid snaky aegis with gorgoneion. *c.* 525

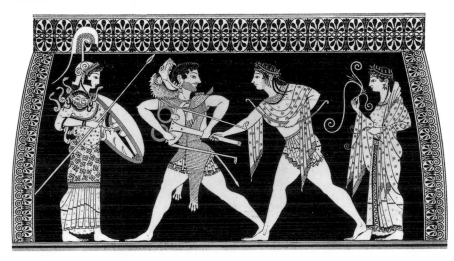

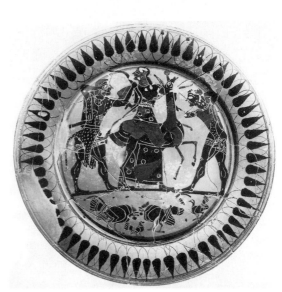

74 Attic black-figure plate from Greece.
Struggle for the deer. Herakles and Apollo
with drawn bows prepare to shoot each other
over a deer. A woman, probably Artemis,
tries to stop them. In the predella, cocks face
off in the presence of hens. *c.* 550. D. 22.8 cm

75 (*below*) 'François Vase' (see *1*). Handle.
Above, Artemis as Potnia Theron. Below,
Ajax carrying the body of Achilles.

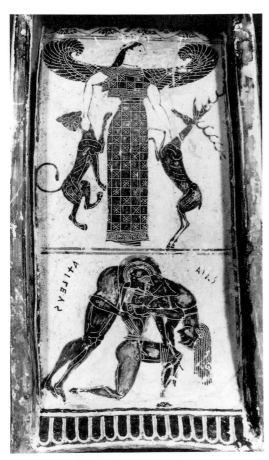

76 Cornelian scarab. Hermes with a cloak over
his arms holds a wreath and a kerykeion. In the
field before him is a knucklebone. *c.* 500. 1.7 cm

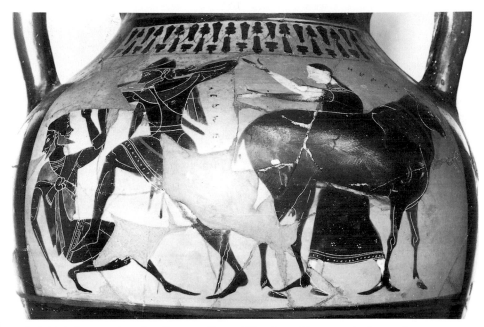

77 Attic black-figure amphora from Bomarzo. Hermes killing Argos. Hermes attacks Argos, whose many eyes are represented here by faces on the front and back of his head. Hera tries to stop him, and Io (the cow) stands looking the other way. *c.* 530

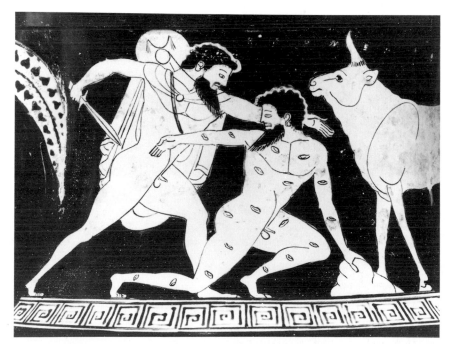

78 Attic red-figure amphora by the Eucharides P. On the neck, Hermes killing Argos. Here Argos' body is covered with eyes and Io is a bull. *c.* 480

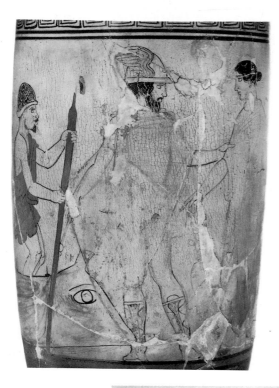

79 (*left*) Attic white ground lekythos by the Thanatos P., from Athens. Hermes psychopompos wearing a winged hat and pointing with his kerykeion leads a woman to a boat poled by Charon, which will take her across the river Acheron. Note the apotropaic eye painted on the bow of the boat to frighten off evil spirits *c.* 440

80 (*below*) Marble relief, column drum from Ephesos. Thanatos (Death), wearing a sword in a scabbard and Hermes with a kerykeion, escort a woman (Alcestis, Eurydice or Persephone?) to the underworld. *c.* 350. 1.82 m

81 (*opposite*) Attic black-figure (Panathenaic) amphora from Vulci. Athena Promachos between columns surmounted by cocks holds a shield with a chariot wheel as a device. The inscription by the column reads, 'a prize from the games at Athens', and on the reverse is a depiction of the event for which it was awarded, here the pentathlon. It is estimated that about 1000 of these vases, filled with olive oil, were given as prizes at the games held in Athens every four years. The earliest Panathenaic amphora dates from before 560 and they continued to be made on into the 2nd Century. *c.* 530. 62.5 cm

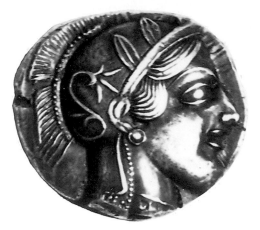

82 Silver decadrachm from Athens. Athena. *c.* 470

83 Silver stater from Corinth. Athena. Note the differences between helmets worn by Athena on this coin and the previous one, known as Corinthian and Athenian helmets respectively. *c.* 510

84 Attic red-figure cup from Vulci. A sculptor carves a marble horse in the presence of Athena and patrons (?) *c.* 480

85 (*opposite*) Marble statuette. 'Varvakeion statuette'. A second-century AD version of the Athena Parthenos by Pheidias. The crest holders of the helmet on the original were a sphinx (as here) and two griffins (replaced here with pegasoi). Note the aegis with gorgoneion and the Nike (Victory) she holds in her right hand. 1.05 m

86 (*above*) Detail of *38*. Athena and Artemis with a bow in a chariot followed by horned, fish-bodied Okeanos holding a fish and a snake, Tethys and Eileithyia (Goddess of childbirth) and Hephaistos riding sidesaddle on a mule

87 (*right*) Bronze relief, shield band panel. Herakles and Nereus. Herakles clings to fish-bodied Nereus whose transformations are indicated by the flame and snake erupting from his head. The inscription identifies the figures as 'Halios Geron' (Old man of the sea) and Herakles. Mid-6th Century

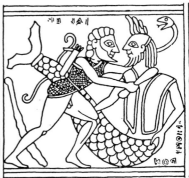

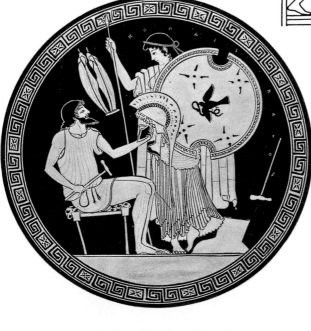

88 Attic red-figure cup from Vulci. Tondo, Hephaistos and Thetis. Hephaistos presents Thetis with armour for Achilles. The shield is a curious cross between a normal hoplite shield and the heroic Boeotian form. The device shows a bird with a snake. See *297*. *c*. 480

Chapter Four

THE ASCENDANCY OF THE OLYMPIANS

The ascendancy of the Olympians under the aegis of Zeus came through the overthrow of his father, Kronos, who had himself overthrown his own father, Ouranos. The history of the progenitors of the Olympians is dark and confusing, but some of them appear in ancient art, so a brief review of the relevant parts of the genealogy will not be out of place here.

At the beginning of the line, according to Hesiod, Gaia (Earth) bore Ouranos (Heavens) and then mated with him to produce twelve Titans, including Okeanos, Themis, Tethys, Iapetos, Rhea and the youngest, Kronos. Also born to Gaia were the Cyclopes among others. Ouranos, who was jealous of his children, hid them all away in the Earth, who in pain devised a plan to free them and convinced Kronos to help her. She gave him a sickle (harpe) and when Ouranos came to mate with her, Kronos castrated him and threw his members into the sea. From drops of blood that fell on Earth (Gaia), the Giants were born, along with the Erinyes (Furies) and the Melian nymphs, and from the foam that gathered around the members floating in the sea, Aphrodite arose (the word *aphros* means foam).

Not surprisingly, this barbaric narrative is not a subject of ancient art, but Aphrodite rising from the sea is. The scene first appears in about 460 on Attic red-figure vases. Eros is often present to help her or to greet her. According to Pausanias (5.11.8) Eros receiving Aphrodite was one of the subjects depicted by Pheidias on the base of the throne of Zeus at Olympia, and a silver medallion from Greece may reflect that work [89]. Sometimes Eros is joined by a woman and sometimes he is replaced by two women. The beautiful 5th-century relief on the 'Ludovisi Throne' surely shows the birth of Aphrodite [90]. Another version of her birth appears in the 4th century when she rises from, or rides in, an opening scallop shell.

Hesiod knows Eros as one of the original forces that emerged from Chaos and who can thus be present, with Himeros (Desire), at the birth of Aphrodite. The earliest depiction of Eros is on an Attic black-figure plaque from c. 560 found on the Acropolis at Athens [91]. There Aphrodite holds two naked, wingless children named Himeros and E[ros], and the scene seems to refer to another tradition according to which they are her children. Prior to the middle of the 5th century, children are usually depicted as small adults. On the east frieze of the Parthenon, Eros is a young boy leaning against her knee, clearly her son [92].

69

The winged adolescent Eros first appears toward the end of the 6th century on Attic red-figure vases and is only occasionally associated with Aphrodite. He can appear in depictions of almost any love story [93], and often more than one Eros appears in a scene. Sometimes one of them is named Himeros or Pothos (Yearning), but by the 4th century they are simply Erotes. Eros and Erotes are common figures on South Italian vases as well [234]. The bow only becomes regularly associated with Eros in the 4th century, and it is only at the end of our period that he appears as the pudgy baby adopted by the Romans.

To return to the genealogy, the Titan Kronos mated with his sister Rhea, and the offspring were Hestia, Demeter, Hera, Hades, Poseidon and Zeus. Kronos had learned from his parents, however, that he was destined to be overthrown by his son, so he swallowed each of the first five as they were born. When Rhea was about to deliver Zeus she tricked Kronos by hiding the child in a cave on Crete and she gave the father a rock wrapped as a baby in his place. On at least two Attic red-figure vases from the middle of the 5th century a sanitized version of this myth is shown with Rhea giving Kronos a rock wrapped in swaddling [94].

When Zeus reached maturity, Kronos was somehow induced to regurgitate the swallowed children and there followed a ten-year war between the gods and Titans, the Titanomachy. With the help of the Cyclopes, who gave Zeus his thunderbolt and lightning, and the hundred-handed Kottos, Briareos and Gyes (Hekatoncheires) all of whom Zeus freed, the gods ultimately won the battle and relegated the Titans to Tartaros, a realm said to be as far below the earth as the heavens are above. It has been suggested that the battles from the Titanomachy are shown on the west pediment of the Temple of Artemis on Corfu dated to about 580 [95]. In the group to the right a beardless Zeus (?) with his thunderbolt attacks a larger bearded man while another has fallen beside them. In the group to the left a seated figure, identified as Rhea or Kronos, faces a spear-wielding attacker (missing) and another fallen figure lies to the left. The unusual beardless Zeus suggests that this may be the battle of the Olympians to overthrow the Titans, but as with several fragmentary vase-paintings, it is not possible to be certain that it is not the Gigantomachy, a later battle discussed below. The seated figure to the left has sometimes been identified as Priam in the *Ilioupersis*.

A challenge to the authority of Zeus came later from Typhon, the youngest son of Gaia (Earth). Hesiod says that a hundred heads grew from his shoulders, while Apollodorus has the hundred heads somehow attached to Typhon's hands and adds the details that he was winged and that his human torso was attached at the thighs to the coils of a snake.

In Archaic art, Typhon has a single bearded head and a winged torso attached at the waist to one or two great snake coils. The battle between Zeus and Typhon is depicted on several shield bands from Olympia dated between 580 and 550 [96], on a bronze plaque from Ptoion and on a Chalcidian hydria [99], both

from soon after the middle of the 6th century. In each depiction a bearded Zeus prepares to strike the monster with his thunderbolt. The battle may also be the subject of a fragmentary Attic black-figure cup from about the same period. After these it appears many times in Etruscan art, but its only recurrence in Greek art is on an Apulian oinochoe from the end of the 4th century, where Zeus with his thunderbolt rides in a chariot driven by Hermes while a snake-bodied man tries to escape [97]. Above the monster's head is a huge, bloated face that appears to huff and puff. This, of course, recalls Typhon's association with unpleasant winds. According to Pausanias, the body of Boreas (North Wind) on the Chest of Kypselos also ended in serpent tails, and in art from later than our period, giants are often given a similar form.

The deities who would be known as Olympians after the defeat of the Titans were the children of Kronos (with the exception of Hades who ruled the underworld and never resided on Olympos). To them were added Aphrodite and another generation: four illegitimate offspring of Zeus (Athena, Apollo, Artemis and Hermes), one legitimate child of Hera and Zeus (Ares), and one child produced by Hera on her own (Hephaistos). Later Dionysos, another of Zeus' illegitimate offspring, was added. The birth and childhood of several of these younger gods are depicted in ancient art.

Just as Kronos had been warned that a son of Rhea would overthrow him, Zeus learned that a son of Metis who would follow the birth of her daughter would become king of gods and men. Metis was already pregnant by him with a daughter, Athena, so he sought to avoid this fate by swallowing the mother. Then, when she had come full term, Athena sprang from his head fully armed. According to some literary versions and many depictions in the arts, Hephaistos served as midwife by splitting Zeus' skull with his axe.

This birth may be the subject on a 7th-century relief amphora from Tenos. An armed figure seems to spring from the head of a figure seated on a throne, but both figures are winged and the sex of neither is clear. The earliest certain depictions of the subject are on shield bands from Olympia from the end of the 7th century and beginning of the 6th. The moment of birth is shown [98]. Zeus sits on his throne while Athena with helmet, shield and spear, rises from the top of his head. Hephaistos gestures with alarm as he departs with his axe, having freed Athena with a blow, and Eileithyia, the goddess of childbirth stands behind the throne. Pausanias (3.17.3) tells that the birth was a subject of a bronze relief on the Archaic temple by Gitiadas at Sparta.

Not surprisingly, the greatest number of depictions of the myth come from Attica. It appears on many Attic black-figure vases clustered around the middle of the 6th century. On most of them many gods attend as the armed Athena springs out [100]. Hephaistos with his axe only appears on about half of them. Eileithyia is usually present. She, like Eros, can sometimes be a generic figure, so two Eileithyiai can also be shown. Sometimes Demeter assists. On a few vases Athena stands on her father's lap, and on a few the gods stand waiting before she

has appeared. On one of these a confused painter has Hephaistos already rushing off, which makes nonsense of his presence. The myth is the subject of only a few Attic red-figure vases, and those from the first half of the 5th century.

Certainly the most conspicuous depiction of the birth of Athena was the east pediment of the Parthenon, though little of it survives today. Pausanias (1.24.5) tells that the myth was the subject there, and a Roman relief on a circular altar, or *puteal*, probably shows the scheme of the central group [101]. A fully grown Athena stands in front of a seated Zeus as Nike with a wreath flies up to crown her. Behind Zeus, Hephaistos with his axe moves away. On the pediment, other gods and goddesses observe. Thus the essentially comic jack-in-the-box scenes on shield bands and Archaic vases were, if only once, given an heroic form during the High Classical period.

Leto in labour with Apollo may appear on a 4th-century Attic red-figure pyxis [102]. A half-naked woman sits on a chair bracing herself with one hand and holding on to a palm tree with the other. Two women stand behind her, one comforting her, and Athena stands before her. The palm tree is the reason for the identification since, according to the Homeric *Hymn to Apollo*, she clung to such a tree on Delos as she bore him. The woman behind her on the pyxis, then, would be Artemis, who helped deliver her twin brother, and perhaps Eileithyia.

According to some sources the child Apollo killed the dragon Python soon after his birth, and this is certainly the subject on a group of related Attic black-figure lekythoi from the second quarter of the 6th century. On two, Leto holds the child Apollo in her arms as he draws his bow about to shoot a huge snake in a cave near palm trees, which point to Delos as a location. On another from the same group, a young Apollo sits on an omphalos beside a tripod about to shoot a sweet dragon worthy of Lewis Carroll [103]. The *omphalos* (a rounded mound) and the tripod, show that the setting here is Delphi, since both are associated with the sanctuary there. As mentioned in Chapter 2, a mound similar in shape can appear in other scenes as a grave monument, and, of course, the tripod can appear in a wide variety of scenes, but when the two appear together in the presence of Apollo, the location must be Delphi. A woman holding a child with a bow on a red-figure lekythos from about the same date must also be Leto with the child Apollo. Apollo shooting Python from behind a tripod was a coin type for Croton at the end of the 5th century [104].

The infant Hermes appears in the story of the theft of the cattle of Apollo on a Caeretan hydria from about 520 and on an Attic red-figure cup from about 490. The scene is divided into two parts on the earlier vase [105]. In one part cattle stand at the mouth of a cave, in the other a baby sleeps on a bed that looks something like a tea trolley, while two men and a woman carry on an animated discussion above him. According to the myth, Hermes, soon after his birth, slipped out of the cave where he lived with his mother Maia, stole the cattle of his half-brother Apollo, and hid them. He drove the herd backwards to their hiding place to disguise the route. When Apollo, with information from an informer,

came to accuse him of the deed, Hermes was back in his cradle and his mother, of course, protested his innocence. Thus, two of the adults conversing must be Apollo and Maia (or the nymph Kyllene as another version has it), but the identity of the third is unclear.

The other scene is on the outside of an Attic red-figure cup [106] where Hermes, wearing a *petasos* (traveller's hat) rests in a *liknon* (winnowing basket) at the mouth of a cave while his mother proclaims his innocence and cattle fill much of the space around them. On the other side Apollo rushes away. A bearded Hermes with cattle on a Tyrrhenian amphora from the middle of the 6th century may also refer to this myth.

Dionysos was twice-born, and both of his births are depicted in vase-paintings. Zeus had seduced the mortal Semele, daughter of Kadmos, king of Thebes, by promising to fulfill any request she might make of him. Perhaps tricked by Hera, she asked to see him in his full glory, as he would come to Hera, but she died of fright in the face of such power and was destroyed by thunderbolts. Zeus, however, snatched the unborn Dionysos from her womb and sewed him into his own thigh where he remained until the child came to full term.

The death of Semele appears on an Attic red-figure krater from early in the 4th century and on an Apulian krater from late in that century. On the Attic vase, Semele lies on a bed while Iris and other women stand about her and Hermes rushes off with the child [107]. On the Apulian krater, the subject is treated in two bands – in the upper a naked Semele falls back among maenads and satyrs, while in the lower Hermes delivers the child to women, presumably the nymphs of Nysa, who are said to have raised him, as an actor dressed as Papposilenos observes. In both the Attic and Apulian scenes a thunderbolt above Semele indicates the cause of her death, but there is no allusion to the role of Zeus as second mother. However, mildly comic depictions of the birth of Dionysos from the thigh of Zeus appear on Attic vases from about 460 [108] and on Apulian vases from early in the 4th century. Zeus is also shown giving the infant Dionysos to nymphs on several Attic vases from the first half of the 5th century.

Hermes carrying the infant Dionysos is the subject of a well known mid-4th-century statue by (or after) Praxiteles from Olympia [109]. According to Pliny (34.87) it was also the subject of a slightly earlier work by the sculptor Kephisodotos. On Attic vases from the middle of the 5th century, on Boeotian and Lucanian vases from the first half of the 4th, and on the Apulian krater already mentioned, Hermes delivers the infant to nymphs. On some Attic vases from the second half of the 5th century, Hermes delivers the infant to Silenos [110].

One other birth depicted in ancient art – that of Erichthonios – should be mentioned here. Though he belongs to the next generation, he is also a son of Gaia. According to Apollodorus, Hephaistos became enamoured with Athena and on one occasion pursued her in a fit of uncontrolled passion. She escaped, but

not before he spilled his seed on her thigh. Disgusted, she wiped it off with a piece of wool which she threw on the ground (Gaia). From the seed Erichthonios was born and was entrusted by Gaia to Athena.

Depictions of Athena receiving Erichthonios, the future king of Athens, from Gaia appear primarily in Attic art. The earliest is on a black-figure lekythos from the end of the 6th century. As in the later versions, Gaia is shown as a woman rising out of the earth as far as her waist. She holds a child in her arms and Athena stands ready to receive it. A fish-bodied man similar in form to Triton, or the early Okeanos, watches. This is Kekrops, the first king of Athens, to whose daughters the infant Erichthonios is entrusted by Athena. In later depictions (as in literature) he has the body of a snake. Perhaps the painter of this vase did not have an established iconographic form on which to rely and therefore had to improvise – or perhaps he was simply careless.

Athena receiving Erichthonios appears on Attic red-figure vases through the 5th century and on into the 4th [111]. It is the subject of a Melian relief from the middle of the century. It may also have been the subject of a relief on the pedestal of the statues of Hephaistos and Athena by Alkamenes in the Hephaisteion (c. 420), and perhaps of a frieze on the Erechtheion.

Athena put the infant in a chest and entrusted it to Pandrosos, Aglauros and Herse, the daughters of Kekrops, warning them never to open it. They did, of course, and were driven mad by what they saw. Presumably the child had something of the snake about him as well. The opening of the chest is depicted on mid-5th-century Attic red-figure vases.

The final challenge to the authority of the Olympians came from the giants, sons of Gaia born from the drops of blood that fell from Ouranos' severed members. Homer does not mention the Gigantomachy, as this battle is called, but it must have been the subject of a lost poem, or poems, from before the middle of the 6th century when the first depictions of it appear. The earliest surviving references to it come from the beginning of the 5th century, while the earliest summary dates from the 2nd century A D.

The gods learned from an oracle that they could only defeat the giants with the help of a mortal. Thus, they enlisted Herakles, an illegitimate son of Zeus. Through his efforts the gods were victorious, and according to some sources they rewarded him with immortality, a place among the Olympians and the hand of Hebe.

The battle was popular with artists from the middle of the 6th century on into Roman times. The earliest certain depictions of it are on fragments of Attic black-figure vases from c. 560–550 which were dedicated on the Acropolis in Athens. On these the full battle is shown, while on later vases episodes extracted from the battle are more common. Certainly, part of the popularity of the subject with artists was the potential in it for lively scenes, but even from the start it seems to have had a broader meaning and one that could change with the times.

74

In the early scenes Zeus with his thunderbolt mounts a chariot in which Herakles stands with his bow drawn [112]. Athena marches along beside the horses with her spear raised and Gaia approaches Zeus with her hands raised in supplication. The giants here, as in most Archaic and Early Classical depictions, are simply warriors with no distinguishing characteristics. Often they are named, but aside from Enkelados whom Athena usually fights, there is little consistency in which god fights which giant – or even in the names of the giants.

Several of the gods are easily recognized by their attributes which appear on these early vases and continue to appear on black- and red-figure vases through the middle of the 5th century. Hephaistos, though sometimes dressed as a hoplite, wields tongs and often stands by his furnace. Dionysos wears an ivy-wreath and is aided by panthers and lions and snakes [113]. Poseidon holds his trident and is about to throw (or has thrown) a great boulder which is the island of Nisyros off Cos.

The Gigantomachy was a popular subject with sculptors as well. As mentioned above, it is sometimes said to be a subject of the pediment from the Temple of Artemis on Corfu [95]. It is certainly the subject of the well-preserved north frieze of the Siphnian Treasury at Delphi, c. 525 [114]. An unusual element of imagery here is a chariot drawn by lions and driven by a woman who has recently been shown to be Themis. The Gigantomachy was the subject of the pediment on the Megarian Treasury at Delphi from a decade or so later and of the west pediment of the Temple of Apollo built there during the last quarter of the 6th century. Euripides (*Ion* 205–218) describes the latter in some detail. It was the subject of metopes on two temples at Selinus in Sicily from the late 6th and early 5th centuries, of a frieze on the mid-5th-century Temple of Poseidon at Sounion and of metopes on the Heraion at Argos c. 400.

On the Acropolis in Athens the myth had particular importance. As we have seen, it was the subject on several large vases dedicated there in the middle of the 6th century. It was the subject woven into the peplos for the cult statue of Athena presented during the Panathenaic festival. It was the subject of a pediment on an Archaic temple from about 520, and later of the east metopes on the Parthenon where individual duels were depicted. Pliny (35.54, 36.18) tells that it was the subject painted on the inside of the shield of Athena Parthenos by Pheidias in the Parthenon and it now seems clear that this painting had a direct influence on vase-paintings of the Gigantomachy from the last quarter of the 5th century [115]. On these later vases, the giants' armour has been replaced by animal skins tossed over one shoulder and their weapons are rocks. In short, they have become barbarians and the myth has taken on a clearly symbolic meaning.

On a lekythos from the beginning of the 4th century, Dionysos in a chariot drawn by griffins fights a giant who, for the first time in Greek art, has serpent legs. This is the form giants take in most Hellenistic and Roman art.

Even after Zeus had established his rule he faced occasional insubordination

from both his relatives and outsiders, and the punishment for outsiders could be severe indeed, as the story of Prometheus shows. The son of the Titan Iapetus, Prometheus brought to men the gift of fire, which Zeus had carefully hidden from them lest they become too powerful. When he learned of the deed, Zeus devised punishments for both Prometheus and mortals. He had the Titan bound to a mountain and sent an eagle each day to devour his liver, which grew back each night. Prometheus was only released from this torture when Herakles came to him while he was seeking the apples of the Hesperides.

For mortals, Zeus had Hephaistos create from clay the first woman – Pandora. Each of the Olympians gave her a gift (thus her name) and Hermes led her to Epimetheus who welcomed her even though his brother Prometheus had warned him never to accept a gift from Zeus. She had with her a casket, or jar, filled with evils and, of course, she lifted the lid in spite of admonitions. The evils escaped, and mankind has ever after suffered from them.

The punishment of Prometheus appears as early as the second half of the 7th century, on an ivory from Sparta and a gem from Crete. On each a large bird attacks a bound man. So too, the bird attacks him on a shield band from Olympia, and on a Laconian cup (c. 550) where his brother, Atlas, holding a huge boulder (the Heavens) on his shoulder also appears [116].

Herakles is shown rescuing Prometheus on two Attic vases from late in the 7th century. He shoots arrows at the bird as he approaches the Titan who is bound to a stake. Essentially the same scene appears on four vases from the Tyrrhenian group from about 560 [117], and on a cup from about 520. The similarities between these few Attic scenes scattered as they are over a century suggests that there might well have been a common source from which each was drawn. The subject does not appear again after about 520 except on an Apulian krater from the middle of the 4th century, clearly inspired by theater, though from Pausanias (5.11.6) we know it was the subject of a painting from the second half of the 5th century by Panainos in the Temple of Zeus at Olympia.

On a few Attic vases from the end of the 5th century, probably inspired by a satyr play, Prometheus is shown with what must be the 'narthex', a stalk of giant fennel, in which he brought fire to men [118]. In these scenes, satyrs light torches from the coals he carries in the narthex. A similar scene also appears on two Lucanian pelike from the middle of the 4th century.

The creation of Pandora is shown on a few Attic vases from shortly before the middle of the 5th century; and on a slightly later vase, Epimetheus receives her in the presence of Zeus, Hermes and Eros [119]. On a Campanian imitation of an Attic neck-amphora a similar scene appears with only Epimetheus and Pandora. All of these scenes may well have been inspired by a satyr play – perhaps Sophocles' *Pandora*.

Both Pausanias and Pliny tell that the birth of Pandora was depicted in a frieze on the base of Pheidias' statue of Athena in the Parthenon, but the only detail we know is that twenty gods were present (Pliny 36.18). Six out of ten figures on a

small Hellenistic copy of the base survive, but add no new information on the depiction of the myth.

After the defeat of the Titans, the three sons of Kronos had cast lots to determine their domains. Zeus won sovereignty over the heavens, Poseidon over the seas and Hades over the underworld. Though Hades never dwells on Olympus and was certainly not a popular deity, he does appear occasionally in art, and it is to him and his realm we should finally turn before leaving the world of the gods for that of the heroes.

The only myth depicted by ancient artists in which Hades plays an active role is the rape of Persephone. It is the subject of two mid-5th-century Attic red-figure vases. On one, a fragmentary skyphos found at Eleusis, Hades holds Persephone in his chariot as it sinks into the ground. Scenes with Hades and Persephone in his chariot also appear on several Apulian red-figure vases from the 4th century and is the subject of a well-preserved wall-painting from Vergina in Macedonia [121]. The early 5th-century statue of a fleeing girl from Eleusis suggests that the rape may have been the subject of a pedimental group there.

On the other Attic vase depicting the rape, Hades, with his sceptre and cornucopia, pursues a fleeing Persephone on foot. The cornucopia (not to be confused with Dionysos' drinking horn) is his attribute on several red-figure vases where he is occasionally named Plouton, a title that refers to the wealth that comes out of the ground, be it mineral or vegetable. On one vase from the mid-5th century, Hades and Demeter appear together, he with his cornucopia, she with a plough [120]. He is to be distinguished, however, from Ploutos, the personification of wealth, who appears as a child with a cornucopia on at least one 4th-century Attic vase, and as an infant in the arms of Eirene (Peace) by the sculptor Kephisodotos (c. 375) of which copies survive [122]. Pausanias (9.16.2) also tells of a Tyche (Fortune or Chance) carrying the infant Ploutos.

Hades (Plouton), sometimes with Persephone, is occasionally shown in vase-paintings observing various activities in the underworld, and a word should be said here about depictions of some of the denizens of that realm. Odysseus' vision of the shades in the underworld (Odyssey 11.30) was the subject of a mid-5th-century painting at Delphi by Polygnotos of Thasos. Though not a patch of the painting survives, Pausanias (10.28.1–31.12) describes it in such detail that it has been possible to reconstruct what is probably a fairly accurate picture of it.

Several of the figures said to be in Polygnotos' painting appear in other art forms from our period. The first scene Pausanias describes is Charon as an old man rowing his ferry across the river Acheron. Charon is not mentioned by Homer (the earliest surviving reference to the boat across the river is by Aeschylus), however, Pausanias suggests that Polygnotos used the Minyad, an epic about which we know almost nothing, as his source for him.

The earliest depiction of Charon is on fragments of an Attic black-figure vase from early in the 5th century where he is a white-haired old man sitting at the

steering oar in the stern of his boat. A dozen or more winged figures (souls) flutter about. Apart from this piece, he appears from about 450 on through the end of the 5th century on dozens of Attic white-ground funerary lekythoi which, filled with oil, were used as grave offerings. On these he is usually portrayed as a vigorous bearded man dressed as a laborer in a brimless cap (much like the one often worn by Hephaistos) and smock, standing with a pole at the stern of his boat. Hermes, as psychopompos, often leads the deceased to him for the trip across the river [79].

More elegant transport to the underworld appears on a few white-ground lekythoi where the winged youth Hypnos (Sleep) and the winged man Thanatos (Death) carry the deceased [123]. These scenes are derived from heroic scenes, as on Archaic red-figure vases from before 500 where Hypnos and Thanatos carry the body of Sarpedon [310]. More than a century later, this Homeric subject appears on at least one Lucanian and one Apulian red-figure vase. Hypnos appears as a small winged youth on a few black- and red-figure depictions of Herakles and Alkyoneus from about 500, and Thanatos is a winged youth leading a woman (Eurydice?, Alcestis?) on a late-4th-century column drum from Ephesos [80]. Hesiod calls Hypnos and Thanatos the children of Nyx (Night) and on the Chest of Kypselos they appeared as children (one white, the other black) asleep in her arms. Apart from the scenes mentioned above, however, they have little iconography during our period.

Several of the figures named by Pausanias appear together on an Attic red-figure krater from soon after the middle of the 5th century [124]. On the upper frieze on one side of the vase Elpenor, Ajax and Palamedes stand in the presence of Persephone who sits enthroned between columns that indicate her palace. In the same frieze on the other side, Meleager stands to one side while at the center Theseus and Peirithoos sit on a rock as Hades, Herakles and Hermes observe.

The punishment of Theseus and Peirithoos may have been the subject of a painting in Athens by Mikon, a colleague of Polygnotos, and it has been convincingly argued that the painting is reflected on a mid-5th-century Attic red-figure krater [125]. Theseus and Peirithoos had gone to the underworld to take Persephone as a bride for the latter. Hades, feigning good cheer, welcomed them and urged them to sit and be comfortable, but once they did they were held fast, stuck to their chairs (or in some versions, to rocks). Theseus was eventually freed by Herakles when he came for Kerberos (see Chapter 6), but according to most accounts, Peirithoos was doomed to remain there for eternity.

The earliest depiction of this scene is on a mid-6th-century shield band from Olympia [126]. Theseus and Peirithoos (both named) sit on chairs as Herakles approaches drawing his sword. The subject does not appear again for nearly a century when a few Attic red-figure vase-painters take it up as shown above. On a red-figure cup, Peirithoos sits alone on a rock as Herakles vainly pulls at his arm. Roman copies survive of an Attic three-figured relief from the last quarter of the 5th century where Peirithoos sits on a rock while Herakles and Theseus

78

stand on either side of him. On a mid-4th-century Apulian krater, Hades sits and Persephone stands with torches while both deities watch a grotesque winged fury bind one of them [128]. The other lies already bound in front of them.

Pausanias tells of several examples of endlessly repeated tasks as a type of punishment that appeared in the painting, and some of these appear elsewhere as well. Oknos (Hesitation or Indecision) who plaits a rope that a donkey eats as fast as he plaits it is surely the old man on an Attic black-figure lekythos from about 490 behind whom a donkey kneels to eat [127]. The water-carriers, also on this vase, endlessly filling a great pithos, recall figures in Polygnotos' painting whom Pausanias says were punished for ignoring the Eleusinian mysteries. Water-carriers appear on black-figure vases from the late 6th century and on some Apulian vases from the 4th. While neither of these punishments is mentioned in the *Odyssey*, those of Sisyphos and Tantalos are.

Little about Sisyphos, a king of Corinth, is clear aside from his punishment. He pushes a great boulder up a steep hill only to have it roll back each time he reaches the top. This is the subject of nearly a dozen Attic black-figure vases from the middle to near the end of the 6th century, and Persephone sometimes observes him at his task. It is also the subject of a metope from the Heraion at Foce del Sele near Paestum (*c.* 540) where a grotesque winged demon clings to his back as he pushes the boulder up the incline [129]. Sisyphos is shown pushing his boulder on the inside of a few Attic red-figure cups from about 500 and is one of the figures in depictions of the underworld on a few Apulian red-figure vases from the second half of the 4th century [131].

Tantalos, King of Sipylos in Lydia, committed many offences against the gods, but it is not clear precisely which led to his punishment. There are also variations in the details of the punishment itself. In the *Odyssey*, Tantalos stands in a pool from which he cannot drink. Over the pool fruit dangles from branches, but as he tries to pick, the wind blows them out of his reach. Polygnotos added to these punishments a great rock balanced over him. This is not a subject in Attic art, but in the bottom frieze on an Apulian red-figure krater from the last quarter of the 4th century, Tantalos the king, elegantly dressed and holding a sceptre, looks up and gestures in dismay at an overhanging cliff just above him [131]. At the other end of the frieze, balancing the composition, Sisyphos pushes his rock up a cliff.

One other endless punishment, though not mentioned by Homer nor included in Polygnotos' painting, appears in art from our period – that of Ixion. He is said to have fallen in love with Hera and to have boasted to other mortals that he had slept with her. In fact, he had slept with a cloud fashioned by Zeus into the shape of Hera (an early example of entrapment!). But, for his indiscretion, he was bound to a wheel that forever spins through the air. From the impregnated cloud, Centaurus, the progenitor of the race of centaurs was born.

Ixion bound to the wheel appears on the inside of several Attic red-figure cups from early in the 5th century. On a kantharos from the middle of the century,

Hermes and Ares hold him before Hera while Athena holds the winged wheel
[132]. Ixion on his wheel also appears on Lucanian, Campanian and Apulian red-
figure vases from the beginning to the end of the 4th century.

From this brief survey of divinely commissioned punishments, it should be
clear that the Greeks of our period made no attempt to fit the punishment to the
crime.

Polygnotos included in his painting the young Theban huntsman Aktaion
sitting by his mother with dogs at his feet. According to most versions of the
story he offended Artemis and she maddened his hounds so that they turned on
him and killed him. In the early versions his offence was his boast that he was a
better huntsman than Artemis or that he sought her hand in marriage. The
version where he comes upon her naked is first told by Ovid well after the end of
our period.

The punishment of Aktaion first appears on an Attic black-figure cup from
about 550 where he flees as seven dogs attack him, but its greatest popularity is in
the 5th century. On black-figure and some red-figure vases he is naked, on some
red-figure vases he wears a deer-skin and on some horns have begun to sprout
from his head, referring to the version of the story in which Artemis
transformed him into a stag. His horned head is a coin type from Cyzicus c. 440.
Artemis is sometimes present in red-figure scenes. On a metope from Selinus,
Artemis watches as the dogs attack [130], and she is also present on two roughly
contemporary Melian reliefs [133]. The punishment is a subject on Apulian,
Lucanian, Paestan and Campanian red-figure vases from the beginning to the
end of the 4th century.

Though Polygnotos did not include him in his painting, Aktaion's cousin
Pentheus should be mentioned here, as he too met a sad end brought about by a
deity. As a young ruler of Thebes, he forbade the worship of Dionysos, as
Euripides tells in his *Bacchae*, and was torn to pieces by his mother and aunts who,
driven mad by the spurned god, mistook him for a lion.

The earliest depiction of the death of Pentheus appears on a fragmentary Attic
red-figure psykter from the last quarter of the 6th century, where women carry
parts of his dismembered body. Similar scenes appear on other red-figure vases
from the beginning of the 5th century [134] on to about 425, and it is a subject
picked up by Apulian and Campanian vase-painters. Pausanias (1.20.3) tells that
it was the subject of a painting in a temple of Dionysos near his theater in Athens
(close by a depiction of the Return of Hephaistos).

Finally, the three musicians in Polygnotos' painting should be mentioned –
Marsyas, Thamyras and Orpheus. According to Pausanias, the satyr Marsyas sat
on a rock beside the young Olympos, teaching him how to play the *aulos* (two
flute-like pipes played together) a scene which also appears on a mid-4th-
century Apulian krater [135].

Marsyas plays a central role in only one myth, and this is well illustrated in
Greek art from the second half of the 5th century. Athena invented the aulos, but

when she saw a reflection of herself with puffed-out cheeks as she played, she threw the pipes away. The satyr Marsyas picked them up, and ignoring Athena's warning, learned to play them. Eventually he challenged Apollo to a musical contest, lost and was flayed for his impertinence.

Various parts of this story are illustrated in Greek art. The earliest was probably a bronze statue or group by Myron (c. 450) mentioned by Pliny (34.57), which is perhaps the same group seen by Pausanias (1.24.1) on the Acropolis. Several representations of Athena throwing the pipes and Marsyas jumping back in wonder that appear in Roman copies, on coins and on an Attic red-figure oinochoe from about 400, probably reflect Myron's work [136].

During the last quarter of the 5th century the contest appears on several Attic red-figure vases with Marsyas playing his pipes while Apollo, and often other deities, listen [137]. On a few of the vases Marysas plays the kithara, a variation which may have been inspired by a literary work in which he was converted to the lyre as a superior instrument. On a marble relief from Mantinea dated to the last quarter of the 4th century, Apollo sits holding his lyre while Marsyas plays, and on some 4th-century Attic vases Apollo plays while Marsyas listens.

Marsyas bound after losing the contest was the subject of a painting by the 4th-century artist Zeuxis (Pliny 35.66) and appears on at least one 4th-century Attic red-figure vase. On several 4th-century Lucanian vases Marsyas holds a large knife [138], presumably the one that will be used to flay him, and on one Campanian vase Apollo approaches him with a knife.

According to Pausanias, Thamyras sat humiliated with sightless eyes, his hair and beard grown long, his broken lyre at his feet. He was a Thracian musician, mentioned by Homer and the subject of a lost play by Sophocles, who boasted that he could defeat even the Muses in a musical contest. Of course, when such a contest was held he lost and his punishment was blindness and the loss of his musical skills. In an aside Pausanias comments (4.33.7) that in his view Thamyras lost his sight through disease and gave up his art as a result of the accompanying stress.

Thamyras appears on less than a dozen Attic red-figure vases, all from the last half of the 5th century. On most he sits playing a lyre or kithara, surrounded by Muses. Often he is shown in Thracian dress. His punishment is the subject of a scene on a hydria from about 430 where he sits blinded between his mother and a Muse, his lyre falling from his lap [139]. Pausanias says (9.30.2) that the blind Thamyras was also the subject of a statue on Mount Helicon in Boeotia where his broken lyre was shown.

Finally, Orpheus, another Thracian musician, was depicted in Polygnotos' painting leaning against a tree on a hill holding his kithara with his left hand and touching a branch with his right. Pausanias notes that he was shown as a Greek with nothing Thracian about either his clothing or his headdress.

Orpheus was the son of a Muse (usually Kalliope) and the mortal Oiagros (or sometimes Apollo) who became a musician of such great talent that with his lyre

and song he could enchant wild beasts, streams, trees and even rocks. Aside from his inclusion in depictions of the Argonauts, which will be discussed in Chapter 8, he probably does not appear in art before the beginning of the 5th century. On a few late Attic black-figure vases he is shown playing his lyre or kithara. On a few Attic and Apulian red-figure vases he sometimes plays for Thracians [140] or later is himself shown in Thracian dress. Pausanias (9.30.4) tells that there was also a statue of him on Mount Helicon where he was surrounded by animals in stone and bronze.

The most famous myth associated with him and shown in ancient art concerns his wife, the Dryad Eurydice. When she died from a snake bite, he went to the underworld and persuaded Hades to release her. The one condition was that he would not look at her until they had completed their journey. But as they proceeded he was unable to wait any longer and looked back, only to see her vanish. That painful moment before she vanished was the subject of another three-figure frieze [141] (connected with the Herakles, Theseus and Perithoos frieze mentioned above) from the late 5th century of which Roman copies survive. Orpheus appears as one of many inhabitants of the underworld on several Apulian red-figure vases from the 4th century (with Eurydice beside him at least once), but there he simply stands in Thracian dress and plays his lyre – these probably reflect his connection with the Orphic mysteries, which were very popular in South Italy, rather than myth.

The death of Orpheus appears on many Attic red-figure vases during the second and third quarters of the 5th century. There, with only his lyre to defend himself, he is attacked by women with a variety of weapons – spits, sickles and swords are common, axes and rocks are also used [142]. Though the dress or tattoos of the women often show them to be Thracian, Orpheus (particularly in the earlier vases) is usually depicted as an unexceptional youth. On a few Apulian red-figure vases from the middle of the 4th century he wears ornate Thracian dress.

There are different reasons given for the attack on Orpheus – that he was heartbroken at the loss of Eurydice and ignored women entirely – that he kept other men from women (even that he invented homosexuality), or that he offended Dionysos who was worshipped by the women (and this seems to have been the subject of a play by Aeschylus). It should be noted, however, that on none of the vases do the women have the attributes of maenads.

In any case, the women dismembered the body of Orpheus and threw his head and lyre into a river where they floated into the sea and then drifted on to Lesbos. The severed head of Orpheus appears on a few Attic red-figure vases from the second half of the 5th century, presumably giving oracles – on one a youth sitting in front of the head writes on a tablet [143]. The earliest literary source for the oracular head of Orpheus is from the 3rd century AD, so it is not possible to interpret the details of these scenes with any confidence.

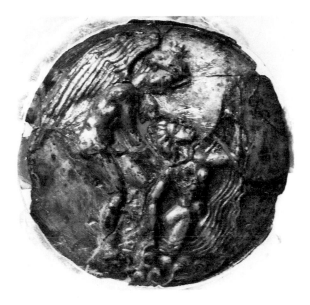

89 Silver gilt medallion from Galaxidi. Eros receiving Aphrodite. This probably reflects the scene depicted on the base of the throne of Pheidias' Zeus at Olympia. Late 5th Century (?) D. 3 cm

90 (*below*) Marble relief. 'Ludovisi Throne'. Aphrodite, rising from the sea, is received by attendants who hold a cloth in which they will wrap her. *c.* 460. 84 cm

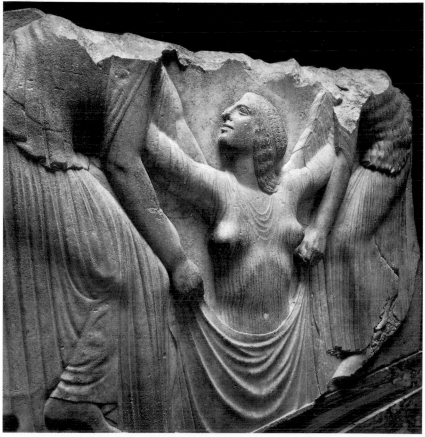

93 (*opposite*) Attic white ground lekythos by Douris. Atalanta pursued by Erotes. Eros holding a wreath and a whip (which has been incorrectly restored as a floral) pursues Atalanta. Two more Erotes hover beyond her. The significance of the scene is not clear, but it may refer to her dislike of men. Eros is sometimes shown with a whip pursuing a youth. *c.* 500. 32.5 cm

91 Attic black-figure fragment, from the Acropolis in Athens. Aphrodite holding the children Himeros and Eros. *c.* 550

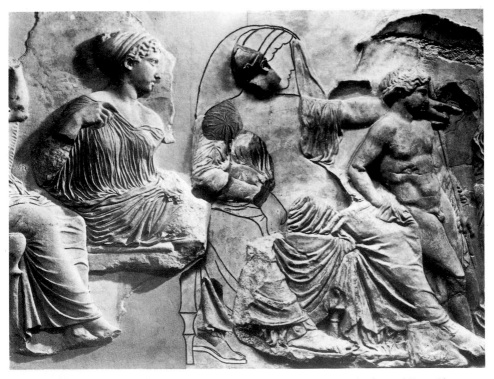

92 Marble relief, east frieze of the Parthenon in Athens (reconstructed). Artemis, Aphrodite, and Eros with a parasol resting against her knee. *c.* 440. 1.06 m

ΕΡΟΣ

94 Attic red-figure column-
krater from Vulci. Rhea,
carrying a large rock wrapped as
a child, faces Kronos, who holds
a sceptre. The identity of the
women behind Rhea is unclear.
c. 450. 44 cm

95a Limestone pedimental group from a
temple of Artemis on Corfu (reconstruction)
(see also 155). A Gorgon in the archaic
running pose, with Pegasos and Chrysaor at
her sides, is flanked by panthers and small
figure scenes to the far right and left. c. 580.
L. 22.16 m

95b Detail of pediment. Beardless Zeus (?)
with a thunderbolt attacks a Titan or a
Giant (?)

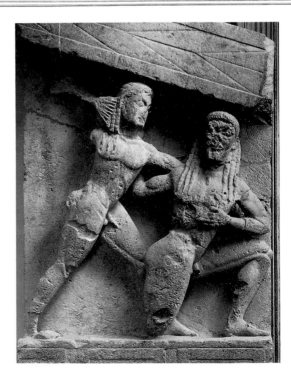

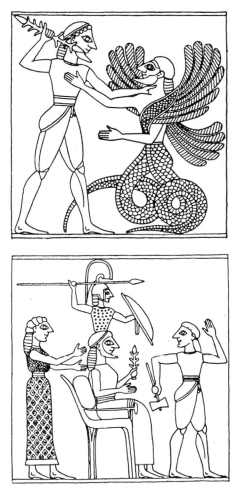

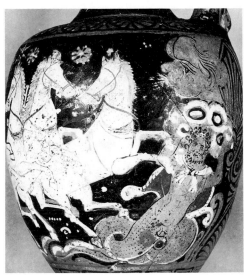

96 (*above left*) Bronze relief, shield band panel from Olympia. Zeus and Typhon. Zeus grabs the winged, serpent-bodied Typhon by the throat and prepares to strike him with a thunderbolt. *c.* 550. 8.6 cm

97 (*above right*) Apulian red-figure oinochoe. Zeus, driven by Hermes in a chariot, charges a snake-bodied Typhon who wears an animal skin and lifts a great rock. Above Typhon is a bloated face of a wind-god. Late 4th Century

98 (*left*) Bronze relief, shield band panel from Olympia. Birth of Athena. Zeus sits on his throne holding a thunderbolt as Athena, wearing a helmet and brandishing a spear and shield, emerges from his head. Eileithyia serves as midwife and Hephaistos moves away, having split Zeus' skull with his axe. *c.* 550. 8.6 cm

99 Chalcidian hydria from Vulci. Zeus and Typhon. Zeus rushes at Typhon, about to throw a thunderbolt at him. Below, an animal frieze with goats and panthers is unrelated to the scene above. *c.* 540. 46 cm

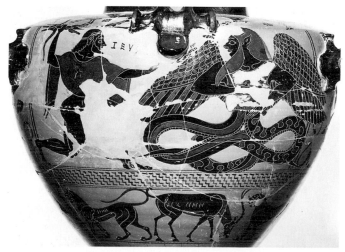

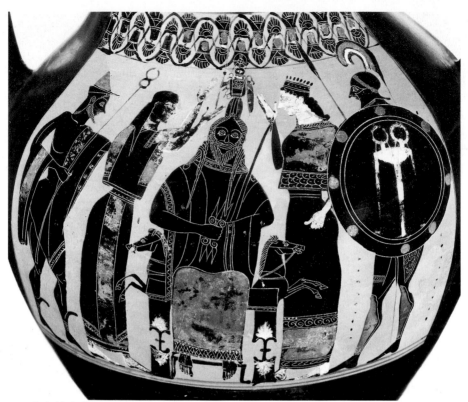

100 Attic black-figure amphora from Group E. Birth of Athena. Zeus with his thunderbolt and sceptre, sits in a frontal pose on an elegant throne with horse protome arms as Athena emerges from his head. Note her aegis. Eileithyia and another goddess assist while Hermes and Ares observe. Note the tripod device on Ares' shield. *c.* 540. 42.5 cm

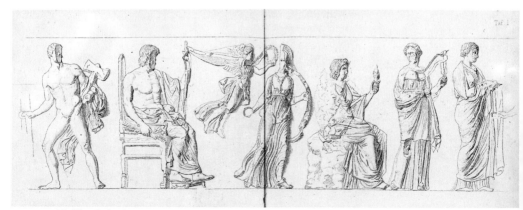

101 Marble relief, cylindrical altar or well head. Birth of Athena. Probably a Roman copy of a 4th-Century original based on the east pediment of the Parthenon. 99 cm

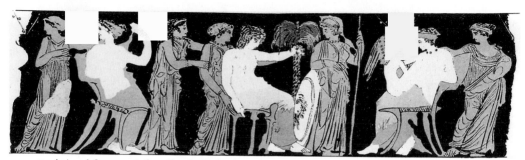

102 Attic red-figure pyxis from Eretria. Birth of Apollo (?) Leto sits on a stool and holds onto a palm tree in the presence of other deities. Athena stands in front of her. Artemis and Eileithyia may be the women behind her. Eros sits on Aphrodite's lap. c. 350

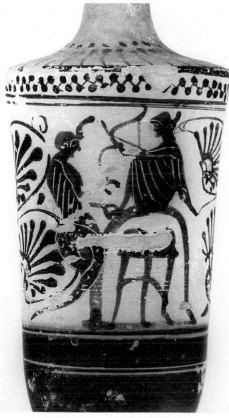

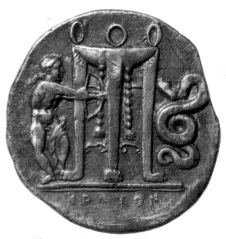

104 Silver stater from Croton. Apollo and Python. The young Apollo stands behind a tripod from which tassels hang, and shoots at Python. c. 420

103 Attic black-figure (on white ground) lekythos from Attica. Apollo and Python. Apollo with a drawn bow sits on the omphalos about to shoot Python who rises up in front of him. Note the tripod in front of the omphalos. c. 470

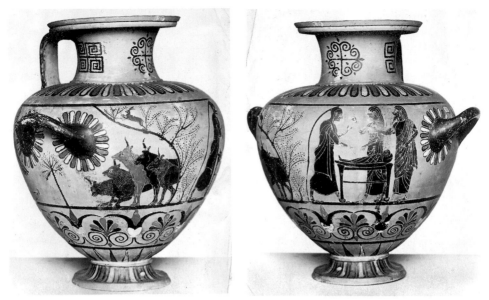

105 Caeretan hydria from Italy. Hermes and the Cattle of Apollo. Apollo argues with Maia and her husband (?) over the sleeping Hermes while the stolen cattle are in a cave to the left. *c.* 530. 42.3 cm

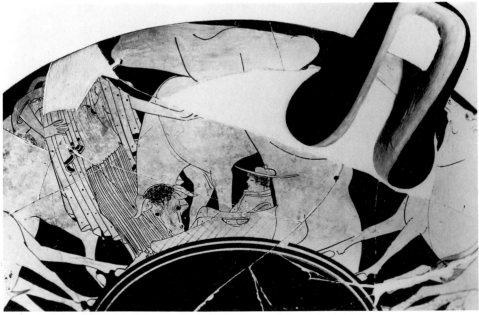

106 Attic red-figure cup by the Brygos P., from Vulci. Hermes and the Cattle of Apollo. *c.* 490

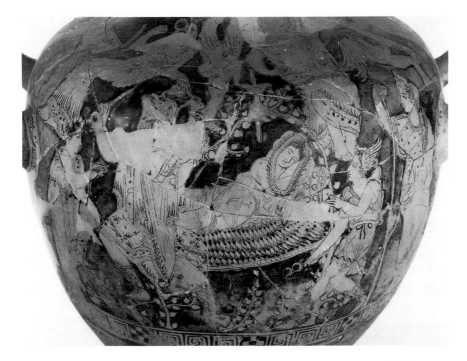

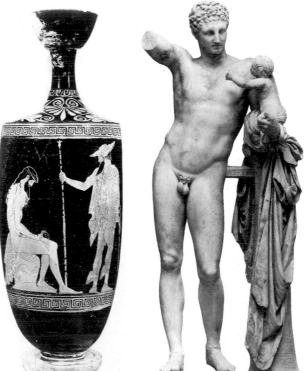

107 (*above*) Attic red-figure hydria. Birth of Dionysos. A thunderbolt drops on the sleeping Semele who has just been delivered of Dionysos. Hermes carries the child to a waiting nymph. Iris with a kerykeion and winged headgear, and Hera with a sceptre stand at the head of Semele's couch. Aphrodite and Zeus sit above amongst Erotes. *c.* 400. 39.2 cm

108 (*right*) Attic red-figure lekythos by the Alkimachos P., from Eretria. Birth of Dionysos. Zeus has given his sceptre to Hermes, who wears a petasos, chlamys and winged boots and sits on a rock, while the infant Dionysos emerges from his thigh. *c.* 460. 42.9 cm

109 (*far right*) Marble group from Olympia. Hermes with the infant Dionysos. Pausanias (5.17.1) tells of such a statue by Praxiteles in the temple of Hera at Olympia, a location that corresponds to the findplace of this work, yet scholars disagree on whether this is the original or a Hellenistic copy. *c.* 340(?) 2.13 m

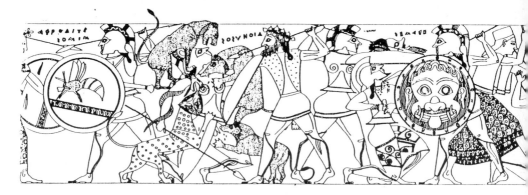

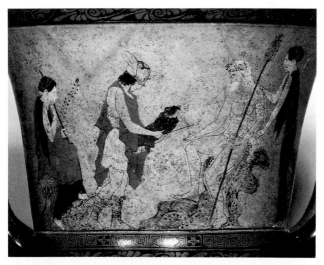

110 Attic white ground calyx-krater by the Phiale P., from Vulci. Hermes wearing winged boots and a winged helmet delivers the infant Dionysos to shaggy old Papposilenos, who sits on an ivy-covered rock and holds a thyrsos while nymphs look on. The scene was probably inspired by a satyr play. *c.* 430. 35 cm

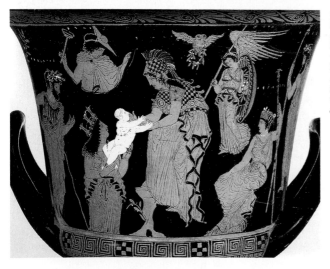

111 Attic red-figure calyx-krater. Birth of Erichthonios. Athena receives the infant Erichthonios from Gaia (Earth) while Hephaistos and Hermes look on from the left; Nike, Aphrodite and Zeus, from the right. An owl with a laurel wreath hovers above Athena. *c.* 400. 37.7 cm

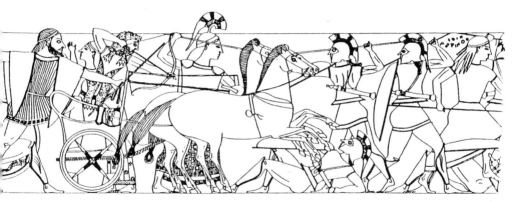

112 Attic black-figure dinos by Lydos, from the Acropolis at Athens (reconstructed by M. Moore). Gigantomachy.
At the centre Zeus mounts the chariot in which Herakles stands with drawn bow, and Gaia pleads for her children,
the Giants. Gods fight giants before and behind them. Notable are Hermes, dressed in hoplite armour, Dionysos
who is aided by lions, panthers and a snake, and Aphrodite, who fights the giant Mimos, whose shield device is a
wasp or bee. c. 560

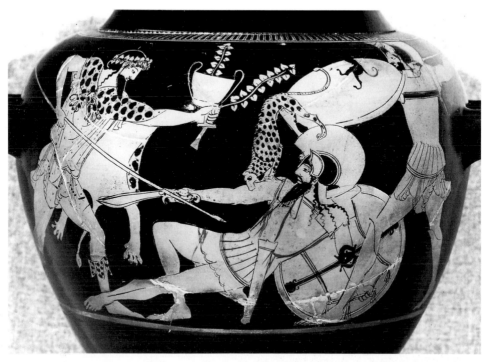

113 Attic red-figure stamnos from Vulci by the Tyszkiewicz P. Dionysos, wearing a panther-skin and boots and
holding a kantharos and ivy sprigs in one hand, a spear in the other, is aided by a panther in his fight with two
giants. c. 480

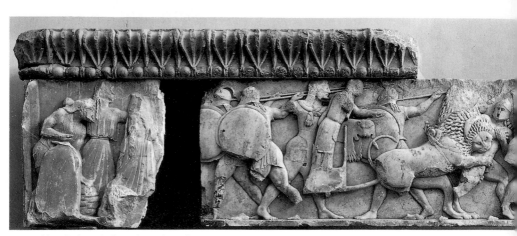

114 Marble relief, north frieze from the Siphnian Treasury at Delphi. Gigantomachy. l to r: Hephaistos with bellows heating coals to throw at giants, while Hestia and another goddess face two giants; Dionysos in a leopard-skin; Themis driving a chariot drawn by lions that attack a giant; Apollo and Artemis pursuing a giant named Tharos; the fallen giant Ephialtas and three giants advancing from the right (Hyperphas, Alektos, and another). Inscriptions identify the figures named here. *c.* 525. 64 cm

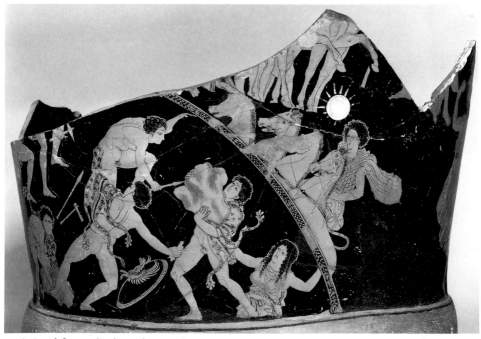

115 Attic red-figure calyx-krater fragment from Ruvo. Gigantomachy. The upper part of the scene represents the heavens where the gods prepare for battle as Helios (the Sun) drives his chariot up, bringing a new day. Below, the Giants, some with leopard-skins, pile up great rocks as they prepare to storm Olympos. Gaia, half risen from the ground, warns or advises them. This scene may have been inspired by the gigantomachy on the inside of the shield of Athena Parthenos. *c.* 400. 31 cm

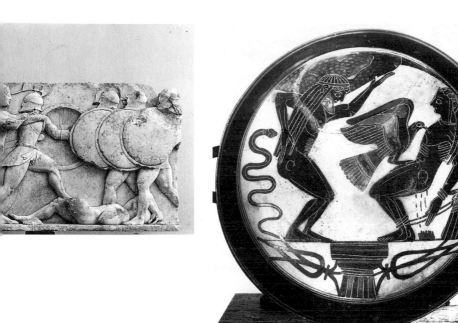

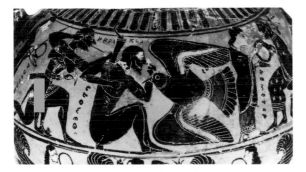

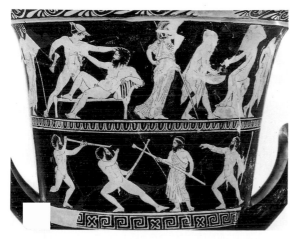

116 (above) Laconian cup from Cervetri. Atlas and Prometheus. Atlas holds the heavens on his shoulders, the dots on it representing stars, and a large bird attacks his brother, Prometheus who is tied to a column. The snake behind Atlas is unexplained, but it may simply be a filling device. c. 560

117 Attic black-figure 'Tyrrhenian' amphora. Prometheus unbound. Herakles, his bow drawn, rushes toward a great bird that flies toward Prometheus who is attached to a stake. Athena stands behind Herakles. Demeter hands a wreath to Poseidon to the right of the bird but it is doubtful that they are connected with the Prometheus scene. c. 550

118 Attic red-figure calyx-krater by the Dinos P. Above, Deeds of Theseus. Poseidon observes as Theseus attacks Prokrustes with an axe; Athena observes as Theseus confronts Sinis. Below, Prometheus firelighter. Satyrs, named Sikinnis, Komos and Simos light torches from coals Prometheus carries in a fennel stalk. The scene was probably inspired by a satyr play. c. 420. 39.5 cm

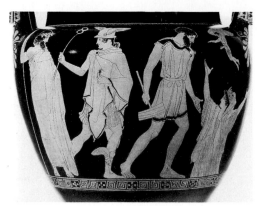 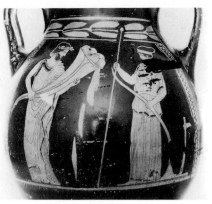

119 Attic red-figure volute-krater. Eros flies overhead as Epimetheus receives Pandora who rises out of the ground and Hermes brings the couple a flower from Zeus. All the figures are named. The mallet carried by Epimetheus refers to a version of the myth in which he frees Pandora from some sort of chthonic prison. *c.* 450. 48.2 cm

120 Attic red-figure pelike by the Orestes P. Plouton, holding a great cornucopia, and Demeter, holding a sceptre and plow. *c.* 450. 26 cm

121 Wall-painting from the 'Tomb of Persephone' at Vergina. Rape of Persephone. Hades holds a distraught Persephone with one arm while he grasps the reins of his chariot with the other hand. Persephone's playmate cowers as the chariot rushes away. Mid-4th Century. 1.01 m

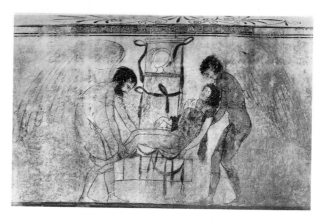

122 (*left*) Marble group. Roman copy of a Greek bronze *c.* 370 of Eirene (Peace) holding the infant Ploutos (Wealth) by Kephisodotos. 1.99 m

123 (*above*) Attic white ground lekythos by the Thanatos P., from Attica. An unkempt and bearded Thanatos and a youthful Hypnos, both winged, lift the body of a young warrior in front of a tomb, which has a helmet drawn on it and fillets tied about it. *c.* 440. 48.8 cm

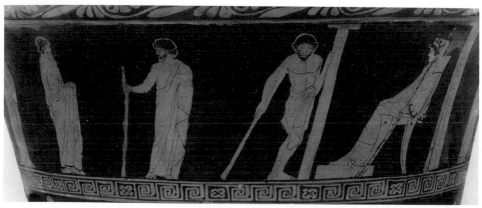

124 Attic red-figure calyx-krater. The Underworld. Elpenor, Ajax with a staff, and Palamedes, who leans on an oar, stand in front of a building in which Persephone, holding a sceptre, sits on her throne. *c.* 440

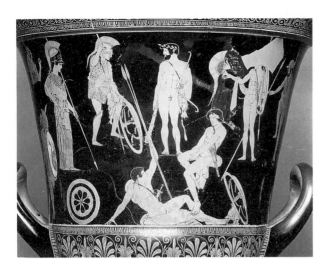

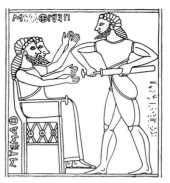

126 Bronze relief, shield band panel from Olympia. Rescue of Theseus. Herakles in the Underworld draws his sword as he approaches Theseus and Peirithoos (both named) who are stuck fast to their chairs. *c.* 560. 6.2 cm

125 (*above*) Attic red-figure calyx-krater by the Niobid P., from Orvieto. Herakles and Athena are easily recognized by their attributes, but the other figures are simply warriors and have variously been identified as Argonauts, some of the Seven who fought at Thebes, and Athenian Heroes at Marathon. The disposition of the figures at several levels instead of on a single ground line suggests the influence of wall-painting, and it has recently been convincingly argued that the scene is Herakles rescuing Theseus from the Underworld based on a painting in the Thesion at Athens. In that case, the two seated figures would be Theseus and Peirithoos. *c.* 450. 54 cm

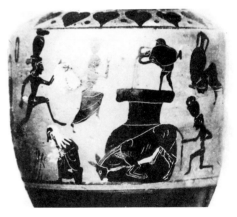

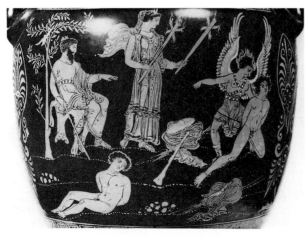

127 (*above*) Attic black-figure lekythos. Punishments in the Underworld. The water carriers are souls condemned to fill endlessly a great pithos, and the old man, Oknos, is followed by a donkey that eats the rope he endlessly plaits. *c.*490

128 Apulian red-figure volute-krater. Theseus and Peirithoos in the underworld. Hades, seated on a panther-skin under a tree, and Persephone with torches, observe as a Fury binds one of the heroes, and the other sits nearby, already bound. Late 4th Century. 5.8 cm

129 (above) Sandstone relief, metope from Foce del Sele.
Sisyphos. A naked winged demon clings to Sisyphos' back
as he pushes a boulder up a steep incline. c. 540. 76.5 cm

130 (right) Limestone and marble relief, metope from
Selinus. Death of Aktaion. Aktaion, who wears a fawn-
skin, is attacked by his hounds at Artemis' command. The
head, arms and feet of Artemis are of marble. c. 460.
1.62 m

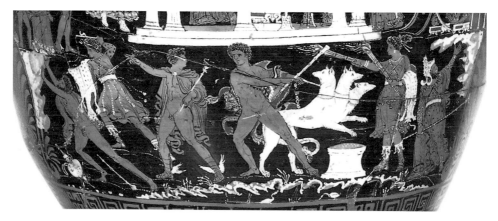

131 (above) Apulian red-figure volute-
krater from Canosa. Bottom frieze. In
the centre, Hermes guides Herakles who
has captured Kerberos and is threatened
by Hekate with torches. To the left,
Sisyphos pushes against a cliff as a fury
with a panther-skin over one arm whips
him. To the right, Tantalos, wearing a
Phrygian cap and holding a sceptre
gestures up at an overhanging rock.
c. 430

132 (right) Attic red-figure kantharos by
the Amphitrite P., from Nola.
Punishment of Ixion. Athena holds the
winged wheel to which Ixion will be
affixed while Ares and Hermes present
him to Hera. c. 450

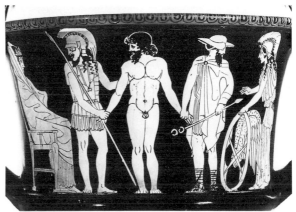

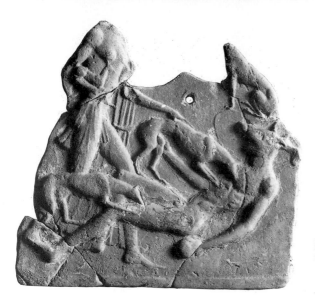

133 Melian relief from Locri. Death of
Aktaion. Aktaion, with the head of a deer,
is attacked by his hounds as Artemis urges
them on. c. 460. 16 cm

134 Attic red-figure cup. Death of
Pentheus. Two maenads wearing
leopard-skins hold the torso of
Pentheus, another holds one of his
legs, and a satyr raises his hands in
horror. On the other side (not
shown) maenads holding parts of
Pentheus' body dance before a
seated Dionysos while a satyr
plays pipes. c. 480

135 Apulian calyx-krater. A
lecherous Marsyas teaches the young
Olympos to play the pipes while
Aphrodite, holding a mirror,
watches and Eros prepares to place
a wreath on his head. Below, Pan
with a thyrsos cavorts and to the
right a naked woman holds up a
garment as she dances (?) c. 350.
41.7 cm

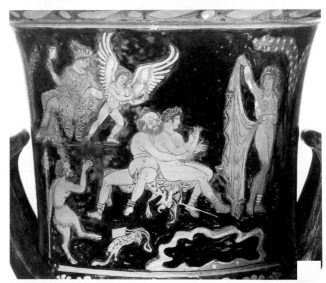

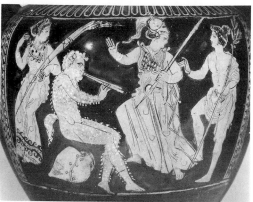

136 (*above*) Reconstruction of a Greek bronze
group by Myron, *c*. 450. Athena and Marsyas.
Marsyas jumps back in wonder and fear at the
pipes Athena has thrown on the ground

137 (*above right*) Attic red-figure column-krater
by the Suessula P. Artemis with a torch, Athena
with a spear, and Apollo with a laurel branch
listen while Marsyas plays his pipes. *c*. 400

138 (*right*) Lucanian red-figure skyphos
fragment. Marsyas holding a knife that will be
used to flay him leans on a pillar with his name
inscribed on it in the presence of Hera and
Artemis, who holds two spears. *c*. 400

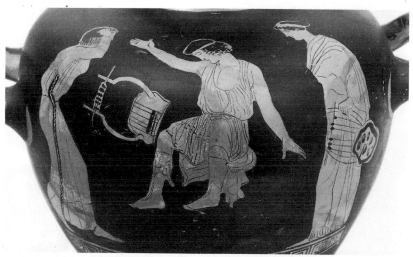

139 Attic red-figure hydria from Greece. Punishment of Thamyris. Thamyris, having just been
blinded and deprived of his musical skills, drops his kithara in the presence of his horrified
mother, Argiope, and a vengeful Muse who holds a lyre. Tattoo marks on Argiope's arm
identify her as a Thracian. *c*. 430. 28 cm

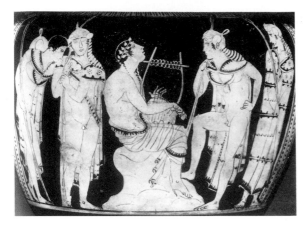

140 (*left*) Attic red-figure column-krater by the Orpheus P., from Gela. Orpheus sits on a rock and plays his lyre for Thracians who can be identified by their distinctive cloaks and fox-skin headgear. *c.* 440. 51 cm

141 (*below*) Marble three-figure relief. Orpheus and Eurydice. Orpheus, in Thracian dress, parts with Eurydice, whom Hermes is about to lead back to Hades. Roman copy of a Greek original *c.* 420 which was part of a set of four that were probably part of an Athenian monument. 1.20 m

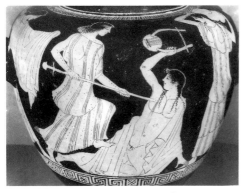

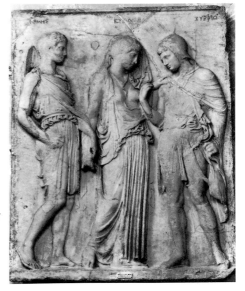

142 (*above*) Attic red-figure stamnos by Hermonax, from Nola. Death of Orpheus. Women with rocks and a spit attack Orpheus, who tries to defend himself with his lyre. *c.* 460

143 (*below*) Attic red-figure cup. Oracular head of Orpheus. A young man with a stylus and writing tablet sits on a rock and records the words of the oracular head of Orpheus while Apollo with a laurel branch looks on. *c.* 400

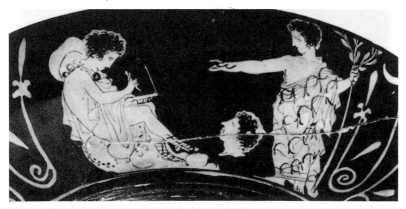

Chapter Five

PERSEUS; BELLEROPHON

The imposition of chronology on the generations of heroes is an unstable business at best. However, by most accounts Perseus is one of the earliest – three generations removed from Herakles, the greatest of Greek heroes, who was himself a generation removed from the heroes of the Trojan war. Perseus is also one of the earliest mythological figures to appear in Greek narrative art, in his beheading of Medusa. Other parts of the Perseus story are shown primarily in 5th- and 4th-century art.

Akrisios, King of Argos, received an oracle that his daughter would give birth to a son who would kill him. In an attempt to protect himself and avoid his fate, he locked his daughter, Danae, in an underground chamber of bronze to keep her from men. Zeus, however, had fallen in love with her and came to her as a golden rain that streamed down from the roof of her chamber. From this union Perseus was born.

Danae receiving the golden rain is shown on a few Attic red-figure vases from about 470 to the early 4th century, on two Boeotian red-figure vases from the end of the 5th century [144], on a few gems and rings [145] and on a mirror from the same period. On all she eagerly awaits the drops to reach her.

When he discovered some years later that Perseus had been born, Akrisios was unwilling to believe Danae's explanation that Zeus was the father. He put mother and child into a chest which he then had thrown into the the sea. Eventually it washed ashore on Seriphos where it was found by Diktys, brother of the king, Polydektes.

Danae and Perseus with the chest is the subject of more than a dozen Attic red-figure vases from the 5th century. On several of them, mostly from the first half of the century, Akrisios observes them as they stand in or by it [146]. On several others from the middle of the century, the discovery of the chest by Diktys on Seriphos is shown. The Perseus theme was the subject of several tragedies (and satyr plays) during the 5th century and, given the iconographic similarities between the scenes with the chest and the grouping of them within the century, it is possible that the stage provided the inspiration.

Perseus and Danae were taken in by Diktys and it was there that Perseus grew to manhood. Later the unscrupulous king, Polydektes, who lusted after Danae and saw Perseus as his only obstacle, held the youth to a foolish boast that he could get for him the head of the Gorgon Medusa, which to look upon turned

men to stone. Polydektes warned him that he would take Danae captive if he did not succeed.

Of course, Polydektes assumed that Perseus would fail, but under the tutelage of Hermes and Athena (according to most sources) Perseus went to the three Graiai, daughters of Phorkys and sisters of the Gorgons. These old women, grey at birth, shared one tooth and one eye amongst themselves. These Perseus stole and refused to give back until they told him the way to the nymphs who kept the cap of Hades (which made the wearer invisible), winged sandals (for flying), and the bag (*kibisis*) to hold the head. These he eventually obtained and Hermes gave him a sickle (*harpe*) of adamantine.

Perseus appears with the Graiai on a few Attic red-figure vases, from the middle to the end of the 5th century [147]. Only the absence of eyes distinguishes them from other women. In these scenes Perseus already has his hat, boots and kibisis, so it seems that the painters may be drawing on a different source from the ones that have come down to us. On a Chalcidian amphora from soon after the middle of the 6th century, Perseus with an unarmed Athena by him is about to receive from the nymphs the boots, hat and bag they hold [148].

The Gorgons, named Sthenno, Euryale and Medusa were daughters of Phorkys and lived beyond Ocean (Okeanos) in a land toward Night. Of the three sisters, only Medusa was mortal and according to Hesiod, the earliest surviving source for the story, she had slept with Poseidon and was pregnant by him.

Perseus came upon the Gorgons while they were sleeping and with the aid of Athena and Hermes (according to later sources) cut off Medusa's head and put it in his kibisis. From her severed neck Chrysaor, who was later the father of Geryon, and the winged horse Pegasos sprang out, and the awakened sisters pursued Perseus through the air as he flew away.

The earliest depiction of this part of the Perseus myth is on a Proto-attic amphora from the second quarter of the 7th century [149]. Medusa, beheaded, lies amid flowers while her sisters start to pursue Perseus who rushes off to the right, but between them and him stands a stately Athena. The heads of the Gorgons are the most remarkable things about the scene. There is almost nothing human about them; rather, they are modelled on a type of bronze cauldron with animal or monster attachments that first appeared in Greece not long before this vase was made. This form for the Gorgon's head is unique, as is the form of the Gorgon on a relief pithos, found in Boeotia but probably Cycladic, made not much later than this vase. There she is a frontal-faced woman with the body of a horse [150]. She bares her teeth as Perseus, the kibisis over his shoulder, reaches out with a sword, about to behead her. Gorgons with horse-bodies do appear on some East Greek gems a century later, but on these the head is what had, by then, become the conventional form.

The craftsmen who painted the Proto-attic amphora and made the relief pithos clearly knew the story of Perseus and the Gorgons. They each knew that

the Gorgon was a monster and with no models to turn to at this early stage in Greek narrative art, they each created their own visions of the monster.

By the end of the 7th century conventions had evolved on mainland Greece for depicting the Gorgon, and it is likely that this process took place with painters in Corinth where apotropaic lion-masks may have served as the model. Her round face has large bulging eyes, the huge mouth grins, baring teeth and sometimes tusk-like fangs. The tongue sticks out, the large nose is flattened against her face [151]. The ringlets across her forehead are sometimes depicted as snakes and often she is bearded.

The gorgoneion, as the gorgon mask is called, was a popular decorative device throughout the Archaic period and could appear on bronze kraters and painted vases, on architectural terracottas and even in sculpted pediments. As a rule the early gorgoneia are more convincing than the later ones – by the end of the 6th century some are almost clown-like. Then, a new gorgon type appears, probably created in the second half of the 5th century, where the face is that of a beautiful woman [152].

The pursuit of Perseus is the subject of painted clay metopes from a temple of Apollo at Thermon near Corinth dating to the second half of the 7th century. On one panel Perseus flees, winged boots on his feet, cap on his head, the kibisis with the head in it on his back, and a sword at his side (the curved harpe only appears much later). On another panel the Gorgon sisters pursue him and on a third there is a gorgoneion. Pausanias tells that the pursuit was the subject on the Corinthian Chest of Kypselos.

The pursuit appears on some of the earliest Attic black-figure vases from the last quarter of the 7th century, and it is very popular during the first half of the 6th. The actual beheading appears around the middle of the century and both scenes appear occasionally on red-figure vases [153]. The beheading is depicted on a mid-6th-century shield band and on one of the metopes from a late 6th-century temple at Selinus [154].

Medusa running by herself first appears on a clay relief from Syracuse dated to the second half of the 7th century, and a similar figure is at the center of the pediment on the Temple of Artemis at Corfu dated to about 580 [155]. Both Syracuse and Corcyra, it is worth noting, were Corinthian colonies. On the Corfu pediment entwined snakes form her belt and there are snakes at her shoulders as well. On both, the winged horse Pegasos is at her left, and on the Corfu pediment the young Chrysaor is at her right. That Chrysaor and Pegasos can appear here though they were born after Medusa's decapitation is a good example of the lack of concern with time and sequence in Archaic narrative art.

The running Gorgon appears on shield bands from the end of the 7th century to the middle of the 6th – once with Pegasos and Chrysaor. She also appears on Corinthian, Laconian, Attic and Chalcidean vases. The figure of Medusa, with Pegasos and Chrysaor [156] posed at her side, recalls the depictions of Artemis as Potnia Theron discussed in the previous chapter, particularly on the Corfu

pediment where she is also flanked by panthers. In fact, on a Rhodean plate from the late 7th century, a Gorgon is shown as Potnia (or Potnia as a Gorgon) holding two geese by the neck [157]. The Mistress of Animals is a powerful and frightening figure and it is possible to see how the imagery for the two could be conflated.

On his way home, according to Apollodorus and other late sources, Perseus came upon the beautiful Andromeda chained to a rock. She was the daughter of King Kepheus of Ethiopia and his queen, Kassiopeia. The queen had boasted of her own beauty, comparing herself with the Nereids, and in angry response to this outrage, Poseidon sent a flood and a monster to ravage the land. Kepheus learned from an oracle that the only way he could appease the monster was by sacrificing his daughter to it, and thus he had her bound to the rock where Perseus found her. Having fallen in love with her at first sight, Perseus made an agreement with Kepheus that he could have Andromeda as his wife if he killed the monster. Kill it he did, either with a sword or by showing it Medusa's head, but when he tried to leave with Andromeda he discovered resistance from Phineus, brother of Kepheus, to whom she had earlier been promised. Phineus, too, was shown the Gorgon's head.

Neither Homer nor Hesiod even hints at knowing this silly story, nor does the 5th-century Pherkydes, who relates other elements of the Perseus myth, but both Sophocles and Euripides wrote plays on the theme. Evidence from vases shows that the story was current even in the 6th century. On a Corinthian amphora from the second quarter of the 6th century, Perseus throws stones at a monster (ketos) while Andromeda stands behind – all three figures are named [158], and the harpe held by the bearded man facing a monster on a Caeretan hydria suggests he too is Perseus (rather than Herakles, who also fights a monster) [159].

The subject next appears on several Attic red-figure vases from the middle of the 5th century where Andromeda, in Oriental dress, is bound, or about to be bound, to stakes [160]. On one of these she is named so there can be no doubt about her identity. These scenes may well have been inspired by Sophocles' play, but they are too early for Euripides' version which we know was first performed in 412. One Attic vase dating to about 400 may have been inspired by Euripides' play as may many of the South Italian depictions.

During the 4th century the subject is very popular with South Italian vase-painters. Some of these follow the Attic model with Andromeda bound to stakes or trees, others show her bound in front of a cave or grotto, and on a Campanian hydria from the middle of the 4th century she is shown bound to a rock [161], as later literary and artistic versions have her. Perseus is also shown attacking the monster with his harpe on some of these.

On his return to Seriphos, Perseus went to Polydektes to present the head, learning in the meantime of the king's abuse of his mother and Diktys. Perseus removed the head from the kibisis and, of course, when Polydektes gazed on it,

he too was turned to stone. This scene is depicted on a few Attic red-figure vases from the middle of the 5th century [162] and on a Campanian imitation of Attic red-figure.

Perseus finally gave the head to Athena who, according to Apollodorus, set it in her shield (while in the *Iliad* (5.741) it is said to be set in her aegis). The gorgoneion is a relatively common shield device on Attic vases, but it is no more often given to Athena than to any other warrior. After about 530, however, the gorgoneion does quite often appear on Athena's aegis on red-figure (and the occasional black-figure) vases and in sculpture.

The remaining parts of the Perseus story – his accidental killing of his grandfather Akrisios with a quoit, his rule of Tiryns and his founding of Mycenae – are not depicted in ancient art. However, one other group of scenes with Perseus, on South Italian vases, should be mentioned. In most of these Perseus, in the presence of startled satyrs (and sometimes Athena), holds up Medusa's head. Though we cannot know the precise meaning of these scenes, it seems clear that they were inspired by a lost satyr play that dealt with the beheading of Medusa. All of the vases date from the 4th century.

Finally, the myths of Bellerophon belong here because of his association with the winged horse Pegasos, offspring of Medusa and Poseidon. Homer, Hesiod and Pindar tell of his deeds, and Sophocles and Euripides made him the subject of plays now lost. He first appears in art before the middle of the 7th century and then occasionally appears in various forms on through the 4th century.

As Homer tells the story (*Iliad* 6.152–205) Bellerophon, the grandson of Sisyphos, King of Corinth, was granted beauty and virtue by the gods. But Anteia (more often called Stheneboia), wife of Proitos, King of Argos, fell in love with him, and when he rejected her advances she told the king that he had tried to rape her. The furious king then sent Bellerophon to his friend, the King of Lycia (elsewhere named Iobates) with a secret message to have him killed. Iobates ordered him to kill the Chimaera, a fire-breathing monster that was part lion, part goat and part snake, assuming, of course, that he would perish in the attempt. When Bellerophon succeeded here, the king ordered him to fight the Solymi, a particularly fierce tribe of warriors, and then the Amazons. When an ambush by the bravest Lycian warriors failed, Iobates finally decided to honour Bellerophon and gave him his daughter in marriage along with half his kingdom. Homer concludes his account with the comment that Bellerophon later became hated by the gods and wandered alone eating his heart out.

Homer does not mention the winged horse Pegasos, but Hesiod says that Bellerophon rode him when he killed the Chimaera. Pindar (*Oly* 13.64–69) tells of Bellerophon's harnessing of Pegasos with the aid of Athena, and elsewhere he tells of Bellerophon's attempt to fly up to heaven – the act that led to his fall. Sophocles wrote a play, *Iobates* of which virtually nothing survives, and Euripides wrote two plays, *Stheneboia* and *Bellerophon*. Of the former an outline remains, of the latter fragments.

Bellerophon's fight with the Chimaera first appears on two Proto-corinthian vases from the middle of the 7th century *[163]*. Bellerophon rides Pegasos toward a monster who is primarily lion, but has a goat-head growing from his back and a snake for a tail. Not much later than these is a plate from Thasos with a similar scene. The subject appears on several Attic black-figure vases from early in the 6th century, and on one of these the three parts of the Chimaera are more evenly distributed – the lion's body is joined at the shoulders by a goat protome, and it ends in the coils of a snake. The fight appears on a few other Attic vases down to about 530, on a Laconian cup (without Pegasos) and on a Chalcidian hydria. It then ceases to appear in art for nearly a century when it reappears in a few Attic red-figure works and later on South Italian vases.

The Chimaera alone, without any reference to the narrative scenes, appears as a decorative device (much as the Gorgon does). In addition to Attic and Corinthian vases, it appears on gems from the second half of the 6th century and on a contemporary shield band *[164]*, and as the coin type for Sicyon on the Peloponnese after the middle of the 5th century. Pegasos alone is the coin type for Corinth from the beginning of coinage there before the middle of the 6th century on through the 5th *[165]*, a device that was much copied.

Depictions of other parts of the Bellerophon story only appear on South Italian vases. The departure from Argos is shown on Lucanian, Campanian and Apulian red-figure vases from the end of the 5th century on through the 4th. Proitos hands Bellerophon a letter while often Stheneboia watches from a distance and Pegasos waits nearby *[166]*. On several Campanian and Apulian vases he is shown arriving in Lycia and being greeted by Iobates, who is sometimes shown in Oriental dress. It is likely that these scenes were inspired by Euripides' *Stheneboia*. Bellerophon's battles with the Solymoi and Amazons are not depicted in Greek art, nor is his attempt to fly up to heaven.

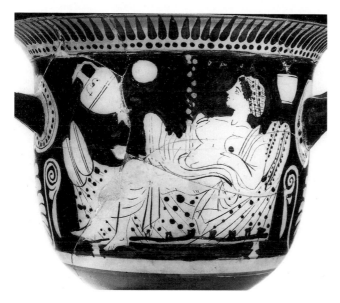

144 Boeotian red-figure calyx-krater from Boeotia. Danae and the Golden rain. Danae (named) lies back on her couch and bares herself to the shower of golden rain. *c.* 410

146 (*below*) Attic red-figure lekythos. Danae and Perseus. Perseus, already in the chest, looks up at Danae who holds an alabastron as Akrisios with a sceptre urges her to get in with her son. The elaborate decoration of the chest hints at what we have lost in ancient woodwork. *c.* 470. 40.5 cm

145 Silver ring. Danae (named) holds out her dress to catch the golden rain. An eagle above her symbolizes Zeus. *c.* 410. L. 2.1 cm

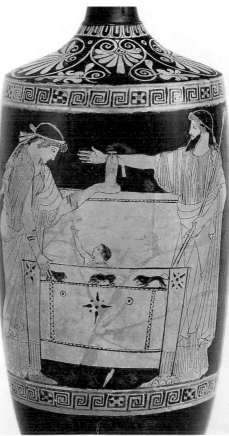

147 (*right*) Attic red-figure krater fragment by the Phiale P., from Delos. Perseus and the Graiai. Perseus, wearing winged boots, the kibisis thrown over his shoulder, steals away having seized the eye of the Graiai, one of whom still reaches out to her companion for it. The surviving Graia is a beautiful figure whose only anomaly is the absence of an eye. *c.* 430

148 (*centre*) Chalcidian amphora from Cervetri. Perseus, chaperoned by Athena (named but without attributes) receives winged boots, hat and kibisis from nymphs (inscribed Neides). *c.* 540

149 (*below*) Proto-attic neck-amphora from Eleusis. Perseus and the Gorgons. Medusa lies beheaded among flowers and her sisters pursue Perseus who is protected by Athena who stands between them and him. The various decorations around the running gorgons are filling devices. The painter has used a known type of bronze cauldron for the heads of the gorgons. *c.* 670

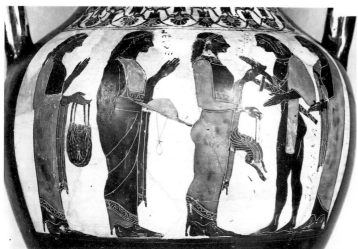

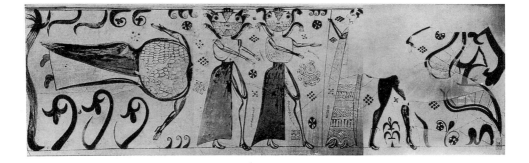

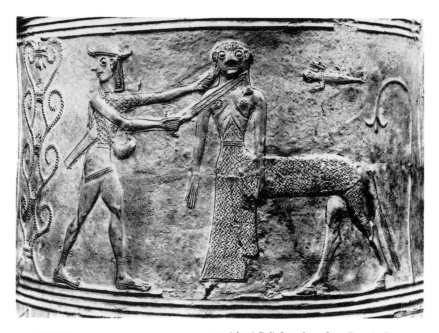

150 (*above*) Relief amphora from Boeotia. Perseus, wearing boots and hat and with the kibisis over his shoulder looks away as he beheads Medusa who has the form of a female centaur. *c. 660*

151 Attic black-figure plate by Lydos. Gorgoneion

152 Marble mask. 'Medusa Rondanini'. Roman copy of a 5th-Century work in which the gorgon had the sad face of a beautiful woman. 40 cm

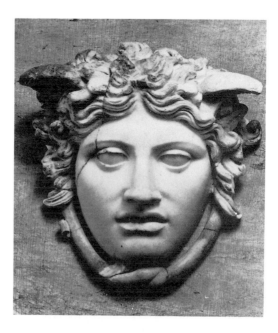

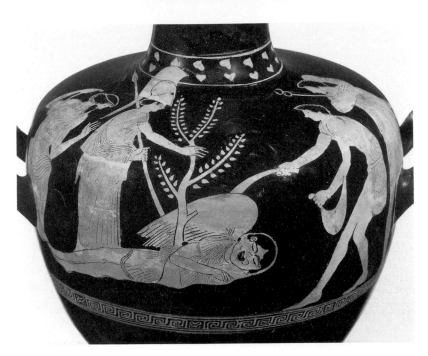

153 (*above*) Attic red-figure hydria. Perseus, harpe in one hand, kibisis in the other, stalks the sleeping Medusa under the tutelage of Athena and Hermes. The bearded figure seated to the left may be king Akrisios who is later turned to stone. *c.* 450. 44.4 cm

154 Limestone metope from Selinus. Perseus beheads Medusa who already holds the winged horse Pegasos. Athena, without attributes, stands beside him. *c.* 530. 1.47 m

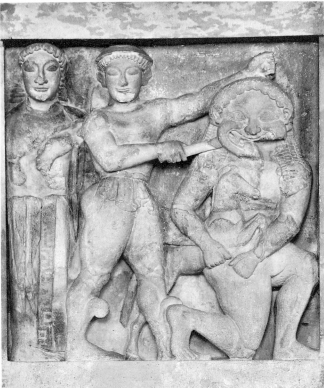

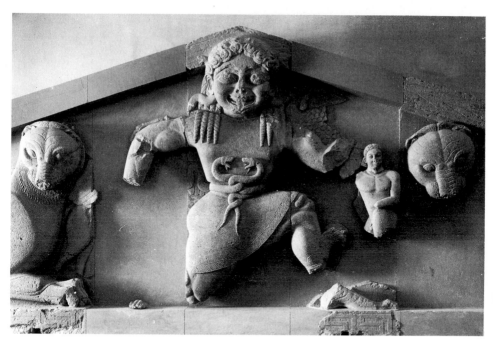

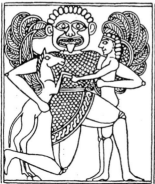

155 (*above*) Limestone pedimental group from the temple of Artemis on Corfu (see 95). Medusa, wearing a belt of snakes and running to the right, is flanked by Pegasos (most of whom is missing) and Chrysaor. *c.* 580

156 (*left*) Bronze relief, shield band panel from Olympia. Winged Medusa with Pegasos and Chrysaor. *c.* 620. 7.4 cm

157 (*below left*) Rhodean plate from Rhodes. Potnia Theron (Mistress of Animals). The Potnia, who holds two geese by the neck, has been given a gorgon's head. *c.* 600. D. 38 cm

158 (*below right*) Corinthian amphora from Cervetri. Perseus and Andromeda. Perseus, wearing his hat and boots, and with the kibisis over his shoulder, throws rocks at a ketos (sea monster) while Andromeda stands behind him. *c.* 560

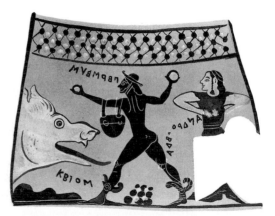

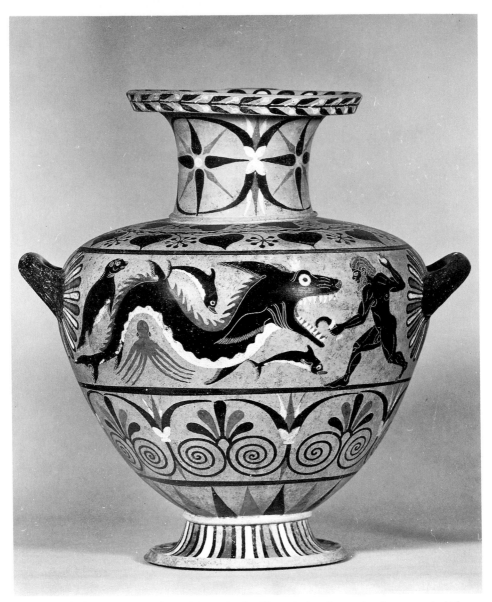

159 Caeretan hydria. Perseus (?) with a rock in one hand and harpe in the other attacks a ketos around which a seal, dolphins and an octopus swim. The man has also been identified by some as Herakles. *c.* 530. 40 cm

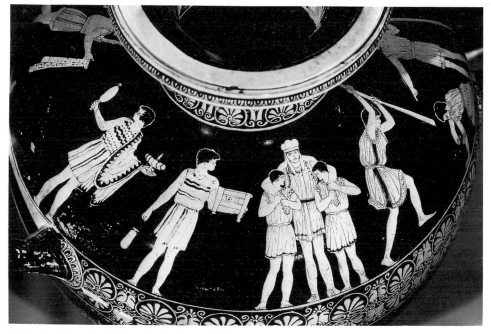

160 Attic red-figure hydria from Vulci. Servants hold Andromeda's arms while others carry her mirror, perfume (in a plemochoe) and jewellery box, and still others pound into the ground stakes to which she will be tied. To the far right (not shown here) her father Kepheus sits leaning on his staff grieving over her fate. Note the negroid features of the servants which point to the setting of the myth in Ethiopia. *c.* 430. 45.6 cm

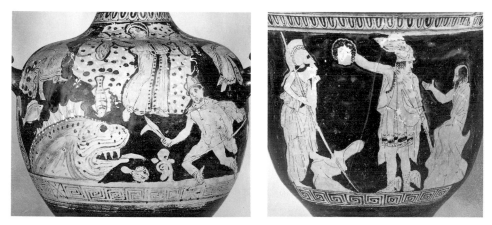

161 (*above left*) Campanian red-figure hydria. Perseus and Andromeda. Andromeda stands chained to a rock while Perseus, wearing a winged helmet, attacks the ketos with a harpe. Kepheus sits to one side, a woman to the other. Mid-4th Century. 36.5 cm

162 (*above right*) Attic red-figure bell-krater. Perseus and Polydektes. Perseus, wearing winged boots and helmet, holds up the gorgon's head and a balding Polydektes, who gazes on it, has already started to turn to stone (from the bottom up). Athena looks on impassively. *c.* 430

163 Proto-corinthian aryballos from Thebes. Bellerophon and the Chimaera. Bellerophon, with a spear, riding the winged horse Pegasos, attacks the Chimaera, which has the body of a lion, snake-tail, and a goat head growing from its back. The filling devices around the figures are characteristic of Proto-corinthian vase-painting. *c.* 650

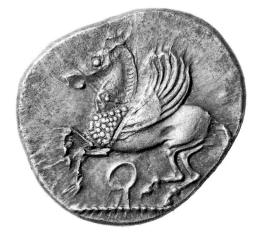

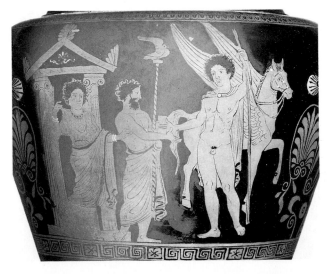

164 (*above left*) Bronze relief, shield band panel from Olympia. Chimaera. *c.* 560. 7.5 cm

165 (*above*) Silver stater from Corinth. Pegasos. The archaic letter koppa (for Corinth) appears below the horse. *c.* 550

166 (*left*) Apulian red-figure stamnos. Proitos, with an elegant sceptre, hands Bellerophon the letter while the treacherous Stheneboia stands in front of the entrance to the palace. Pegasos waits behind Bellerophon. *c.* 400

Chapter Six

HERAKLES

Herakles was the greatest of the Greek heroes, alone worshipped as both a hero and god, the common property of all Greeks. Though closely connected with Peloponnesian centers, he was born in Boeotian Thebes and in historical times he was tremendously popular in Athens – particularly during the latter half of the 6th century. As the pre-eminent Greek hero, he served as a kind of magnet over the centuries attracting a multitude of stories, many of which may have originally belonged to lesser, local heroes. So too, some visual images were borrowed from other sources to depict his deeds.

For almost every Herakles story several often quite different versions have survived, and since the major ancient sources for his life have been lost, it is not always easy to sort through the confusing array of antagonists and events. By Classical times the majority of the exploits had been organized (quite artificially) into three groups: the Labours (*athloi*), twelve in number and performed in the service of his overlord Eurystheus; the Deeds (*praxeis*) done independently and varying in number; and the Incidentals (*parerga*) that took place during the completion of the labours.

Popular attitudes toward Herakles changed over the centuries, and it is through the visual arts that many of these changes are seen most clearly. His heroic deeds were favorite subjects with Archaic artists in Athens and elsewhere on into the early years of the 5th century and they appear on large numbers of what might be termed private works (gems, shield bands, vases) as well as in public monuments (architectural sculpture). Attic black-figure vase-painters show him in the canonical adventures, but they also include him in many scenes for which no literary record survives and sometimes put him in scenes where he does not seem to belong – for example, observing the birth of his patron Athena. During the 5th century, however, his popularity as a subject in private arts rapidly decreases, but at the same time he is chosen as the subject of metopal groups on major public buildings in Olympia and Athens. It is also during the 5th century that Herakles becomes a favorite character in satyr plays on the Attic stage where the comic potential of the heroic is exploited, a dimension sometimes illustrated on Attic vases.

Toward the end of the 5th century and on into the 4th, there is a revival of interest in him as a subject on vases, but the emphasis is on his human rather than his heroic nature. Thus he appears in mildly romantic scenes amongst the

admiring Hesperides or Amazons, or he rides up into the heavens in a chariot driven by Athena while his funeral pyre, symbolizing his mortal suffering, still burns below.

Throughout our period Herakles' physique is unexceptional, and it is only his attributes or the context of the scene that allows him to be identified. In Attic art he almost always wears a lion-skin and carries a club and bow. On Laconian vases, however, he never wears the lion-skin but is sometimes shown as a warrior wearing a corselet. There, too, the club is his most common weapon. He is usually bearded in Archaic representations (and has exceptionally large eyes), but by the last decades of the 6th century (and in some earlier fights with the lion) he sometimes appears as a beardless youth. In the more romantic scenes from the late 5th and 4th century he is rarely bearded.

What follows here is a survey of the more important scenes in which Herakles appears. A sequence of events in his life (adapted from Apollodorus) is the basis of organization, but such a sequence should not be seen as rigid. Brief summaries of the stories include only those elements and variations relevant to the study of the iconographic traditions.

Elektryon, a son of Perseus and King of Mycenae, betrothed his daughter Alkmene to his nephew Amphitryon and handed over his kingdom to him while he went off to avenge the death of his sons, killed by the Teleboeans. However, before the king could leave, Amphitryon accidentally killed him and was banished to Thebes. Alkmene went with him but refused to consummate their marriage until he avenged the death of her brothers. Meanwhile, Zeus took a fancy to her and came disguised as Amphitryon on the night he was to return from completing his revenge. Amphitryon, too, slept with Alkmene during that extraordinary night (extended by Zeus to three times the normal length) and eventually gave birth to twins – Herakles, the son of Zeus, and Iphikles, the son of Amphitryon.

Pausanias tells that on the Chest of Kypselos Zeus was shown coming to Alkmene as she took hold of a cup and necklace he held out to her, implying she was bribed rather than tricked, but no depictions of this scene have survived.

Euripides wrote a play entitled *Alkmene* and it is probably the source of 4th-century South Italian depictions of her seated on an altar with Amphitryon about to light the fire laid in front of her [167]. According to this story, Amphitryon suspected that Alkmene had received another mortal lover, and when he threatened her, she fled to an altar. He was determined to burn her off it, but Zeus intervened, throwing a thunderbolt and dowsing the flames with a shower. The scene appears on an Apulian krater from about 400, a mid-4th-century Sicilian krater, and on Campanian amphorae and a Paestan krater from later in that century.

Hera's hostility is one of the themes that runs through many of the Herakles stories, starting with his delayed birth that made him subservient to his cousin Eurystheus. Soon after his birth she sent snakes to destroy him, but the infant

strangled them with his bare hands. This subject appears on a few Attic red-figure vases from the first half of the 5th century where Iphikles cringes and Alkmene and Amphitryon rush to their aid [168]. Athena, Herakles' constant protectress and patron in Attic art, stands by watching. Pliny (35.61) tells that a similar scene (probably without Athena) was painted by Zeuxis of Herakleia around 400. The two infants, Herakles with the snakes and Iphikles cringing, was a coin type for Cyzicus during the early 4th century, while the infant Herakles alone with the snakes was a coin type for Thebes soon after the middle of the 5th century. At the end of the 5th century, the latter type reappeared in Thebes and was also the common obverse on coins of several East Greek cities that had formed an alliance, perhaps prompted by the Spartan, Lysander [169]. As mentioned earlier, Greek artists usually depicted children as small adults prior to the middle of the 5th century, and it is only on the later coins that a convincing infant is shown.

Of Herakles' formal education, only one episode is shown in Greek art, on several red-figure vases from the first half of the 5th century. Linos, sometimes said to be a son of Apollo or a brother of Orpheus, was the music teacher for both Iphikles and Herakles. On one side of a skyphos from *c.* 470, he is shown instructing an attentive Iphikles, while on the other side an old crone with a lyre follows a less docile Herakles, presumably to his lesson [170]. The music lessons ceased when Linos, on one occasion, struck Herakles for his inattention. The angry youth jumped up and brained his teacher with a stool, killing him – an incident that appears on several red-figure vases [171].

It is worth noting that Herakles must have learned his music since he is occasionally shown on Attic black-figure vases mounting a platform (*bema*) with a kithara, the stringed instrument often played by Apollo and by professional musicians.

When he was eighteen, Herakles settled a quarrel for Creon, King of Thebes, and in return was given the hand of his eldest daughter, Megara. After some years and several children (chronology and number varies with different authors) Herakles was driven into a fit of homicidal madness by Hera and slaughtered all of his children (and in some versions Megara as well). The only depiction of these events is on a 4th-century Paestan krater, signed by the painter Asteas, where Herakles is about to dash a child to the ground amidst the rubble of burning furniture, and Megara flees through a door to the right [172]. According to Euripides, these events took place after Herakles had completed his labours, but Apollodorus put them before and says that his servitude under Eurystheus as well as the labours were the result of an oracle given him at Delphi where he had gone to ask where he should live the rest of his life. He was told that if he completed the servitude and the labours he would be immortal. The more common reason for both was jealous manipulation by Hera.

The earliest representations of all twelve of the canonical labours are the mid-5th-century metopes from above the inner porches on the Temple of Zeus at

Olympia [173]. Pausanias (5.10.9) mentions the subjects of six from the west end and five from the east (he omits Kerberos), but it is not certain that the order he gives for them was the original order. For the following discussion Apollodorus is used as the authority for the order of the labours – an order which is, for the most part, accepted as the canon. The first six labours are usually called the Peloponnesian Group for obvious reasons.

The first task Eurystheus set for Herakles was to kill a lion that was ravaging the countryside around Nemea. According to Hesiod the lion was the offspring of the dog Orthos and the monster Echidna, and according to later sources it was invulnerable. After discovering that his weapons were useless against the lion, Herakles wrestled with it, finally strangling it. Thereafter he wore the skin of the lion as a cloak and, together with his club, it his most common attribute.

On an Attic late-geometric tripod pyxis from the second half of the 8th century a man with a sword and spear is shown in single combat with a lion [174]. A similar scene appears on a roughly contemporary Boeotian fibula. The scene is clearly borrowed from an earlier eastern model, where a hero king fighting a lion was a common theme [175]. Perhaps the image was borrowed to depict an already existing story of Herakles – or, as at least one scholar has suggested, perhaps the story of Herakles and the lion was invented to explain the randomly borrowed image.

Whatever its origin, this is the labour most often depicted in ancient art, with the greatest number from the Archaic period. Herakles fights the lion on shield bands found at Olympia from the last part of the 7th century on through the middle of the 6th. The first vase on which the scene certainly appears is an early Corinthian alabastron from the end of the 7th century. The subject also appears on Laconian, Ionian, Caeretan and Chalcidian vases from the 6th century, but by far the greatest number is on Attic vases. More than seven hundred black-figure vases with the subject have survived and nearly one hundred red-figure vases, primarily from the late Archaic period. It is only rarely a subject on vases after the first quarter of the 5th century.

The early version of the fight shows Herakles standing facing the lion that stands upright [176]. After about 530 he often wrestles with it on the ground, their bodies extending in opposite directions, and in these scenes the lion often paws at him with a hind leg [177]. On at least one vase Herakles is shown throwing the lion over his shoulder. In all versions (and in many other labours as well) his patron Athena, and his companion and nephew Iolaos, holding his useless weapons, often observe.

The version shown on the metope from Olympia is unusual. There a beardless Herakles rests with one foot on the dead lion while Athena and Hermes stand on either side. The only other examples of this pose are from 5th-century gems, presumably later than the Olympia metopes. This is the only one of the twelve metopes on which he appears beardless; it is the sculptor's way of showing that this was the first labour, and is a device sometimes also used by Archaic vase-

painters in their depictions of the scene. The subject appears on only a very few South Italian vases.

Herakles' second task was to kill another of Echidna's offspring, the Hydra who was fathered by Typhon and lived in a swamp near Lerna. Hesiod does not describe the Hydra, but gives its lineage. Apollodorus tells that it had a huge body and nine heads, one of which was immortal, and that it was ravaging the countryside.

Herakles went to Lerna in his chariot driven by Iolaos. After flushing the monster into the open he found that each time he cut off one of its heads, two grew to replace it, and on top of that, Hera sent a great crab to bite his ankles as he fought. This one time he asked Iolaos for help and according to some versions had him cauterize the stumps as he cut off the heads. After he finally cut off and buried the immortal head he dipped his arrows in the Hydra's blood, a particularly potent poison which would later cause him much suffering.

The earliest depictions of this labour are on Boeotian fibulae from the end of the 8th century [178], and like the early Greek depictions of a hero fighting a lion, there can be little doubt but that they are derived from an Eastern prototype. On these early examples Herakles and Iolaos fight the Hydra and even Hera's crab appears.

It is in Corinth, however, that the canonical iconography for the scene is fully developed at the end of the 8th century, and the scene appears more than a dozen times on Corinthian vases from the late 7th century and on through the 6th [179]. Herakles and Iolaos fight the monster while Athena stands to the side by a chariot. On several vases she holds a small oinochoe which, it has recently been suggested, was to collect the poison blood of the Hydra for Herakles' arrows. Often the crab attacks.

Pausanias tells that Herakles and the Hydra were shown on the Chest of Kypselos at Olympia. While describing the depiction of the funeral games of Pelias on the chest he writes (5.17.11):

Iolaos, who of his own free will shared in labours of Herakles is shown on his chariot after he has won a victory. After this the games in honor of Pelias come to an end and the Hydra is shown . . . being shot at with a bow by Herakles as Athena stands by.

With the surviving Corinthian examples in mind (the Chest too was presumably made by Corinthian craftsmen) scholars have pointed out that Pausanias probably misunderstood the scene and that Iolaos and the chariot go with the Hydra scene rather than with the funeral games.

This labour appears several times on Laconian vases from the first half of the 6th century and in a particularly lively version on a Caeretan hydria c. 530 [180].

In Athens it was the subject of an early 6th-century pediment on the Acropolis, where it followed the Corinthian form. It appears on black-figure vases mainly from the second half of the 6th century and on a few, primarily Archaic, red-figure vases. Both on the black-figure and red-figure vases the

scene is often abbreviated – the crab and chariot often missing. On the mid-5th-century metope from Olympia, Herakles alone fights the Hydra. The subject does not appear on South Italian vases.

According to Apollodorus, the third task Eurystheus set for Herakles was to bring to him alive a hind with golden horns that was sacred to Artemis. Such sexual ambiguity in animals is not unusual in Greek art – Io the cow is often shown as a bull. Herakles hunted the Keryneian hind, named for a river in the Peloponnese, for a year before he finally wounded it with an arrow and was able to capture it. However, as he was carrying the deer back to Mycenae, Artemis and Apollo stopped him and would have taken it away from him had he not convinced them of the justice of his cause. According to Euripides, Herakles killed the deer.

The iconographic evidence for this myth is less than straightforward. A warrior attacks a deer on a Boeotian fibula from the end of the 8th century. The depiction of Herakles fighting the Hydra on the other side of the same fibula suggests that this too may be the hero, and if so, capturing the hind. However, the first certain depictions of the subject are on Attic black-figure vases nearly two hundred years later. On one vase from soon after the middle of the 6th century, Herakles breaks off the deer's horns, clearly a different version of the story [181]. On a few black-figure vases and on one late Archaic red-figure vase he grasps it by the horns, and this is presumably what he is doing on a metope from the Treasury of the Athenians at Delphi, c. 500, [183] and on the metope from Olympia. As mentioned in Chapter 2, Apollo and Herakles struggle over a deer – as over the tripod – on several vases, and this scene may refer to the meeting described by Apollodorus. Depictions of this labour do not appear in non-Attic works from our period.

Herakles' fourth task was to bring alive to Eurystheus in Mycenae a great boar that was ravaging the countryside around Mount Erymanthos. On his way to find the boar he was entertained by the centaur Pholos, who fed him and, at Herakles' request, gave him wine from a great pithos that was the common property of all the centaurs. The smell from the open jar attracted the other centaurs who attacked Herakles. He routed them, of course, but in the process fatally wounded the wise centaur Chiron with an arrow dipped in the Hydra's blood. Pholos too died, after dropping one of the poisoned arrows on his foot. Herakles' subsequent capture of the boar follows this episode as something of an anti-climax, and even ancient artists had difficulty making it exciting. In fact, most chose to show it in a comic light.

Various stages in the capture of the boar are shown on a sizeable group of Attic black-figure vases from the second half of the 6th century. Sometimes he picks it up by its hind feet and pushes it like a wheelbarrow [182], or lifts it, his arms around its middle, or he carries it on his shoulder. Athena and Iolaos often observe. It may be Herakles who carries a boar on his shoulder on fragments of a painted terracotta metope from the late 7th century temple at Calydon.

In another, more interesting, scene with a longer life, Eurystheus is shown cowering in a great pithos buried in the ground as Herakles stands over him with the boar on his shoulder, threatening to drop it. Though popular with Attic vase-painters, particularly during the second half of the 6th century, the scene was probably not invented there. All the elements of it appear on a mid-6th-century Laconian cup and on shield bands; it was the subject of a metope from the contemporary temple at Foce del Sele near Paestum [184]. Nearly a century later it appears on one of the metopes from Olympia and soon thereafter on a metope from the Hephaisteion in Athens. It does not appear on Attic vases after about 500 nor is it a subject depicted by South Italian vase-painters.

Of the Pholos episode, only the meal and the attack and rout of the centaurs is shown in ancient art. The earliest example is on a Corinthian skyphos from early in the 6th century [185]. Herakles rushes out of a cave brandishing firebrands at fleeing centaurs while Pholos stands at the mouth still holding his cup. Behind him is a pithos and above it hang Herakles' quiver and bow, showing that he was resting when the centaurs attacked. Pausanias says that Herakles shooting the centaurs was shown on the Chest of Kypselos.

The attack is the subject of metopes on the mid-6th-century temple at Foce del Sele and of a later frieze on the Temple of Athena at Assos [186]. On both of these Herakles pursues fleeing centaurs with his bow while Pholos watches.

During the second half of the 6th century, Herakles and Pholos at the pithos is a popular subject with Attic black-figure vase-painters, and it continues to appear on red-figure vases down to the middle of the 5th century [187]. Herakles' fight with the centaurs also appears – he alone amongst many centaurs – and is not to be confused with either his fight with Nessos or the Centauromachy following the wedding of Peirithoos.

The fifth labour imposed by Eurystheus was to clean in a single day the stable of Augeas, King of Elis, who had vast herds of cattle. Herakles accomplished this task by diverting the rivers Alpheus and Peneus through the stable. The only surviving representation of this from our period is the metope from Olympia [188]. There, under the direction of Athena, Herakles breaches the walls of the stable with a long crowbar to let the waters in.

The sixth labour, and the last of the Peloponnesian group, was to rid the woods around the lake near Stymphalos in Arcadia of a flock of pesky birds (man-eating according to Pausanias!). Athena gave Herakles bronze *krotala* (castanet-like clappers often used by komasts and by maenads in Dionysian scenes) which had been made by Hephaistos. With these he frightened the birds into the air and then shot them.

It has been argued that the man strangling a bird on a late-8th-century Boeotian fibula (mentioned above under Herakles and the lion) and on a contemporary geometric oinochoe is Herakles with the Stymphalian birds. However, the lack of attributes and the two centuries before the scene reappears, raise questions about this identification. An unmistakable Herakles appears

fighting the birds with a sling or a bow or club on a few Attic black-figure vases from soon after the middle to the end of the 6th century [189]. On the metope from Olympia he presents birds to Athena who sits on a rock [190]. The birds have disappeared, and it is only through Pausanias' mention of the labours shown in the metopes that we can, through a process of elimination, identify this one.

The first of Herakles' extra-Peloponnesian labours took him to Crete where he captured a great and savage bull, which he then took back to Mycenae. After he had shown it to Eurystheus, he let it go, and according to some versions, it made its way to Marathon where Theseus later subdued it (see Chapter 7).

The struggle with the bull first appears on fragments of Laconian cups from about 550. One is quite well preserved and shows a naked man rushing forward and grasping a bull around the neck [191]. Though there are no attributes, there can be little doubt but that this is Herakles. The subject then appears on more than two hundred Attic black-figure vases, almost all from the last third of the 6th century or early in the 5th. A great many of them are poor quality lekythoi. Often it is only the quiver and bow hanging nearby that let us distinguish depictions of Herakles and the Cretan bull from depictions of Theseus and the bull of Marathon. The subject also appears on about a dozen red-figure vases, mostly late Archaic.

In another scene that appears on Archaic Attic vases Herakles peacefully leads a bull to sacrifice. This scene is not connected with the Cretan bull episode and should not be confused with it [192]. Sometimes the altar appears, or sometimes Herakles carries sacrificial knives or spits.

The metope from Olympia where Herakles swings his club at the bull is the only sculptural work from the Archaic or Classical period that shows the subject, but a similar scene appears on the obverse of coins from Selinus in Sicily made soon after the Olympia metope [193]. The capture of the bull also appears on a few South Italian (Lucanian and Apulian) vases from the 4th century where Nike and Athena look on.

As his eighth labour, Herakles was sent to Thrace to bring back the man-eating mares of Diomedes, a son of Ares who was King of the Bistones. He went alone or with a group of warriors, killed Diomedes, either in battle or by feeding him to his horses, and successfully brought the mares back to Mycenae. In some versions a companion, Abderus, is eaten by the horses, and in a recently published fragment from Pindar, Herakles feeds the horses their groom as he prepares to take them.

Herakles with the horses of Diomedes appears on a few Archaic Attic vases. The earliest are cups (c. 520) with similar iconography. On the inside of one cup, black-figure on a coral-red ground, Herakles struggles with a single stallion (again the confusion over the sex of some animals in myth) [194]. From the mouth of the stallion the head and one arm of a youth protrude. On one side of the other cup, which is red-figure, an arm hangs from the mouth of the single

horse Herakles subdues; on the other side Diomedes is shown running, presumably to rescue his horses.

A few decades later a less brutal version of the myth is depicted on a black-figure lekythos with a white ground. There Herakles struggles with four winged horses. All three of these vases are earlier than the Pindar fragment which is the earliest surviving literary reference to the myth.

Though little of the metope from Olympia survives, it is clear that Herakles struggled with a single horse there, as he did also on a metope from the Hephaisteion. Nearly two decades later the horses he leads on an Attic cup must be the horses of Diomedes, as must those on an Apulian red-figure oinochoe a century later, but clearly these vases have no iconographic connection with the earlier scenes.

The ninth task Eurystheus set was to bring him the belt of the Amazon queen, Hippolyte. The Amazons were a tribe of warrior women who lived at the outer reaches of the known world (when given an actual geographical location, usually said to be on the Black Sea). Again Herakles was either alone when he went to the land of the Amazons or with an army. Once there, he either killed or did not kill Hippolyte, but he did manage to get the belt.

The earliest depiction of a warrior fighting an Amazon is on a terracotta votive shield from about 700, but the warrior has no distinguishing attributes and there is no particularly good reason to call him Herakles. Both Achilles and Theseus are also often shown in such fights.

The earliest certain depiction of Herakles in this scene is on a Corinthian alabastron from the end of the 7th century where he and his two companions are named, as are the three Amazons they fight. But the chief Amazon is named Andromeda, not Hippolyte, and when she is named on later Attic vases, she is Andromache [195]. The naked warrior with a sword pursuing Amazons on a Laconian cup (c. 560) is probably Herakles, and it has been suggested that he is reaching for the belt. This seems unlikely, though, since the belt does not figure in any of the hundreds of other Archaic depictions of the scene. The visual representations of the myth of Herakles appear nearly two centuries before the earliest surviving literary source and depict a story different from those sources in significant ways.

Herakles and the Amazons is, after his fight with the lion, the second most popular labour with Attic black-figure vase-painters, appearing on nearly four hundred vases. In single combat or in the midst of a mêlée, he wears his lion-skin and fights with a sword or his club. The Amazons are usually dressed as hoplites, though later they are shown as archers in Scythian dress and still later as Persians. Their weapons are usually spears and bows, and later sometimes axes.

The popularity of the story reaches its peak with vase-painters around 525 and decreases rapidly after about 500. It is the subject of relatively few Attic red-figure vases, mostly Archaic and none later than about 450. The nature of the scenes on red-figure vases changes little from those on black-figure.

Herakles fighting a single Amazon is the subject of metopes from the Treasury of the Athenians at Delphi, Temple E at Selinus [196], the Temple of Zeus at Olympia (as well as on a crossbar of the throne of Zeus inside the temple) and of the Hephaisteion at Athens. At the beginning of the 4th century Herakles and an Amazon comprise the central group of the frieze from the Temple of Apollo at Bassae [197].

Another version of the myth appears on South Italian vases alongside a few examples of the traditional fight. On nearly a dozen Lucanian, Campanian and Apulian red-figure vases from about 430 to the last quarter of the 4th century, Herakles is shown in a peaceful encounter with an Amazon, and in some she hands him the belt mentioned in the literary versions of the story [198]. The scene does not appear in Attic art from our period.

During his return voyage to Mycenae after his encounter with the Amazons, Herakles came upon Hesione, the daughter of King Laomedon of Troy, chained to a rock and about to be devoured by a sea monster. Poseidon, who had built the walls of Troy, sent the monster to ravage the countryside when Laomedon reneged on payment. An oracle had told that the monster could only be appeased if the king's daughter were sacrificed to it. All of the surviving sources for this story are late, and its similarities with the Perseus and Andromeda story led some scholars to see it as a late conflation.

Iconographic evidence shows, however, that the story was known at least as far back as the mid-6th century. It first appears on a Corinthian krater (c. 560) where Herakles shoots at the monster with his bow while Hesione throws rocks at it [199]. On an Attic black-figure cup a decade or two later Herakles is shown about to cut out the tongue of a huge monster while Hesione stands behind him. It is also possible that the hero fighting a sea monster on a Caeretan hydria mentioned in Chapter 5 may be Herakles rather than Perseus [159].

For his tenth labour Herakles was sent to Erytheia in the far West to get the cattle of Geryon, a formidable three-bodied warrior, who was a son of Chrysaor, offspring of Medusa, and Kallirhoe, daughter of Okeanos. The herdsman Eurytion guarded the cattle with the help of Orthos, a two-headed dog, offspring of Typhon and Echidna. Hesiod told the tale in the 8th century and Stesichoros wrote a long poem on the subject in the 6th.

On his long journey Herakles was at one point angered by the heat of the sun and raised his bow to shoot at it. Impressed by his audacity, Helios gave him a golden bowl in which to cross the sea. Once at Erytheia, Herakles killed Orthos, Eurytion, and finally Geryon, loaded the cattle into the bowl and sailed back across the ocean. After returning the vessel to Helios, he made his way with the cattle back to Mycenae (encountering many adventures not depicted in the arts of our period).

Herakles watching Helios rise in his chariot appears on several Attic black-figure lekythoi from the end of the 6th century, and these may be connected with the challenge. Certainly connected are the scenes on a few other Attic

black- and red-figure vases from the last quarter of the 6th century and the first quarter of the 5th, where Herakles, looking very silly, rides across the sea by himself in a bowl [200].

The earliest depiction of Herakles and Geryon is a crude drawing on a Protocorinthian pyxis from the middle of the 7th century. There Herakles shoots at a warrior with three bodies joined together, and the rest of the frieze is filled with cattle and lions. The fight is also the subject of a fragmentary Corinthian cup from the beginning of the 6th century, and Pausanias says that it was depicted on the Chest of Kypselos.

On a recently published bronze relief from Samos from about 600, Herakles, with his sword, attacks Geryon who has three heads but only two legs (his torso is hidden by his shield) [201]. The dog Orthos lies beside him, an arrow in one of his two heads, and Eurytion lies behind him, his hand to his head where Herakles has presumably struck him. Behind Herakles are the cattle. The only other depictions of Geryon with a similar physique are on two Chalcidian vases from after the middle of the 6th century and on both of those he is also winged. On shield bands from the first half of the 6th century, Herakles fights Geryon with a sword [202].

The fight is very popular with Attic black-figure vase-painters around the middle of the 6th century and appears on more than seventy vases from the second half of the century. Herakles' weapon can be a bow, a sword, a club or a combination of these. Eurytion, Orthos and Athena are sometimes included. Geryon always has three heads and torsos on six legs. The subject appears on only a few red-figure vases, all from the last quarter of the century, but some of these are very fine depictions [204].

During the 5th century the subject only appears in architectural sculptures. It filled six metopes on the west side of the Treasury of the Athenians at Delphi (where the cattle, Iolaos and perhaps Eurytion were also shown), one metope from the Temple of Zeus at Olympia, and two from the Hephaisteion at Athens (Herakles with his bow and the fallen Eurytion in one, Geryon in the other).

On a Lucanian red-figure vase from the middle of the 4th century, Herakles fights a Geryon who has three faces on one head, and on a contemporary Apulian vase a fallen Geryon has two bodies attached to two legs. These pictures obviously have no iconographic connection with the earlier ones.

The eleventh task Eurystheus set for Herakles was to bring him golden apples, a wedding gift from Gaia to Hera, which grew in the garden of the Hesperides at the outer reaches of the world (usually the far West). In the course of this labour Herakles had several adventures that appear with varying degrees of frequency in ancient art.

To find the way to the garden of the Hesperides he first had to catch Nereus, the old man of the sea. He came upon the old man asleep and clung to him as he changed himself into various animals and even into water and fire in his attempt to escape. The earliest depiction of this subject is probably that on an island gem

from the last quarter of the 7th century where Herakles wrestles with a man whose body ends in a fish-tail, though he has no other attributes. During the second quarter of the 6th century the subject appears on Corinthian and Attic vases and on a shield band from Olympia. On each the old man's body ends in a fish-tail, and his mutations are indicated by snakes or flames or animal heads erupting from his body or head. Before the middle of the 6th century another version appears in which Nereus is shown to be wholly human, and in these he sometimes carries a fish as an attribute [203]. The scene appears on black- and red-figure vases on through the first quarter of the 5th century. Soon after Nereus becomes wholly human, scenes in which Herakles wrestles with another fish-tailed man, Triton, appear on Attic black-figure vases [205]. No literary source for this fight has survived, and its occurrence is limited primarily to the second half of the 6th century.

Having learned the way to the garden of the Hesperides from Nereus, Herakles proceeded to Libya where he was forced to wrestle with the giant Antaios, son of Poseidon and Gaia, who was said to roof his father's temple with skulls of his victims. In later versions he was said to renew his strength through contact with his mother, Earth, and that Herakles defeated him by lifting him off the ground.

The fight between Herakles and Antaios appears on Attic black- and red-figure vases from the last quarter of the 6th century and first quarter of the 5th [206], and on one Argive shield band from the beginning of the 5th. It is always shown as an unexceptional wrestling match during our period – Herakles is not shown lifting him off the ground as he is in later art.

Herakles next went to Egypt where Busiris, another son of Poseidon, was king. After many years of drought, Busiris had learned through an oracle that he should make a sacrifice of a stranger each year to insure himself against such plagues. Herakles' arrival coincided with the need for a stranger and he was chosen for sacrifice and led to the altar. Realizing what was about to happen, Herakles broke away from his captors and killed both Busiris and his son.

The story is the subject of a few fragmentary Attic black-figure vases from the first half of the 6th century. The first complete scene is on a Caeretan hydria where a huge Herakles tosses about and tramples helpless little Egyptians at an altar [207]. The subject is most popular with Attic red-figure painters during the first half of the 5th century [208, 270]. It is always the scene at the altar that is shown, though servants of Busiris with instruments for the sacrifice may appear elsewhere on the vases. The scene at the altar appears on one Lucanian krater from the end of the 5th century, and on another slightly later krater Herakles attacks Busiris who sits on his throne, a version unknown elsewhere.

Herakles eventually reached the Caucasus where he freed the Titan Prometheus from his bondage, a subject already discussed in Chapter 4. According to one version of the myth, Prometheus told Herakles not to go to the garden of the Hesperides himself, but to send the Titan Atlas, Prometheus'

brother, in his place. Atlas, whose role it was to support the heavens on his back agreed to get the golden apples if Herakles would temporarily relieve him of his burden. When he eventually returned he was in no hurry to take back the heavens, and it was only through trickery that Herakles managed to unburden himself.

This is the version of the labour represented in the metope from the Temple of Zeus at Olympia [209]. Herakles stands supporting the heavens with Athena's aid, while Atlas approaches holding out the apples. On an Attic black-figure lekythos from the first quarter of the 5th century a similar scene appears, though Athena is not present. The earliest depictions of Herakles and Atlas are on a shield band [210] and an Attic black-figure cup signed by Nearchos, both from the mid-6th century. On both, Atlas has taken back the heavens and Herakles moves off with the apples, but we also know it was the subject on the Chest of Kypselos. Pausanias (5.11.5) also says that Atlas holding the heavens with Herakles beside him was the subject of a painting inside the Temple of Zeus at Olympia by Panainos, brother or nephew of Pheidias, but the subject is rare in surviving art from the 5th century.

In another version of the labour, which appears to be coeval with this one, Herakles goes to the garden of the Hesperides himself. There he kills a guardian snake said to be many-headed, another offspring of Echidna and Typhon, and picks the apples or persuades the Hesperides to pick them for him.

On a black-figure lekythos contemporary with the one mentioned above, Herakles, with the apples, walks away from the tree around which a two-headed snake is coiled [211]. This too is a rare scene in surviving art, though it was clearly known well in 5th-century Athens as a red-figure chous shows [212]. There a satyr with a club approaches a tree with a snake in it and pitchers hanging from its branches. Perhaps inspired by a satyr play, this is certainly a comic version of the labour.

During the late 5th century and on into the 4th, Herakles is often shown resting in the garden with the Hesperides gathered about him and with Eros sometimes hovering nearby [frontispiece, 213]. The tree with the snake is the key to the location, otherwise these scenes are simply romantic visions of an idyllic garden with an erotic overtone. Herakles seated by the tree with an Hesperid on either side of him was also the subject of one of the three-figure reliefs from the late 5th century mentioned in connection with Theseus and with Orpheus in Chapter 4, and not surprisingly, this romantic perception of the labour was also popular with 4th-century South Italian vase-painters.

The twelfth labour, the only one mentioned by Homer, was to bring up from the underworld Kerberos, a hound of Hades. This monster, yet another offspring of Echidna and Typhon, had three dog-heads and the tail of a dragon, and snakes grew from his body. Herakles descended to the underworld where he negotiated with Hades who ultimately consented to the loan of Kerberos as long as Herakles did not use weapons to master it. Thus Herakles was forced to

depend on his own courage and strength, which of course prevailed, and he brought the hound to Eurystheus.

The earliest depiction of this labour is on a Corinthian cup from about 580 [214]. There Athena tries to restrain Herakles as he prepares to throw a rock at Hades who has left his throne and flees to the left. Hermes stands behind Herakles and a single-headed Kerberos moves off toward a column to the right.

A splendidly frightening three-headed Kerberos whose body is covered with snakes walks across the inside of a Laconian cup of *c.* 560 [215]. Only parts are shown of Hermes who precedes (his winged boot identifies him) and Herakles with his club who follows holding the chain attached to the dog's collar. On two Caeretan hydriai, Herakles leads a three-headed Kerberos to Eurystheus who stands terrified in a great pithos – a detail normally associated with depictions of the Erymanthian boar.

By far the greatest popularity of the subject was in Athens during the second half of the 6th century where it appears on nearly one hundred black-figure vases. In the more common version Herakles leads or drags Kerberos, usually accompanied by Athena or Hermes or both and sometimes in the presence of Persephone, rarely of Hades. In another version, which first appears about 530 and runs parallel with the other, Herakles reaches out to catch Kerberos while Persephone, and sometimes Hades, look on [216]. Hermes and Athena often encourage him. On Attic vases Kerberos has only two heads and his snakiness is restricted to his tail.

The subject appears on only a few Attic red-figure vases, none later than about 475, and the schemes there are essentially those found in black-figure. On the metope from the Temple of Zeus at Olympia, the one Pausanias neglected to mention, Herakles tugged at the dog whose head and shoulders emerged from the ground while Hermes looked on. (The remains of this metope are very fragmentary.) A three-headed Kerberos appears with Herakles in several Apulian red-figure underworld scenes from the 4th century.

Other episodes from the *praxeis* and the *parerga* appear at various times during the Archaic and Classical periods. The Kerkopes are the subject of one of the more entertaining and long-lived stories. These two mischievous brothers (sometimes said to be ape-like in appearance) came upon Herakles sleeping under a tree and tried to steal his weapons. When he caught them in the act, he bound them and hung them upside down from a pole he carried over his shoulder. As he walked on with them so suspended, their comic comments about the hairiness of his rump so amused him that he let them go.

This apparently trivial tale is, quite remarkably, a subject of ancient art from Corinth, Sparta, Attica and South Italy and Sicily over a period of more than two centuries – the beginning of the 6th on into the 4th. In all cases the Kerkopes are shown hanging upside down from the pole Herakles carries on his shoulder.

The earliest depiction is on fragments of a Corinthian cup from the beginning of the 6th century. From the middle of that century it appears on a Laconian cup,

a shield band from Olympia, gems, an Attic cup and a metope from the Heraion at Foce del Sele. It also appears on a metope from Selinus [217]. Then, it is a subject on nearly a dozen Attic black-figure vases from the last quarter of the 6th century. It is not a popular subject with 5th-century vase-painters in Athens, where a different sense of humour seems to have then prevailed, but it does appear in the 4th century on a few South Italian vases [218].

On several Attic red-figure vases from the first half of the 5th century, Herakles is shown with Syleus of Aulis, a villain who forced passers-by to work in his vineyard. On one of his journeys Herakles fell foul of Syleus (or, in a satyr play by Euripides, was sold into servitude by Hermes) and responded by destroying the vineyard and Syleus' house, and then, when Syleus protested, by killing him and his daughter. On the Attic vases Herakles meets Syleus or works in his vineyard, destroys his house or digs up his vines [219].

Herakles talks with, pursues, or attacks, a naked old man on several Attic vases, also from the first half of the 5th century [220]. On two of the vases the old man is named Geras or Old Age. While there is no mention of this fight in surviving literary sources, its symbolic value is obvious. Several shield bands from Olympia and Perachora, where Herakles fights an unremarkable man, are sometimes said to show Herakles and Geras, but this is questionable.

On several Archaic Attic black- and red-figure vases, Herakles kills the sleeping giant Alkyoneus, who had stolen the cattle of Helios. Alkyoneus' size and unkempt demeanour are often emphasized in these depictions, and a small figure of Hypnos is sometimes included.

After completing his labours for Eurystheus, Herakles sought a new wife. He learned that Eurytos, Prince of Oichalia, had offered the hand of his daughter Iole to anyone who could defeat him and his sons in an archery contest, so he went there to enter the competition. Naturally, he won, but Eurytos refused to give him Iole. Variations on this story can be found in works of authors from Homer to Apollodorus and on, but in all Herakles eventually kills Eurytos and his sons, and Iole becomes his mistress rather than his wife.

On a Corinthian krater from about 600, Herakles is shown dining peacefully with Eurytos and his sons while Iole attends [221]. This is perhaps a banquet before the contest, or after the contest, but before Herakles has been denied his prize. The only other depictions of this story are on a few Attic vases from the end of the 6th and beginning of the 5th century. Several of these also show symposium scenes, but not peaceful ones. Rather, Herakles attacks Eurytos and his sons. On the one black-figure example, where klinai are not included, Herakles, having already shot two of the sons, draws his bow again as Eurytos and another rush toward him [222]. Iole stands to the side pleading.

According to Apollodorus it was after his unsuccessful suit of Iole that he sought the hand of Deianeira, daughter of Oineus of Calydon. First, however, he had to fight the river god Acheloos who was already courting her. Acheloos is variously described as bull-shaped or protean, taking the forms of a bull, a snake

and a man with a bull's face. Herakles wrestles with him and in most versions breaks off his horn as he defeats him.

The fight between Herakles and Acheloos appears on Attic black-figure vases by 570 and continues to appear on through the first quarter of the 5th century when it is also a subject on a few red-figure vases. It appears on a Corinthian cup from the second quarter of the 6th century, on fragments of a Caeretan hydria, and it was probably the subject of a metope at Selinus. It is a subject on gems from the 6th century [223] and of early 5th-century clay reliefs from Locri. Pausanias tells that it was the subject of a wood and gold group in the Treasury of the Megarians at Olympia and on Bathykles' throne at Amyklai (Sparta) both dated to the 6th century. In all cases but one, Acheloos has the body of a bull, sometimes with a human face, sometimes with a human torso attached centaur-like. On one Attic red-figure vase from about 520 he has the triton-like body of a fish. In most depictions Herakles grasps his horn [225], but on only one is the broken horn shown lying on the ground. On the vases Athena, Hermes, Deianeira and Oineus sometimes observe.

On a Sicilian red-figure vase from the middle of the 4th century a wholly human Acheloos with two small horns on his forehead sits in a scene with Herakles, Deianeira, Oineus and Nike. Clearly there is no iconographic connection between this and the earlier scenes; rather, it may have been inspired by Euripides' *Trachiniae*.

Herakles' departure from the house of Oineus is the subject of an amphora from Melos (*c.* 600). Deianeira stands in a chariot drawn by winged horses as Herakles, his lion-skin tied at his throat, mounts and Oineus sees them off.

On a journey sometime after their marriage, they came to the river Evenus where the centaur Nessos offered to carry Deianeira across while Herakles made his own way. But once across Nessos tried to rape Deianeira and Herakles shot him with one of the arrows dipped in the Hydra's blood. As he lay dying Nessos told Deianeira that she should collect his blood tainted with the Hydra's poison because it would be an infallible love charm should Herakles' affections ever turn away from her.

Herakles fights many centaurs in ancient art and unless the centaur is named or Deianeira is on its back, in its arms, or standing near it, it is difficult to be certain that he is Nessos. Probably the earliest depiction of Herakles killing Nessos is that on an early black-figure amphora from the end of the 7th century where both are named, though Deianeira does not appear [224]. There he grasps the centaur's hair as he plunges his sword into him. The subject appears on nearly one hundred other Attic black-figure vases as well as on Corinthian vases, Caeretan hydriai and a shield band from Perachora, but its popularity in art seems to have been restricted primarily to the 6th century. It rarely appears on 5th-century Attic vases or on 4th-century South Italian vases. In the depictions, Herakles usually attacks Nessos with a sword or club [226], rarely with a bow, which is clearly not in keeping with the surviving literary versions.

Hyllos is the one son of Herakles by Deianeira to appear in ancient art. On a black-figure neck-amphora from about 530, he must be the child Herakles leads by the hand while further on Nessos carries a protesting Deianeira [227], and on a few Attic red-figure vases Deianeira holds the infant Hyllos as Herakles returns from, or departs on, a journey and grandfather Oineus looks on.

Eventually Deianeira learned about Iole and, plagued by jealousy and fear of losing Herakles, she decided to use the love potion Nessos had instructed her to make. She smeared it on the inside of a fine cloak which she then gave to Herakles, but when he put it on, the Hydra's blood ate at his skin and the cloak fused horribly with his flesh. When she saw what she had done, Deianeira killed herself. Herakles, in great pain and knowing there was no cure, went to Mt Oita and built (or had built) a funeral pyre on which he lay. But no one would light the fire until a passer-by, Philoktetes (or his father Poias) agreed to do it. In thanks, Herakles gave him his bow and quiver, a gift to have great significance later during the Trojan war. As the fire burned, Herakles was transported to Olympos where he was made immortal and given Hebe as his wife. Such are the major events in most surviving literary versions of Herakles' death and apotheosis.

Deianeira gives Herakles what must be the poisoned robe on an Attic red-figure pelike from the mid-5th century [228], but this is the only known depiction of the subject in ancient art. The pyre, on the other hand, appears on several Attic and South Italian red-figure vases. The earliest is a psykter from about 460, where Herakles, lying on his pyre, holds out his quiver to Philoktetes (or Poias) [229]. On fragments of a vase not much later Philoktetes moves off with the bow as Herakles lies collapsed on the pyre.

At the end of the 5th century and early in the 4th the pyre appears again on Attic vases, but in these only a corselet lies on it while, above, a triumphant Herakles rides to Olympos in a chariot driven by Nike or Athena [230]. A similar scene appears on 4th-century Apulian red-figure vases. Satyrs, who can appear in both the Attic and Apulian versions, may suggest a theatrical inspiration. On other Attic and Apulian 4th-century vases, Herakles rides in a chariot driven by Nike or Athena when the pyre is not shown, and these call to mind a scene that was popular with black-figure vase-painters more than a century earlier also often described as the apotheosis of Herakles.

Before looking at these earlier chariot scenes, a word should be said about depictions of the introduction of Herakles on Olympos popular with Attic black-figure vase-painters during the second and third quarters of the 6th century. In these scenes Herakles is led on foot to Zeus. Hermes often leads, and Athena is usually present. This is also the subject of a mid-6th-century pedimental group from the Acropolis [231]. The popularity of this scene is roughly contemporary with that of the depiction of the Gigantomachy in which Herakles plays a central role. Pindar implies (Nem I, 60–67) that Herakles won his place on Olympos for the essential aid he gave the gods in the fight with the

Giants, and it is possible that these depictions of the introduction reflect this tradition. The apple he holds in an introduction scene on at Attic stamnos from about 460 suggests that his visit to the Hesperides may have been seen, by then, as the reason.

On a large group of Attic black-figure vases, mostly from the last thirty years of the 6th century, Athena and Herakles appear together in chariot scenes which have often been seen as another form of the introduction on Olympos [232]. Hermes, Dionysos with his drinking horn or kantharos, and Apollo with his kithara or lyre are often present. Chariots are the normal mode of transport for deities to and from Olympos during the second half of the 6th century, and it is just as likely that these scenes show the deified Herakles departing on yet another trip to visit mortals. In another scene popular with Attic vase-painters at the same time, Herakles is shown as a lone symposiast, presumably resting after his labours, where Athena attends him.

Finally, Hebe, the consort of the deified Herakles, appears with him on a Corinthian aryballos from the early 6th century [233] and on a few Attic black-figure vases from the second half of that century, usually in a chariot, the conventional form for depicting wedded couples. Their wedding itself may appear on a few Attic red-figure vases from the mid-5th century, and on an Apulian krater from the first half of the 4th century Hebe sits on a kline – the marriage bed – with Herakles and Aphrodite nearby, and Eros and Himeros fluttering above [234].

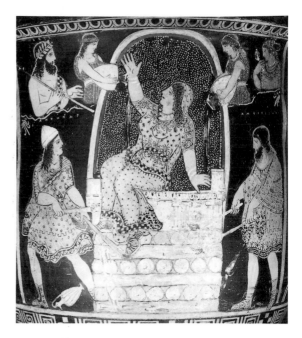

167 Paestan bell-krater from St Agata dei Goti. Amphitryon and Alkmene. Alkmene sits on an altar crying to Zeus for help as Amphitryon and Antenor light a stack of wood placed in front of it. From above clouds pour down water to douse the flames and Eos, with a mirror, observes. Note the thunderbolts in front of the pyre. *c.* 340

168 (*below*) Attic red-figure hydria by the Nausicaa P., from Capua. Herakles and the Serpents. Herakles grabs a snake with either hand as Iphikles reaches out toward a frightened Alkmene, and Amphitryon prepares to strike the snakes with his sword. Athena stands calmly behind the kline. *c.* 450. 36.8 cm

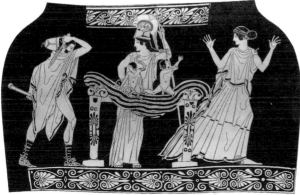

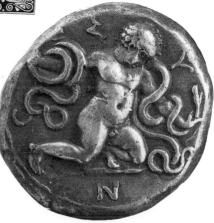

169
Silver stater from Cyzicus.
Herakles and the serpents.
c. 390

170 Attic red-figure skyphos by the Pistoxenos P., from Cervetri. Herakles on the way to his music lesson. The young Herakles walks to his music lesson accompanied by his old nurse, named Geropso here, who carries his lyre. Tattoos on her arms, throat and feet indicate that she is a Thracian. Note Herakles' large bulging eye, a common trait in depictions of him on archaic and early classical vases. c. 470. 15 cm

171 (below) Attic red-figure cup by Douris, from Vulci. Herakles and Linos. The young Herakles holding part of a stool attacks his music teacher, Linos, who tries to defend himself with his lyre as other youths flee in dismay. Note Herakles' large eye and the writing case hanging on the wall. c. 480

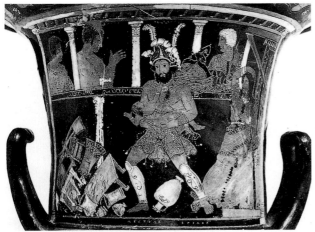

172 Paestan calyx-krater from Paestum. Madness of Herakles. Herakles holds his infant son, about to throw him onto the pile of burning furniture, while Megara, her hand to her head in the conventional gesture of mourning, rushes away through a door. From the loggia above, Iolaos and Alkmene look down on the slaughter, and to the far left is Mania (Madness) with a whip. c. 340. 55 cm

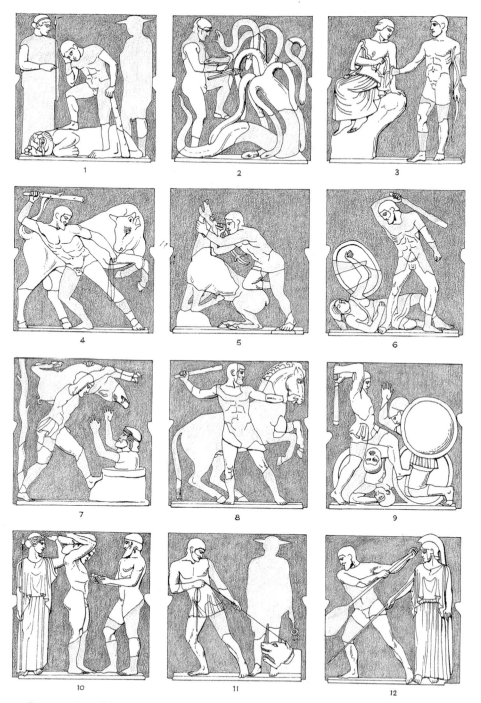

173 Reconstructions of the marble metopes from the Temple of Zeus at Olympia

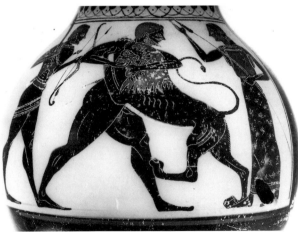

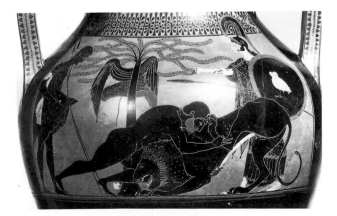

174 (*above left*) Clay tripod from Athens. Herakles (?) and the lion. A warrior with a spear and sword (?) fights a lion. Second half of the 8th Century. 17.8 cm

175 (*above*) Royal Assyrian seal impression. Assyrian king with a sword in single combat with a lion. 9th Century

176 Attic black-figure oinochoe by the Amasis P., from Etruria. Herakles and the lion. Herakles wrestles with the lion, forcing its mouth open with his hands, between Iolaos, who holds his club and bow, and Athena who holds her spear. *c.* 540. 18.3 cm

177 Attic black-figure amphora by Psiax, from Vulci. Herakles and the lion. Herakles wrestles with the lion encouraged by Athena, and Iolaos (?) looks on. Herakles' quiver and cloak hang in the tree beside him. Female flesh is often painted white on black-figure vases. *c.* 520. 58.5 cm

178 Boeotian bronze fibula plate. Herakles and the Hydra. Two warriors with swords struggle with a many-headed monster. The presence of the crab confirms the identification of Herakles and Iolaos fighting the Hydra. End of the 8th Century. 14 cm

179 (*below*) Corinthian skyphos. Herakles and the Hydra. Herakles with a sword and Iolaos with a harpe attack the many-headed Hydra while Athena, holding an oinochoe, stands by their chariot. The oinochoe may be to collect the blood of the Hydra, a particularly potent poison that eventually led to Herakles' death. *c.* 580. 12 cm

180 Caeretan hydria. Herakles and the Hydra. Iolaos with a harpe steps over a fire (for cauterizing) and Herakles with a club is bitten by the crab as they attack the Hydra. Both the hero and his companion wear greaves and corselet. *c.* 530. 44.4 cm

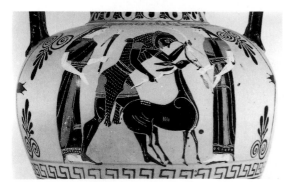

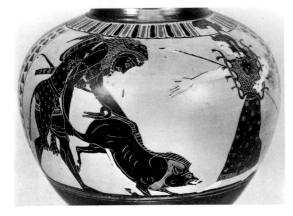

181 Attic black-figure amphora from Vulci. Herakles and the Keryneian hind. Herakles wearing his lion-skin has broken off one of the deer's antlers. Behind him Athena holds his sword, in front of him Artemis holds a bow. *c.* 540. 39.5 cm

182 Attic black-figure oinochoe by the Lysippides P., from Vulci. Herakles and the Erymanthian boar. Athena, armed and wearing her aegis, encourages Herakles as he pushes a rather puny boar wheelbarrow style. *c.* 530

183 Marble relief, metope from the Treasury of the Athenians at Delphi. Herakles and the Keryneian hind. Herakles, his lion-skin tied at his throat, his quiver and cloak behind him, struggles with the deer. *c.* 500. 67 cm

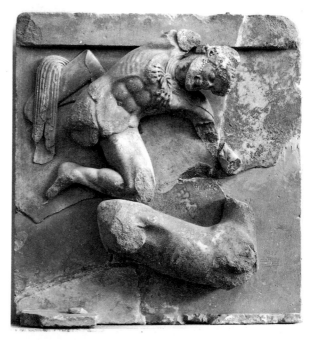

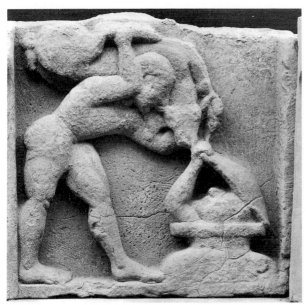

184 Limestone relief, metope from Foce del Sele. Herakles and the Boar. Herakles with the boar on his shoulder is about to drop it on Eurystheus who hides in a great jar buried in the ground. c. 550. 77 cm

185 Corinthian skyphos. Herakles and Pholos. Disturbed by the centaurs, Herakles has grabbed a burning log from the fire and pursues them, while Pholos, cup in hand, stands at the mouth of the cave where he has been dining with Herakles. Inside is the great wine jar, and Herakles' arms hang on the wall. Outside, Hermes with his kerykeion and a bowl, and Athena, passively observe. Note that the human part of Pholos is clothed while the other centaurs are naked and hairy. c. 580

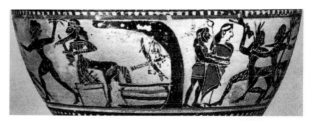

186 Andesite relief, frieze from the temple of Athena at Assos. Herakles and Pholos. Pholos holds a cup and watches as Herakles, with drawn bow, pursues centaurs. Second half of 6th Century

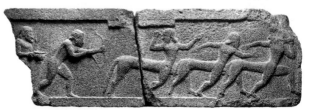

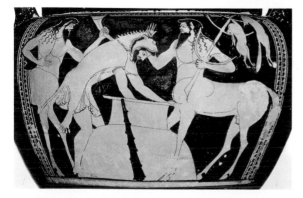

187 Attic red-figure column-krater by the Tyszkiewicz P. Herakles and Pholos. Herakles reaches with his cup into a great pithos partially buried in the ground while the centaur Pholos, standing in front of him, gestures in alarm and a centaur holding a drinking horn approaches from the left. Pholos holds a tree branch from which the carcasses of a hare and a fox hang

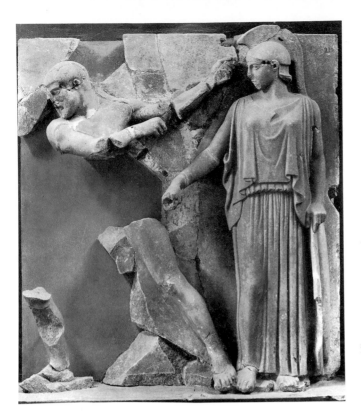

188 Marble relief, metope from
the Temple of Zeus at Olympia.
Herakles in the Augean stables.
Athena calmly directs as
Herakles breaches the walls of
the stable with a long crowbar
to let in the river. c. 460. 1.6 m

189 (*below*) Attic black-figure
amphora from Group E, from
Vulci. Herakles and the
Stymphalian birds. Herakles uses
a sling to shoot at the birds,
some of which have not yet
taken to the air. c. 550. 40.8 cm

190 (*above*) Marble relief, metope from the Temple of Zeus at Olympia. Herakles presents a bird or birds to Athena, who, wearing her aegis, sits on a rock. The birds have disappeared and the identification of the subject depends on Pausanias' account. *c.* 460. 1.6 m

191 Laconian cup. Herakles and the bull. A naked man wraps his arms around the neck of a bull. Though he has no attributes, there can be little doubt but that this is Herakles. The siren with lotus buds and the birds are probably decorative and no more. *c.* 550

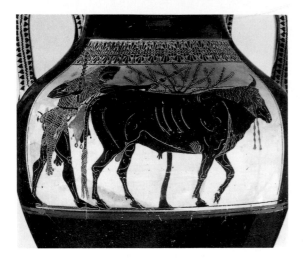

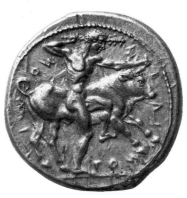

193 Silver didrachm from Selinus. Herakles and the bull. Herakles grasps the horn of the bull and swings his club. *c.* 450

192 (*above*) Attic bilingual amphora. Herakles carrying a club and spits for roasting meat, leads a bull to sacrifice. The same scene appears on the reverse in red-figure. *c.* 530. 53 cm

194 (*right*) Attic black–figure (on coral red ground) cup by Psiax. Herakles and one of the horses of Diomedes. Note the head and arm hanging from the mouth of the man-eating horse. *c.* 510

195 (*below*) Attic black–figure 'Tyrrhenian' amphora from Vulci. Herakles and Amazons. Herakles grabs the arm of a fleeing Amazon named Andromache and swings his sword while warriors fight Amazons on either side of him. Note the elaborate embroidery on Andromache's chiton and the panels of her shield band. *c.* 560. 39.4 cm

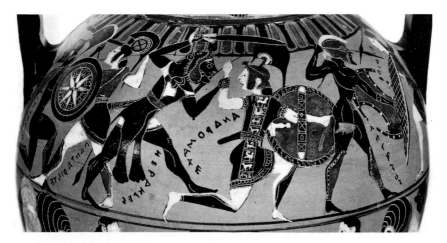

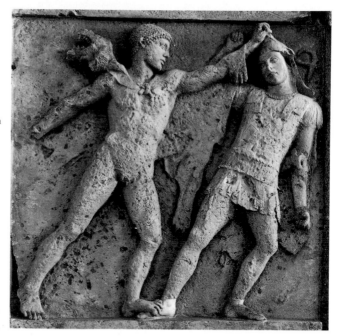

196 (*right*) Limestone and marble relief, metope from Selinus. Herakles and Amazon. Herakles, wearing only a lion-skin, grasps the Phrygian hat of an Amazon and swings his sword. She raises an axe in defence and may have held a sword in the other hand. Note how he holds down the foot of the Amazon with his own. The Amazon's face, hands, one foot and part of the other have been added in marble. *c*. 460. 1.62 m

197 (*centre*) Marble relief, frieze from the Temple of Apollo at Bassae. Herakles and Amazons. Herakles can be identified by his lion-skin. *c*. 400. H. 64 cm

198 (*below*) Apulian amphora. Herakles and Amazons. Herakles chats peacefuly with Amazons who wear Phrygian hats and carry axes. *c*. 340

199 (*above*) Corinthian column-krater from Cervetri. Herakles and Hesione. Herakles, with his bow, shoots at a monster while Hesione throws rocks at it. A chariot waits to carry them away. *c.* 550

200 (*left*) Attic red-figure cup from Vulci. Herakles, wearing his lion-skin and holding his club and bow, rides across the sea in a great golden bowl provided by Helios. Note Herakles' bulging eye. *c.* 480

201 (*below*) Bronze relief from Samos. Herakles and Geryon. Herakles with his sword attacks Geryon, who has three heads (one already dead) attached to one pair of legs. Beside Geryon the two-headed dog Orthos has already been shot with an arrow and behind him the herdsman Eurytion lies dead by a palm tree. To the far left are Geryon's cattle. *c.* 600. L. 53 cm

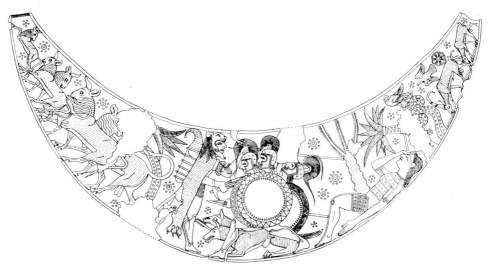

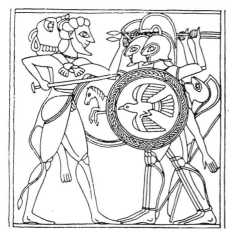

202 Bronze relief, shield band panel from Olympia. Herakles and Geryon. Here Geryon has three bodies and six legs. *c.* 550. 8.6 cm

203 Attic red-figure hydria by the Berlin P., from Vulci. Herakles and Nereus. Herakles hangs on to the white-haired old Nereus who holds a sceptre and a fish. *c.* 490. 55.6 cm

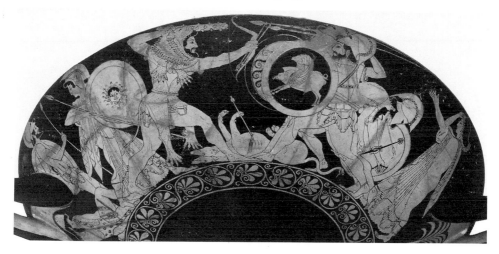

204 (*above*) Attic red-figure cup by Euphronios, from Vulci. Herakles and Geryon. Behind Herakles Athena and Iolaos chat beside the dying Euryction. The grieving woman behind Geryon may be his mother Kallirrhoe. Note the shield devices: Athena's a gorgoneion, Geryon's an octopus and a flying pig. *c.* 510

205 Attic black-figure hydria from Vulci. Herakles and Triton. Herakles wrestles with the fish-bodied Triton while Poseidon with his trident, and white-haired Nereus with a staff, observe. The women are probably Nereids. Below, an unrelated cavalcade. *c.* 530. 47.3 cm

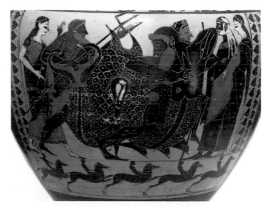

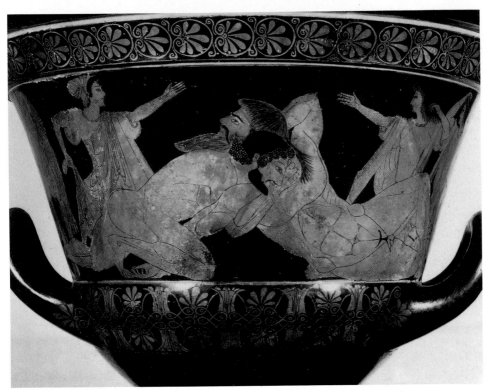

206 Attic red-figure calyx-krater by Eupuronios, from Cervetri. Herakles and Antaios wrestle between unidentified women. Note the contrast between the hair and beards of the barbarian Antaios and the civilized Herakles. *c.* 510. 46 cm

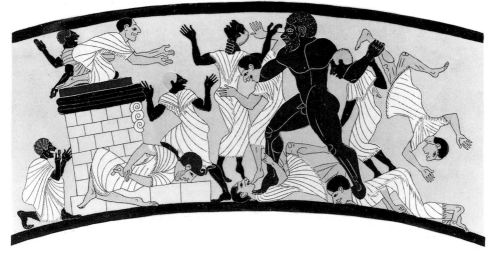

207 Caeretan hydria from Cervetri. Herakles and Busiris. Herakles tosses about the servants of the Egyptian king Busiris in front of an altar on which he was to be sacrificed. The picture seems to have been inspired by Egyptian reliefs which the vase-painter could only have seen in Egypt. *c.* 530. 44.7 cm

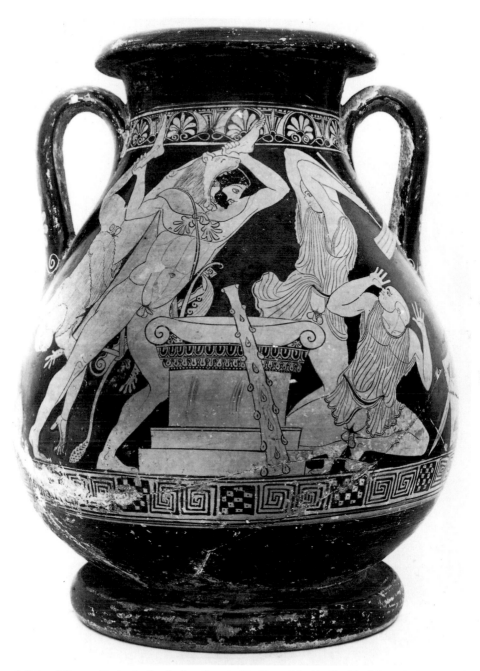

208 Attic red-figure pelike by the Pan P., from Boeotia. Herakles and Busiris. Herakles fights with the servants of Busiris at an altar. Note that the Egyptians have shaven heads and negroid features and are circumcised. *c*. 460

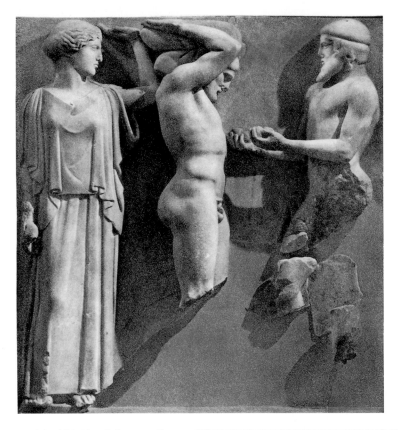

209 (*above*) Marble relief, metope from Olympia. Herakles and Atlas. Athena effortlessly helps Herakles support the heavens as Atlas brings him the apples from the Hesperides. *c.* 460. 1.60 m

210 Bronze relief, shield band panel. Herakles and Atlas. Herakles with the apples has returned the heavens to Atlas and moves off to the right toward Athena. *c.* 550. 5.4 cm

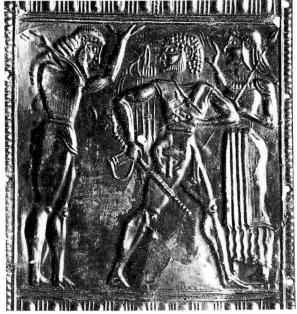

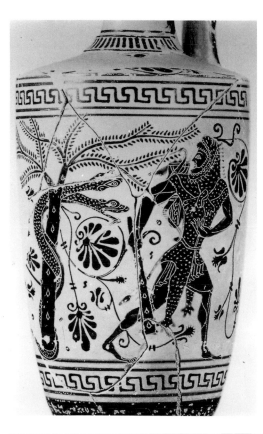

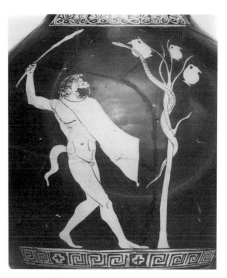

211 (*left*) Attic black-figure lekythos. Herakles at the tree of the Hesperides which is guarded by a two-headed snake. *c.* 500. 27 cm

212 (*above*) Attic red-figure oinochoe (chous) from Capua. Parody of Herakles in the garden of the Hesperides. A satyr with a club attacks a serpent that guards a tree in which choes hang. Pots of this particular shape were used during the celebration of a festival of Dionysos (Anthesteria) in Athens. *c.* 460. 24 cm

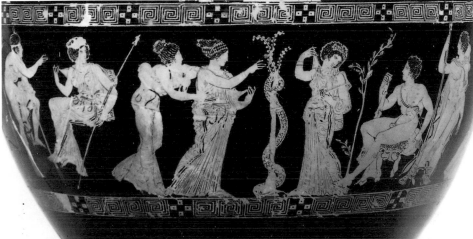

213 Attic red-figure hydria by the Meidias P. Herakles and the Hesperides. Herakles sits on his lion-skin in the garden of the Hesperides accompanied by Iolaos while Chrysothemis with Asterope reaches up to pick an apple from the tree which is guarded by a snake. In front of Herakles is Lipara. To the far left Hygieia is seated, and Klytios stands in front of her. *c.* 410. 52.1 cm. See *frontispiece*

214 Corinthian cup from Argos. Herakles and Iolaos
fight the Hydra, hindered by the crab, between two
women, while their unharnessed chariot waits. Then,
to the right, Herakles is about to throw a rock at
Hades who moves away quickly with his sceptre.
Athena and Hermes seem to restrain Herakles.
Kerberos is to the right. c. 580

215 Laconian cup. Herakles and Kerberos. Kerberos fills the scene while Hermes, who
precedes, can be identified by his winged boot and Herakles, who follows, by his club. This
is called a 'porthole' composition, for obvious reasons. c. 560

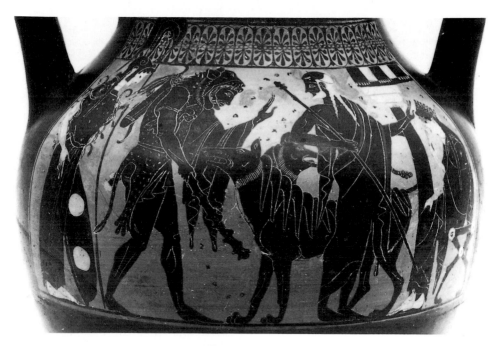

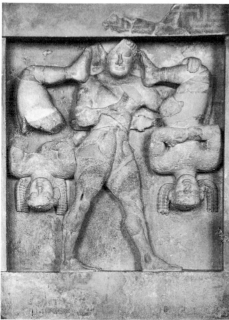

216 (*above*) Attic black-figure amphora from the Leagros Group, from Cervetri. Herakles approaches Kerberos as Athena, a white-haired Hades with a sceptre and a seated Persephone look on. Note the doric column and frieze used to indicate the palace of Hades. *c.* 520

217 (*left*) Limestone relief, metope from Selinus. Herakles and the Kerkope. *c.* 530. 1.47 m

218 (*below*) Lucanian red-figure pelike. Herakles and the Kerkope. Here the Kerkope have been given simian faces and large genitals. *c.* 380. 28.5 cm

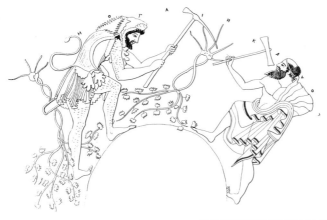

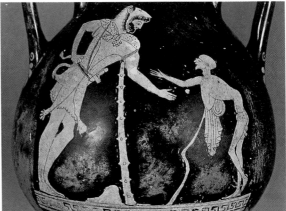

219 Attic red-figure cup. Herakles and Syleus. Syleus with an axe, tries to stop Herakles from digging up his vines. *c.* 480

220 (*below*) Attic red-figure pelike from Cervetri. Herakles and Geras. Herakles, wearing his lion-skin and leaning on his club, converses with Geras (old age), an emaciated old man leaning on a crooked staff. *c.* 470. 31 cm

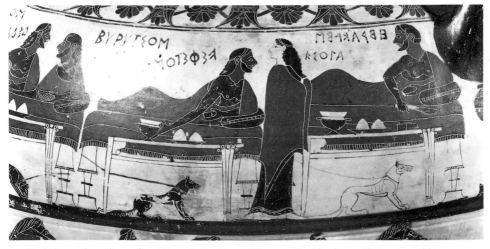

221 Corinthian column-krater from Cervetri. Herakles and Eurytos. Herakles dines with Eurytos and his sons, waited upon by Iole. The symposium, where diners recline on couches, was the traditional form for banquets in Greece, a custom borrowed from the East. The inscriptions are in the Corinthian alphabet. *c.* 600. 46 cm

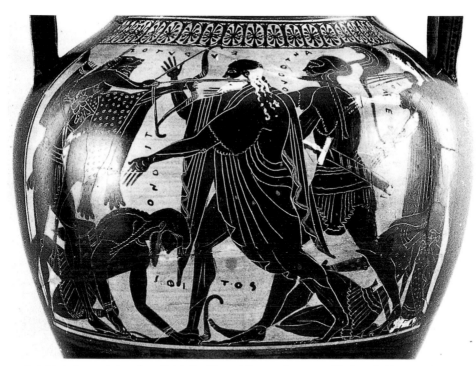

222 Attic black-figure amphora from Vulci. Herakles and Eurytos. Eurytos, a white-haired old man, and one of his sons rush toward Herakles as he draws his bow, and Iole, to the right, gestures in dismay. Two of Eurytos' sons have fallen. Note the Phrygian hat on one of them and the ball (presumably a target) with arrows in it above Iole's shoulder. *c.* 510. 40.5 cm

223 (*above*) Greek scarab. Herakles and Acheloos. Herakles wearing his lion-skin holds up the horn (?) he has broken off Acheloos, who has the body of a bull and the face of a man. Deianeira applauds the deed. Mid 6th Century. 1.8 cm

224 (*right*) Attic black-figure amphora by the Nessos P., from Athens. On the neck, Herakles and Nessos. Herakles grabs Nessos by the hair and plants his foot on his back, about to stab him, as the centaur reaches back to touch the hero's chin, a conventional gesture of supplication. *c.* 620. 1.22 m

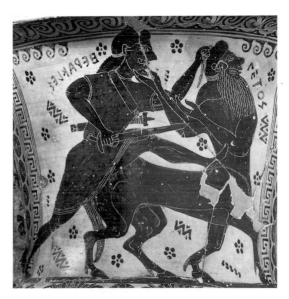

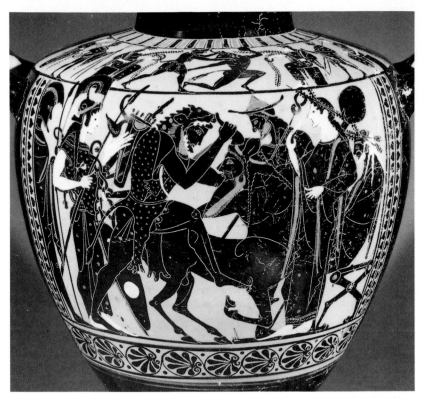

225 Attic black-figure hydria, from Vulci. Shoulder, Theseus and the Minotaur. Below, Herakles and Acheloos. Herakles wrestles with Acheloos who has a human head and torso attached to the body of a horse (though a horn grows from his forehead). Athena and Hermes are easily recognized. Deianeira stands by her white-haired father, Oineus, who sits on a stool. The warrior behind Athena must be Iolaos. *c.* 510. 48 cm

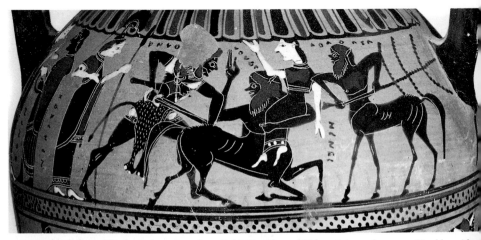

226 Attic black-figure 'Tyrrhenian' amphora from Vulci. Herakles and Nessos. Athena observes as Herakles with a sword attacks Nessos who still holds Deianeira. Another centaur, carrying a small tree as a weapon, comes to the aid of Nessos. The inscriptions are nonsense words. *c.* 540. 36.3 cm

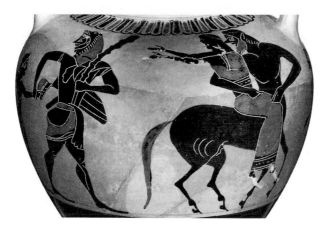

227 (*above*) Attic black-figure amphora. Herakles and Nessos. Herakles leads his son Hyllos while Nessos carries a protesting Deianeira. *c.* 530. 20 cm

228 (*right*) Attic red-figure pelike from Nola. Herakles and Deianeira. Deianeira gives Herakles the robe on which she has smeared the blood of Nessos. *c.* 420

229 (*below*) Attic red-figure psykter. Herakles on his funeral pyre. Herakles, lying on his lion-skin on top of his pyre, hands his quiver to Philoktetes, whose role in the Trojan war will be critical because of it. *c.* 460

230 Attic red-figure pelike by the Kadmos P., from Vulci. Apotheosis of Herakles. Herakles rides away from the pyre in Athena's chariot leaving only a corselet, while Arethousa and Premnosia douse the flames and satyrs (Skopas and Hybris) examine the remains. *c.* 410. 43 cm

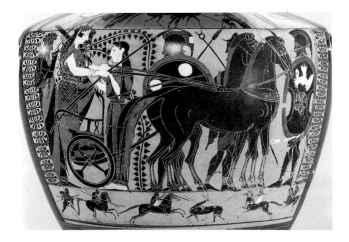

231 (*above*) Limestone pedimental group from the Acropolis in Athens. Introduction of Herakles. Herakles, wearing his lion-skin, and Hermes approach Zeus and Hera who are both seated. Athena (missing) probably led the hero. *c.* 550. 94 cm

232 Attic black-figure hydria. Apotheosis of Herakles (?) Herakles, his club resting on his shoulder, rides in Athena's chariot. Dionysos, with a drinking horn, stands behind them, Hermes with his kerykeion and two warriors (one with a Boeotian shield) stand beside the horses. The deer hunt below is unrelated. *c.* 530. 46.6 cm

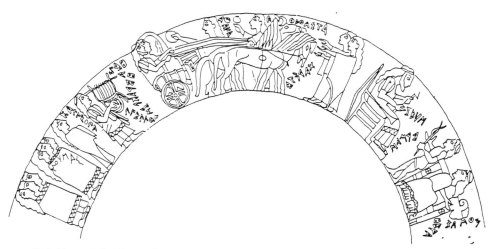

233 Corinthian aryballos from Vulci. Marriage of Herakles and Hebe. Herakles and Hebe ride in a chariot beside which Athena with a wreath (?) and Aphrodite with a flower (?) stand. In front of the horses are two Charites. Following the chariot are Apollo, playing a kithara, Kalliope and six other Muses. Beyond the Charites, Hermes with his kerykeion stands between Zeus and Hera, both seated, recalling the 'Introduction' pediment on the Acropolis (231). c. 600

234 Apulian volute-krater from Ceglie. Marriage of Herakles and Hebe. Herakles with his club stands by the kline on which Hebe sits while Eros flies above and attendants wait on her. To the right, Himeros (Desire) with a fillet stands on Aphrodite's lap. c. 350

Chapter Seven

THESEUS

The popularity of the hero Theseus as a subject for Attic vase-paintings approaches that of his contemporary Herakles at the end of the 6th century. This new popularity for an old hero was undoubtedly influenced by an epic poem (or poems) written during the last quarter of the 6th century, in which his rather vague early history was fleshed out and his connection with Athens emphasized.

During the Classical period, Theseus' great popularity was limited to Attica. Where Herakles belonged to all Greeks, the new Theseus was the property of the Athenians, and some scholars have suggested that he was cast as a symbol of the new democratic Athens – even as a propaganda device. On several vases his pose is clearly borrowed from statues of the tyrant-slayers Harmodios and Aristogeiton that stood in the Athenian Agora. This theory is complemented by another, that Herakles was used in a similar way by Peisistratos. Herodotus' account (1.60) of that tyrant's entry into Athens accompanied by a mock Athena lends credence to that theory.

Prior to about 520, Theseus was known primarily for his fight with the Minotaur, his desertion of Ariadne, his friendship with the Lapith, Peirithoos, and their abduction of Helen and journey to the underworld. He does not appear in the old pediments from the Acropolis as Herakles does, and only his fight with the Minotaur appears with any regularity on Attic black-figure vases. Then suddenly new scenes appear on Attic vases and by 510 whole cycles of deeds on some of them rival the deeds of Herakles. There are nearly twenty of these so-called cycle vases, mostly cups, and they are spread across the whole of the 5th century, but with the greatest concentration at the beginning. Cycles of the deeds also appear on friezes of several public buildings. On the Treasury of the Athenians at Delphi (c. 500) and the Hephaisteion in Athens (449–8), the metopes are divided between Herakles and Theseus; part of the frieze on the Temple at Sounion was dedicated to Theseus; and from the beginning of the 4th century several of his deeds appear in the frieze of a heroon at Trysa in Lycia.

Apollodorus gives a full, if brief, account of Theseus' life, and his sequence of events is followed here. Aigeus, King of Athens, descendant of Erechtheus, slept with Aithra, daughter of Pittheus, King of Troezen and son of Pelops. According to some accounts Poseidon slept with Aithra on the same night, leading to disputed paternity, but in any case, Aigeus, before he returned to Athens, left a sword and sandals under a rock and instructed Aithra to rear the male child that might result from their union without telling him who his father

was until he could roll the rock away, at which point he should proceed to Athens and claim his inheritance.

Eventually the day came when Theseus pushed aside the rock and claimed the sword and sandals. Then, rather than take the safe sea route to Athens, he went overland, clearing the way as he went of bandits who interfered with travellers.

Probably the first depiction of Theseus recovering the *gnorismata*, as the sword and sandals are called, is on an Attic red-figure vase from *c.* 460, where his mother watches as he pushes on the rock, beneath which the handle of the sword can be seen [235]. A similar scene appears on a few other vases from the second half of the 5th century [236], and Pausanias (1.27.8) tells that it was the subject of a bronze statue on the Acropolis in Athens. It is included on only one of the cycle vases, a krater from the last quarter of the 5th century, and of the architectural sculpture it only appears on the frieze of the heroon at Trysa at the beginning of the 4th century [240].

The first of the evil-doers Theseus encountered on the road to Athens was Periphetes, a son of Hephaistos who lived at Epidauros and waylaid passers-by, dispatching them with an iron club. Theseus killed him and afterwards carried his club in an unmistakable reference to Herakles' first deed. The scene rarely appears on cycle vases – on one Theseus swings a club at a man who falls back against a tree – but it was the subject of a metope from the Hephaisteion.

Next Theseus encountered Sinis the Pine-bender at the Isthmus of Corinth. This villain used the spring of a bent pine tree, or trees, to destroy his victims (the exact method is variously described) and Theseus used the same means to destroy him. One of the more popular subjects, this deed is shown on more than half of the cycle vases and on many other red-figure vases from throughout the 5th century [118, 236, 238–39]. It was included in the metopes from the Treasury of the Athenians and from the Hephaisteion and on the frieze at Trysa. In most of the depictions Theseus pulls down the top of a tree with one hand as he drags a reluctant Sinis toward it with the other.

For sport, Theseus went out of his way to Krommyon near Corinth to fight a fierce sow, said to be another offspring of Typhon and Echidna, named Phaia after its mistress. This fight is a subject on about half of the cycle vases and of a few other red-figure vases. It is also depicted on a metope from the Hephaisteion and perhaps on a Melian relief. On the vases an old woman, presumably Phaia, is sometimes shown remonstrating as Theseus prepares to attack the pig with his sword [238].

Skiron, a son of Pelops or Poseidon, commanded a narrow passage through the rocks near Megara and forced passers-by to wash his feet, and as they did so he kicked them off the rocks into the sea where they were devoured by a large turtle. Theseus tossed Skiron from the same rocks, a scene depicted on more than half of the cycle vases and on several other red-figure works, most from the first half of the 5th century. On some the foot-bath is included, on some the turtle [237, 239]. Theseus with Skiron is the subject of metopes from the Athenian

Treasury and the Hephaisteion at Athens and of friezes from the heroon at Trysa [240] and the Temple of Poseidon at Sounion.

At Eleusis, Kerkyon forced travellers to wrestle with him and, relying on his superior strength, killed them in the fight. Using skill rather than brute force, Theseus defeated Kerkyon in a wrestling match and killed him. The fight appears on about half of the cycle vases [239], but since there is little to distinguish this wrestling match from any other, it is difficult to recognize it on vases unless other scenes with Theseus appear as well. The fight is the subject of metopes on the Treasury at Delphi and on the Hephaisteion [241].

Prokrustes (Apollodorus calls him Damastes or Polypemon) was the last of the evil-doers Theseus encountered on his way to Athens, and he is perhaps the most memorable of his adversaries. He had a bed (or beds) in his home near Eleusis and offered hospitality to passers-by. But when they lay on the bed, he adjusted their sizes to match the bed, lopping off pieces from those who were too long and hammering out those who were too short. As with the rest, Theseus killed him using the means the villain had used to murder others.

This is one of the first of Theseus' new deeds to appear on Attic vases. It is depicted on most of the cycle vases and on several late 6th-century and early 5th-century black-figure vases as well. On most of these, Theseus attacks with an axe or hammer as Prokrustes falls back, sometimes onto his bed [118, 237]. The deed is the subject of metopes from the Treasury at Delphi and the Hephaisteion, but these are too fragmentary to reveal details of iconography.

Having dispatched the last of the villains on the road from Troezen, Theseus went on into Athens to find his father, Aigeus, who had married the witch Medea and knew nothing of him. Medea, however, knew of Theseus and recognizing him as soon as he arrived in Athens, plotted to destroy him, warning Aigeus against the young stranger and urging that he be sent off to fight a particularly savage bull at Marathon. By some accounts this was the same bull Herakles had captured on Crete and brought back to Eurystheus at Mycenae.

Theseus captured the bull, led it through the city and then sacrificed it to Apollo. Depictions of him capturing the bull or having already tethered it appear on most of the cycle vases as well as on nearly one hundred other red-figure vases and on the reliefs from the Treasury at Delphi, the Hephaisteion, and the Temple of Poseidon at Sounion. Unlike most of the deeds thus far discussed, the fight with the bull was also very popular with black-figure painters [242]. Though most of the many black-figure vases date to the late 6th or early 5th century, the earliest is from about 540. On some of the more hastily executed vases it is difficult to decide whether the painter intended Theseus or Herakles. As a rule, however, a quiver usually hangs nearby in the Herakles scenes and the hero is bearded, while Theseus here is usually beardless. Athena, who is not regularly shown as Theseus' patron in other scenes, often appears in this one. In some depictions an unnamed woman observes who has been variously identified as Medea and a local nymph.

A frustrated Medea persuaded Aigeus that the dangerous stranger must be poisoned, and it was only at the last moment, when he recognized the sword, that Aigeus dashed the cup from Theseus' hand. The recognition scene was certainly a part of Euripides' play, *Aigeus*, performed after 450, and a scene on an early 4th-century Apulian krater probably reflects a production of that play [243]. Theseus pours a libation of wine on to an altar while Aigeus examines the sword and a distressed Medea moves off to the left.

In some versions the recognition comes before Theseus' capture of the bull, and he undertakes that deed as a service to Athens. Some say that Androgeos, son of Minos of Crete, had been killed by the bull and that this had led to the tribute of seven youths and seven maidens Athens paid to Minos each year. The youngsters sent to Crete were shut up in a labyrinth designed by Daidalos to contain the Minotaur, a monster half-bull and half-man, which was the product of a union between Pasiphae, wife of Minos, and a bull.

Theseus volunteered (or was selected) to be part of the tribute. On the voyage to Crete, Minos bragged of his divine connection, and not to be outdone Theseus jumped overboard and with the help of Amphitrite, wife of Poseidon, retrieved a ring thrown into the sea by Minos as a test. Theseus' visit with Poseidon or Amphitrite under the sea is the subject of several Attic red-figure vases, most from the first half of the 5th century [244], and Pausanias (1.17.3) tells that it was the subject of a painting by Mikon in a sanctuary of Theseus in Athens.

On Crete, Ariadne, a daughter of Minos, fell in love with Theseus and gave him a ball of thread to unwind as he went through the labyrinth enabling him to find his way out, after killing the Minotaur who lived deep within it.

Unlike the other deeds discussed so far, Theseus' fight with the Minotaur was an old story and its popularity was by no means limited to Attica. The earliest depiction is on a Boeotian relief amphora from the first half of the 7th century where the Minotaur has the body of a bull and presumably a horned human head, but on a gold relief plaque from the end of that century [245], it has what becomes its conventional form of a human body with a bull's head. The fight is a subject on shield bands throughout the 6th century [246] and it is depicted on several hundred Attic black-figure vases [225, 247] as well as on several 6th-century Corinthian and Chalcidian vases. It is shown on several of the Attic cycle vases and on many other 5th-century Attic red-figure vases. Before the invention of the new Theseus it was the story by which he was usually known, and its popularity continued even after the hero had been remodeled.

On the top band of the François Vase, on the back side, Theseus with a lyre leads the Athenian youths and maidens in a dance after their escape from the labyrinth [248]. Ariadne stands with her nurse, holding out a wreath with one hand, a ball of thread in the other, as a ship of rejoicing Athenian sailors lands to rescue them. Though black-figure fragments from the Acropolis in Athens show that Kleitias painted this scene more than once, the subject does not appear

in later art. However, Theseus with a lyre and Ariadne with a wreath appear on a late 7th-century shield band and they were shown with similar attributes on the Chest of Kypselos. On an early 6th-century shield band, Ariadne is shown holding a wreath as Theseus fights the Minotaur [246].

In the *Odyssey* (11.321) Ariadne is said to have been killed by Artemis on the island of Dia (Naxos) on the orders of Dionysos, whom Ariadne had presumably deserted. In later versions, Theseus abandons Ariadne, sometimes for another woman, and Dionysos rescues and marries her.

Theseus' treacherous behavior in abandoning his savior does not seem to have been acceptable to the poets who were responsible for polishing his image at the end of the 6th century, and several red-figure vase-paintings suggest the means found to cast him in a better light. On a red-figure hydria from *c.* 470, Athena sends Theseus off to the left while Dionysos escorts Ariadne off to the right [249]. Presumably Theseus goes to his higher calling as a leader in Athens and Ariadne gets a god. On other 5th-century red-figure vases, Athena leads Theseus away while Ariadne sleeps, but the message is essentially the same. Not surprisingly, depictions of Theseus abandoning Ariadne also appear on a few South Italian vases as well.

As the result of an oversight by Theseus, Aigeus believed that his son was dead and committed suicide, so Theseus returned to Athens as ruler. The sequence of other tales connected with Theseus is less clear, in part because some of them, or parts of some of them, predate the new Theseus by several generations.

His first marriage was to the Amazon, Antiope (sometimes called Hippolyta) whom he was given as a reward for the help he gave to Herakles on an expedition to the home of the Amazons at Themiscyra on the Black Sea, or, according to other versions, whom he abducted on a visit there on his own. Later a force of Amazons laid siege to Athens in an attempt to retrieve her but were repulsed, with Antiope fighting on the side of her lover, or, according to some accounts, a treaty was made with them. By his Amazon wife, Theseus had a son, Hippolytos.

The abduction of Antiope was the subject of the west pediment of a temple of Apollo at Eretria from *c.* 510 [250], where he lifted her into his chariot in the midst of a battle, in the presence of Athena. Fragments survive. He carries her to his chariot on several black- and red-figure vases from the end of the 6th and beginning of the 5th century as well [251].

The battle between the Athenians and the Amazons was a popular subject with sculptors and painters alike through the 5th century. Several metopes from the Treasury of the Athenians at Delphi depicted episodes from the battle, and it was the subject on the front of the shield of Athena Parthenos [252], and one of several subjects on the throne of Zeus at Olympia. According to Pausanias (1.15.2; 17.2) there were paintings of it in the Stoa Poikile and the Sanctuary of Theseus in Athens. Greeks fighting Amazons appear on literally hundreds of Attic black- and red-figure vases, but unless Theseus or Herakles is clearly

present, it is difficult to know just which battle is being shown. The inclusion of Herakles in the frieze from the Temple of Apollo at Bassae [197] probably means that the battle at Themiscyra is intended there rather than the battle at Athens or the battle at Troy to be discussed in Chapter 10.

The fate of Theseus' Amazon wife is variously explained, but by all accounts he later married Phaidra, another daughter of King Minos and sister of Ariadne, and by her he had two sons, Akamas and Demophon. Phaidra fell in love with her stepson, Hippolytos, and rejected by him when she tried to seduce him, she told Theseus he had attempted to rape her. Enraged, Theseus prayed to Poseidon to destroy his son, and the god sent a bull from the sea that frightened the horses of the youth's chariot, which overturned, killing him. A repentant Phaidra then hanged herself.

Pausanias (10.29.3) tells that Polygnotos painted Phaidra in his depiction of the underworld in the Lesche of the Cnidians at Delphi, and putting her in a swing, grasping the rope at each side, presumably suggested the manner of her death, but no certain depictions of her have survived from our period. Euripides' play *Hippolytos* was probably the inspiration for scenes on two South Italian vases from the 4th century. On an Apulian krater, Hippolytos is shown driving his chariot as a bull rises up from the sea [253].

Homer knew of Theseus' friendship with Peirithoos, chief of the Lapiths from northern Thessaly, and the first certain representations of the two together appear early in the 6th century. The three myths in which they are shown are the battle between the Lapiths and Centaurs, the abduction of Helen, and the journey to the underworld.

On the neck of the François Vase, in the frieze below the dance of the Athenian youths, armed Lapiths fight centaurs in an all-out battle. Only part of Theseus' name survives and Peirithoos is entirely missing, but the names of many other Lapiths and centaurs survive. Three centaurs with rocks and tree-limbs pound at a warrior named Kaineus who sinks into the ground.

Kaineus had originally been a Lapith woman who, seduced by Poseidon, asked the god to turn her into an invulnerable man, which he did. Since weapons were useless against him, the centaurs could only pound him into the ground. The earliest depiction of Kaineus is on a bronze relief from Olympia from the last quarter of the 7th century [254], a scene similar to that on the François Vase. Similar scenes then appear on Attic black- and red-figure vases from the 6th and 5th centuries, and on friezes from the Hephaisteion, the Temple of Apollo at Bassae, the Temple of Poseidon at Sounion, and the heroon from Trysa.

Two forms of the Centauromachy with Theseus appear in Greek art. In the earlier scenes, the François Vase being the first, the Lapiths are armed and no women are included. On other scenes, which first appear around 470 – the first may have been a painting by Polygnotos in the Sanctuary of Theseus in Athens mentioned by Pausanias (1.17.2) – the men fight with their bare hands as the centaurs attempt to abduct the Lapith women and boys.

The latter scenes certainly (and the others probably) show a battle that erupted at the wedding of Peirithoos to Hippodamaia when the centaurs got into the wine (their intolerance for drink has been illustrated in the Pholos story) and tried to violate the bride *[255]*. The most famous depiction of the battle is the pediment of the Temple of Zeus at Olympia where Apollo – mistaken for Peirithoos by Pausanias (5.10.8) – brings order out of chaos *[256, 257]*.

During the Archaic and Classical periods the Centauromachy seems to have symbolized the triumph of civilization over barbarism, and in the 5th century may have quite explicitly referred to the victory of the Athenians over the Persians. According to Pausanias (1.28.2) it was depicted on the shield of Pheidias' bronze Athena (Promachos) made from the spoils left by the Persians at Marathon. Pliny (36.18) says that it was also depicted on the sandal of Pheidias' Athena Parthenos, and it was a subject of metopes on the Parthenon.

Theseus in the battle with the centaurs at the wedding of Peirithoos was used as a subject for friezes from the Hephaisteion, and from the temples at Sounion, Bassae and Trysa.

At some point Theseus and Peirithoos made a vow that they would each marry a daughter of Zeus. With this in mind they went together to Sparta and abducted Helen (whose birth and later abduction by Paris is discussed in Chapter 9) for Theseus and, since she was not yet of marriageable age, left her in the care of Theseus' mother, Aithra. The Dioskouroi, Helen's twin brothers, later rescued her and took Aithra captive while Theseus and Peirithoos were in the underworld, a journey discussed in Chapter 4.

Pausanias (3.18.15) tells that Peirithoos and Theseus carrying off Helen were shown on the Archaic throne at Amyklai by Bathykles. Scenes on several shield bands and on several Attic black-figure vases where a woman is seized by two young men are thought by some to show the abduction of Helen, though the figures are not named. On a red-figure amphora with inscriptions from the last quarter of the 6th century, Theseus carries off a woman named Korone, as Helen runs after them and Peirithoos follows *[258]*. It is likely that the painter accidentally reversed the names of the women here and the scene is, rather, the abduction of Helen, which also appears on a few other Attic red-figure vases.

On the Chest of Kypselos, according to Pausanias the Dioskouroi were shown escorting Helen, presumably in a scene very much like those said to be the abduction of Helen, while Aithra has been thrown to the ground, and a lengthy inscription told that they took Aithra with them. Later, Aithra went on to Troy as Helen's servant and was eventually rescued by Theseus' sons Akamas and Demophon after the fall of Troy. A scene appears on Attic black- and red-figure vases where the two warriors lead her away between them *[259]*. The *Ilioupersis*, of which Aithra is sometimes a part, is discussed in Chapter 9.

Little else of the mythical life of Theseus is shown in Greek art; however, according to Sophocles, Theseus received as a suppliant the disgraced Oedipus, after the latter had been expelled from Thebes, and allowed him to spend his last

days at Colonus near Athens, so this is perhaps an appropriate place to say something of the depictions of the myths associated with Oedipus (events which are for the most part well-enough known to not need recounting here).

The curse that led to the downfall of Oedipus was, according to some sources, brought on by his father, Laios, when he abducted Chrysippos, the son of Pelops with whom he had been staying during an exile from Thebes. Scenes on several Apulian red-figure vases from the second half of the 4th century, in which Laios dashes away in his chariot holding the protesting boy, were probably inspired by productions of Euripides' play that dealt with the subject [260].

On a mid-5th-century Attic red-figure neck-amphora, a herdsman named Euphorbos, carries the infant Oedipus to a man who must be Polybos, King of Corinth, who raised Oedipus as his son [261]. The murder of Laios is depicted on fragments of an Attic red-figure krater from c. 440, but this is the only surviving depiction of that event. In fact, the only part of the Oedipus myth that appears with any regularity in Greek art is his encounter with the sphinx.

The sphinx, a monster with the body of a lion and the head of a human, was originally an Egyptian invention and male. It appears in Mycenaean art, but was probably reintroduced to Greece during the Archaic period via the East, where it had become female. During the Archaic period it appears as a decorative device on many fabrics from all parts of the Greek world and is often associated with funerary art.

The sphinx first appears in narrative scenes early in the 6th century when she is shown carrying the body of a youth on a shield band, on Attic black-figure vases and on gems [262]. This is presumably the deadly sphinx mentioned by Hesiod as the offspring of Echidna and Orthos, and sister of the Nemean lion (and half-sister of Kerberos) who destroyed many of the youths of Thebes. In some accounts Haimon, son of Creon, is the last youth killed by the sphinx.

The sphinx attacking or carrying youths is very popular with Attic black-figure painters at the end of the 6th century. It also appears on a few red-figure vases [263] and Melian reliefs, and according to Pausanias (5.11.2) Theban youths seized by sphinxes were carved into both of the front legs of the throne of Zeus at Olympia. The erotic overtones of some of these scenes of death has often been noted.

Theban youths conversing with the sphinx, presumably trying to answer her riddles, appear on Attic black- and red-figure vases throughout the first half of the 5th century. An identifiable Oedipus and the sphinx first appear in c. 540 on a Klazomenian vase, but the scene does not appear on Attic vases until early in the 5th century. The subject appears on a few black-figure vases, mostly lekythoi, and on red-figure vases [264] from through the 5th century and on into the 4th – rarely on South Italian vases.

After Oedipus was banished, his sons Polyneices and Eteocles agreed to share the rule of Thebes, serving on alternate years, but once in power, Eteocles refused to relinquish it and banished Polyneices, who persuaded Adrastos of

Argos to mount an expedition led by seven great warriors to reclaim his birthright. The undertaking was a failure, and six of the seven were killed – including Polyneices, the two brothers killing each other in a duel.

Several episodes from the myth of Seven Against Thebes are depicted in Greek art. The seven together preparing for battle appear on an Attic red-figure hydria of c. 470 [265] where only Parthenopaios, the youngest, is named, as he is on a fragment of a Laconian cup of c. 550, which seems to have shown heroes quarreling, a very common theme in this myth.

Amphiaraos, an Argive seer, knew that the expedition would fail with six of the seven leaders dead, and he argued with Adrastos against it. Polyneices, however, bribed Amphiaraos' wife, Eriphyle, to intervene in favor of the expedition by giving her the necklace made by Hephaistos that Kadmos, founder of Thebes, had given to his wife Harmonia, a daughter of Ares and Aphrodite.

On several Attic red-figure vases from the middle of the 5th century and slightly later, Polyneices holds out the necklace to Eriphyle, but the scene with the longest life is the departure of Amphiaraos for Thebes. Pausanias describes in great detail the depiction of this subject on the Chest of Kypselos, and a scene on a late Corinthian krater is remarkably similar in details as well as in general conception [266] – and the scene with many of the same details is repeated yet again with remarkable faithfulness on an Attic black-figure neck-amphora of c. 550 [267]. The departure appears on other black-figure vases and on an ivory relief, but its earliest depiction is on a 7th-century bronze relief from Olympia [268]. On each, Amphiaraos looks back as he mounts his chariot. Eriphyle, who sometimes holds her necklace, and her son Alkmaion, who will be required to avenge his father's death, are often present. On a few red-figure vases depicting the subject, Amphiaraos on foot takes leave of Eriphyle in the presence of Alkmaion, and on a red-figure krater of c. 440 he hands the youth a sword which he will eventually use to kill his mother.

A depiction of the actual battle at Thebes appears on an Attic red-figure volute krater of c. 440 [270] where the chariot of Amphiaraos is shown sinking into the ground, having driven into the cleft in the earth made by a thunderbolt from Zeus, who granted him immortality.

Antigone, the daughter of Oedipus, so powerfully portrayed by Sophocles, is not a significant figure in Greek art and only appears on a few South Italian vases. On the other hand, Ismene, Oedipus' other daughter by Jocasta, appears in an unusual scene on a mid-6th-century Corinthian amphora [269]. Tydeus, one of the seven who fought at Thebes, with a sword drawn, grabs Ismene who is reclining bare-breasted on a kline, about to stab her. Behind him a naked Periklymenos, a son of Poseidon who fought against the seven at Thebes, rushes off, apparently having been caught in the act. The murder of Ismene also appears on fragments of a contemporary Attic vase. This old story, for which any literary version has been lost, was not one 5th-century dramatists chose to use.

235 Attic red-figure lekythos by the Sabouroff P., from Sicily. Theseus recovering the gnorismata. Theseus lifts a great rock and discovers the sword his father, Aigeus, had left under it. On the other side of the rock (not shown) his mother stands watching him. *c.* 470

236 (*below*) Attic red-figure calyx-krater (see *118*). Upper register. Deeds of Theseus. Theseus leans on his spear and talks with Sinis, who bends down a tree. Theseus lifts the rock that hides the sword while Pittheus (?) looks on. *c.* 430. 39.5 cm

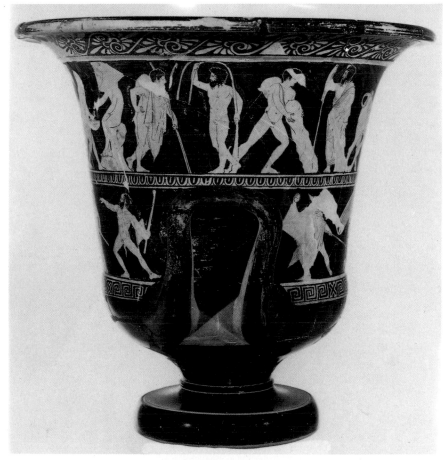

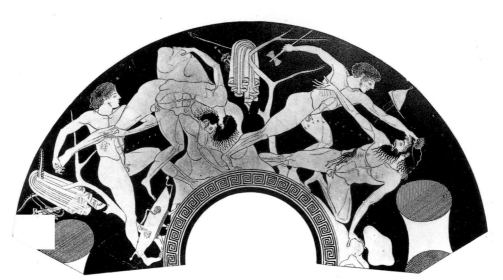

237 Attic red-figure cup by Onesimos from Cervetri. Deeds of Theseus. Theseus tumbles Skiron off the cliff, which is indicated by the large rock beside him. Note the footbath on the ground below Theseus. Theseus with an axe attacks Prokrustes. In both scenes the hero's sword and cloak hang in a tree beside him

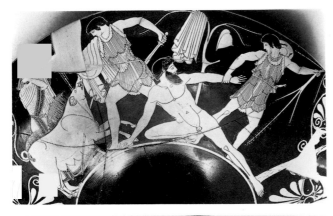

238 Attic red-figure cup by Douris, from Vulci. Theseus, with a sword, attacks the Krommyonian sow as Phaia begs him to spare it; Theseus pulls down the branch of a tree and prepares to attach Sinis to it. c. 480

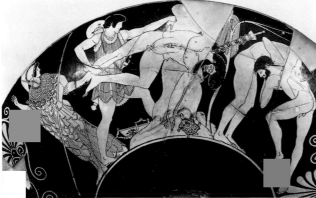

239 (side B of 238) Athena watches as Theseus throws Skiron from the rocks. Note the footbath and 'man-eating' turtle; Theseus, wrestling with Kerkyon, lifts him off the ground

240 (*above*) Limestone relief, frieze from the
Heroon at Trysa. Deeds of Theseus. Theseus lifts
the rock; throws Skiron from a cliff to the waiting
turtle and fish below; bends the tree to which he
will attach Sinis. *c.* 400

241 (*right*) Marble relief, metope from the
Hephaisteion at Athens. Theseus and Kerkyon. *c.* 450

242 (*below*) Attic black-figure amphora from Vulci.
Theseus and the Bull of Marathon. Literally under the
aegis of Athena, Theseus captures the bull. *c.* 500.
42.5 cm

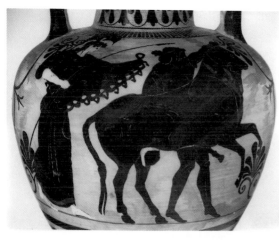

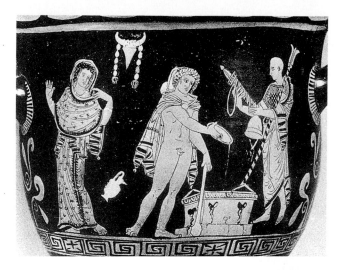

243 (*above*) Apulian red-figure bell-krater. Recognition of Theseus by Aigeus. Theseus, wearing a traveller's hat and cloak and holding his club, pours a libation at an altar. At the same moment, Aigeus, his sceptre resting in the crook of his arm, recognizes the sword and helmet, and Medea realizes that her plans to do away with Theseus have been foiled. *c.* 380. 38.8 cm

244 (*right*) Attic red-figure cup by Onesimos, from Cervetri (see *237*). Theseus under the sea. Supported by a small triton, Theseus is greeted by Amphitrite who will give him a wreath, as Athena looks on. *c.* 500

245 (*below*) Gold relief, plaque from Corinth. Encouraged by Ariadne, Theseus attacks the Minotaur with a sword. *c.* 650. W. 4 cm

246 (*below right*) Bronze relief, shield band panel from Olympia. Theseus and the Minotaur. Between them is Ariadne holding a wreath. *c.* 560

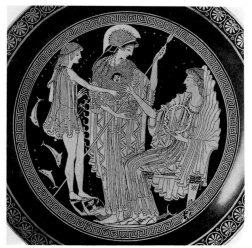

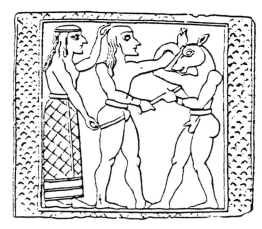

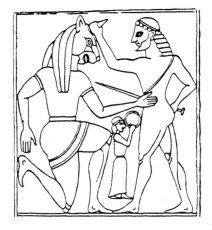

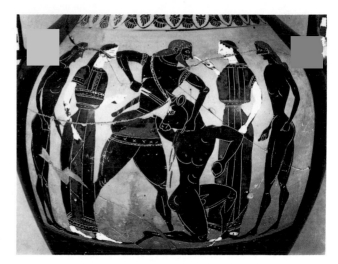

247 Attic black-figure amphora from Group E, from Vulci. Theseus and the Minotaur. Theseus stabs the Minotaur with his sword as two youths and two women look on. While the onlookers here may be interpreted as young Athenians, similar figures appear in other contemporary scenes where they can have no possible connection with the myth depicted and are simply part of the formal design. *c.* 540

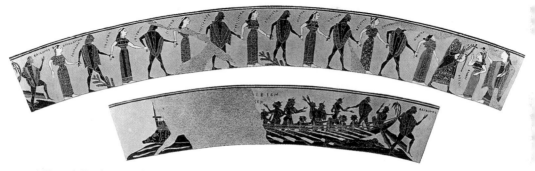

248 'François Vase' (see *1*) The Dance of the Athenian youths. Led by Theseus the Athenian youths and maidens hold hands and dance in front of Ariadne who holds a wreath and a ball of yarn and is accompanied by her nurse. Behind them sailors rejoice as they land to collect their passengers. *c.* 570

249 Attic red-figure hydria by the Syleus P., from Vulci. Theseus abandoning Ariadne. Athena ushers Theseus off to the left while Dionysos leads Ariadne off to the right. *c.* 470

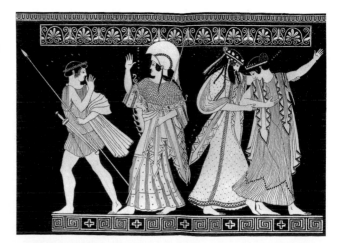

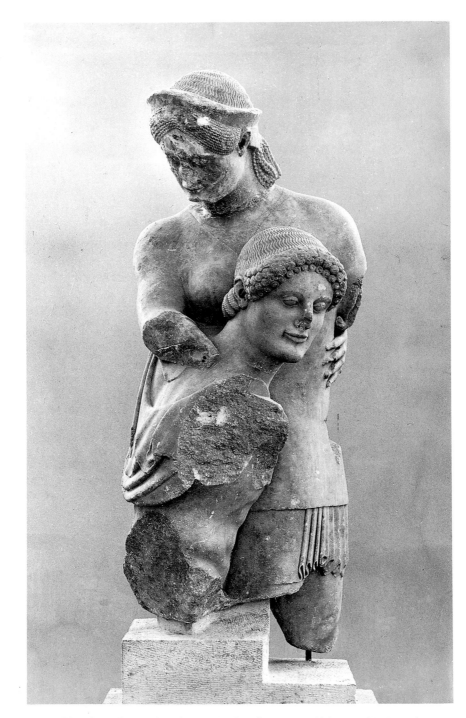

250 Marble pedimental group from the Temple of Apollo at Eretria. Abduction of Antiope. Theseus lifts the Amazon queen Antiope into his chariot. Athena stood at the centre of the pediment, and these figures were to the right of her. *c.* 500. 1.12 m

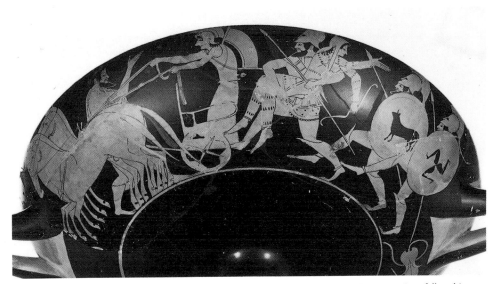

251 Attic red-figure cup by Oltos. Theseus carries Antiope to his waiting chariot as his companions follow him. The shield devices are a bull and a triskeles (three legs). On the other side of the vase (not shown) warriors fight Amazons on horseback. *c.* 510

252 Marble shield. 'Strangford Shield' from Athens. Roman copy of the shield held by Pheidias' Athena Parthenos. In the centre a gorgoneion, and around it warriors fighting Amazons. A gigantomachy was painted on the inside, of which traces survive. D. 50 cm

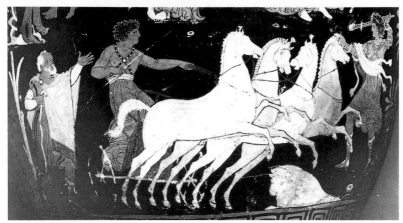

253 Apulian volute-krater. Death of Hippolytos. Hippolytos drives his chariot as a bull rises up from the sea and a Fury with a snake in one hand waves a torch with her other. Behind the chariot an old man looks on in horror. *c.* 340

254 Bronze relief from Olympia. Kaineus. Two centaurs use tree branches to pound Kaineus into the ground, but not before he has wounded one of them with his sword. *c.* 630

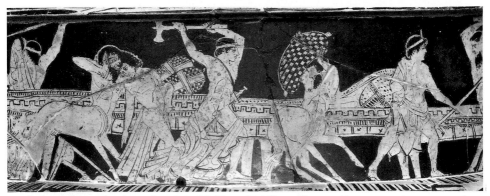

255 Attic red–figure volute-krater from Italy. Wedding of Peirithoos. Theseus with an axe attacks a centaur who shields himself with a pillow he has taken from one of the klinai where the Lapiths had been celebrating the marriage of Peirithoos. To the left and right Lapiths battle with centaurs. *c.* 450

256 Reconstruction of the west pediment of the Temple of Zeus at Olympia. Battle of the Lapiths and Centaurs at the wedding of Peirithoos. At the centre is Apollo, his arm raised to bring order out of the chaos of the battle that rages around him. *c.* 460

257 Marble pedimental group from the west pediment of the Temple of Zeus at Olympia. The centaur Eurytion wrestles with Deidameia, the bride of Peirithoos. 2.35 m

258 Attic red-figure amphora by Euthymides, from Vulci. Abduction of Helen (?) Theseus carries away a woman named Korone while another woman, labelled Helen, tries to stop him, and his companion Peirithoos follows. It is likely that the painter inadvertantly reversed the names of the women and this is a depiction of the well known abduction of Helen. *c.* 510. 57.5 cm

259 Attic red-figure calyx-krater by Myson. Akamas and Demophon with Aithra. Akamas and Demophon lead away their grandmother Aithra after the fall of Troy. Her servitude is indicated by her short hair, her age by her staff. Note the shield devices, a red-figure pegasos and a black-figure centaur with a tree branch. *c.* 500. 40.5 cm

Opposite

260 (*top*) Apulian volute-krater. Rape of Chrysippos. Laios holds the youth Chrysippos as he races away with him in his chariot. Behind the chariot is a warrior in oriental garb, in front of it a hunter with a dog. *c.* 310

261 (*centre left*) Attic red-figure amphora by the Achilles P., from Vulci. Euphorbos with the infant Oedipus. The herdsman dressed as a traveller brings the child to a man (not shown) who must be king Polybos of Corinth. *c.* 450

262 (*centre right*) Cornelian scarab from Orvieto. A winged sphinx carries the body of a youth. *c.* 500. L. 1.2 cm

263 (*below right*) Attic red-figure lekythos. A winged sphinx carries the body of a youth. *c.* 470

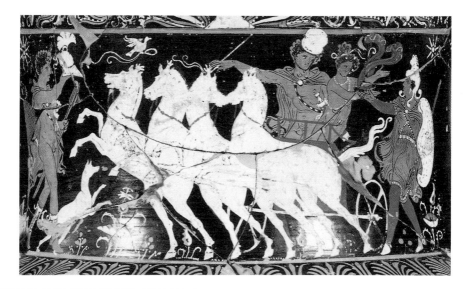

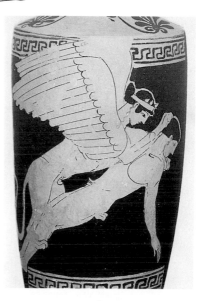

264 Attic red-figure cup from Vulci. Oedipus and the Sphinx. Oedipus, wearing a traveller's hat, boots and cloak, sits on a rock and ponders the riddle of the sphinx, who sits at the top of an ionic column. The floral device beside the column is purely decorative. *c*. 470

265 (*below*) Attic red-figure hydria. Seven Against Thebes. Only one figure is named, Parthenopaios, the youth who is about to cut his hair with a sword, but that one name virtually assures the identification of the other six as warriors who fought at Thebes against Eteocles. The warriors here are preparing for battle. *c*. 460. 35 cm

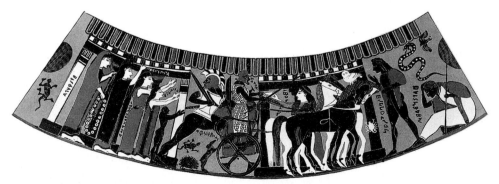

266 Corinthian column-krater from Cervetri. Departure of Amphiaraos. Amphiaraos mounts his chariot and looks back at Eriphyle who holds the necklace with which she was bribed

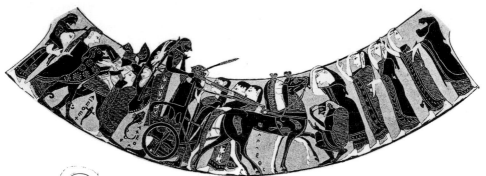

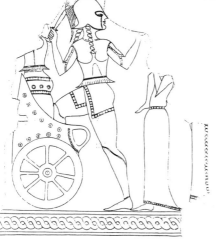

267 (*above*) Attic black-figure 'Tyrrhenian' amphora from Tarquinia. Departure of Amphiaraos. Old men and women mourn as Amphiaraos prepares to mount his chariot. Note the woman holding a child and the youth reaching up to his father. *c.* 550

268 (*left*) Bronze relief from Olympia. Departure of Amphiaraos. The charioteer is already in the chariot as the warrior, holding his sword, mounts and looks back at a woman holding a child. Late 7th Century

269 (*below*) Corinthian amphora from Cervetri. Death of Ismene. Tydeus, with his sword drawn is about to kill Ismene who lies half naked on a kline as Periklymenos escapes. The painter's decision to paint Periklymenos white seems to be more a matter of design than of meaning. Normally white is reserved for female flesh. *c.* 550. 32 cm

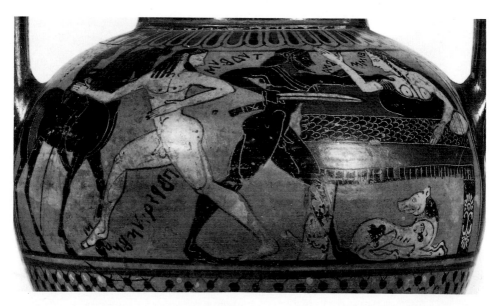

270 Attic red–figure volute-krater from Spina. Seven Against Thebes. At the bottom of the scene the chariot of Amphiaraos sinks into the ground as the battle rages around him. On the neck of the vase, Herakles and Busiris. *c.* 440. 62 cm

Chapter Eight

ARGONAUTS; CALYDONIAN BOAR HUNT

Many of the noblest Greeks from the generation before the Trojan War, including several introduced in these pages, participated in two heroic expeditions, the voyage of the *Argo* to fetch the golden fleece and the hunt for the Calydonian boar, and the myths of these two undertakings are an appropriate place to end the survey of the early heroes.

Jason of Iolkos in Thessaly is the focal figure in the stories of the voyage of the *Argo*. His uncle, Pelias, King of Iolkos, who had managed to take the throne away from its rightful owner, Jason's father, persuaded Jason to go to Kolchis on the Black Sea and get for him a golden fleece that hung there guarded by a dragon in a grove of Ares. His hope was, of course, that Jason would perish in the attempt, but clearly Pelias did not count on the support Jason would receive from the noblest youths of Greece who all seem to have been ready for an adventure just then.

The golden fleece, which was the object of the quest, was from a ram that had been sacrificed in Kolchis by Phrixos, a Boeotian noble. When his wicked stepmother had planned to have him sacrificed, his natural mother put him and his sister Helle on a golden-fleeced ram given to her by Hermes, and on that ram they escaped by flying over the sea. Along the way, however, Helle fell off and drowned, and the body of water into which she fell is named the Hellespont after her. Phrixos landed safely in Kolchis on the Black Sea, and showing an odd sense of gratitude, sacrificed the ram to Zeus and hung its fleece in the grove, where it was guarded by a dragon.

The earliest certain depiction of Phrixos on the ram is a fragment of a marble relief from Olympia *c.* 500, and it is not an uncommon subject on vases throughout the 5th century. Phrixos on, or clinging to, the ram as it flies through the air appears on a gold ring *[271]* and on several Attic red-figure vases. On one, Ino, his stepmother, is shown pursuing with an axe. Scenes of Phrixos (or sometimes Helle) on the flying ram appear on South Italian vases as well *[272]*. On several Melian reliefs *c.* 460, Phrixos or Helle rides the ram. Pausanias (1.24.2) tells of a statue on the Acropolis in Athens of Phrixos sacrificing the ram, and on several South Italian vases he is shown leading it to sacrifice.

The ship on which the heroes sailed, which was built with the help of Athena and included a speaking plank of an oak from the Sanctuary of Zeus at Dodona, was called the *Argo*, and from it the voyagers are known as the Argonauts. The

various lists of many participants do not agree completely, but of figures mentioned in these pages, Theseus, Orpheus, Peleus, Herakles (for part) and the Dioskouroi are often included, and several episodes from the expedition are depicted in Greek art. The earliest certain depiction of the ship with the Argonauts is on fragments of a metope from the Treasury of the Sicyonians at Delphi, c. 560 [273].

When the Argonauts stopped for water in the land of the Bebrykes, they were met by the fierce king, Amykos, a son of Poseidon whose custom it was to challenge strangers to a boxing match, thereby killing them. Polydeuces, brother of Kastor and a famous boxer, accepted the challenge and won. According to a lost poem, Amykos was then tied to a tree and left on the shore, a scene which appears on a Lucanian red-figure vase from the end of the 5th century [274] (and is common in Etruscan art during the 4th).

Next they stopped at Salmydessos in Thrace to consult the blind seer Phineus on how to get to Kolchis. He agreed to help them on the condition they first rid him of the winged harpies who plagued him by stealing and fouling his food. Both Aeschylus and Sophocles wrote plays about Phineus, and the reasons given for the plague of harpies are many. In any case, the winged Zetes and Kalais, sons of Boreas, chased them until they dropped (or agreed never to bother Phineus again).

Elements of this myth are popular subjects for art in many parts of Greece throughout the 6th century and during most of the 5th. The earliest depiction of the Boreads, as Zetes and Kalais are known, in pursuit of the harpies appears on an Attic black-figure louterion from about 600, but it also appears on Laconian cups from the 570s and on an Attic plate by Lydos from before the middle of the century.

Pausanias tells that Phineus along with the Boreads chasing the harpies was depicted on the Chest of Kypselos and also (3.18.15) on Bathykles' throne at Amykle. Fragments have survived of an ivory relief (c. 570) from Delphi [275] that included Phineus, the Boreads and the harpies, as have fragments of a somewhat earlier Corinthian krater and a Chalcidian cup of c. 530. Phineus with the Boreads and/or harpies is also a popular subject on Attic red-figure vases during the 5th century [276], but it is not a common subject on South Italian vases.

After more adventures, none of which are depicted in ancient art, the Argonauts arrived at Kolchis where Jason demanded the fleece from King Aietes, who set him two impossible tasks on the completion of which he would give it to him. The witch Medea, daughter of King Aietes, who quickly fell in love with Jason, helped him accomplish the tasks on the condition that he would take her with him when he left. When Aietes reneged on his promise and refused to part with the fleece, Medea helped Jason take it.

Literary sources are of little use in interpreting the few surviving depictions of Jason and the dragon. On an Attic red-figure cup of c. 470 [277], a huge dragon

vomits out the naked body of Jason in the presence of Athena near the tree with the fleece hanging from it. The huge snake vomiting out a man on a late 7th-century Corinthian alabastron probably represents the same subject and thus shows the antiquity of the subject – but no source has survived to tell how Jason got inside the dragon in the first place, or why Athena rather than Medea is shown.

Athena also appears in another depiction of the subject on an Attic red-figure krater, c. 460 [278]. There she watches as Jason reaches up for the fleece which is guarded by an unprepossessing dragon. On another krater by the same painter with a similar scene, Jason has been replaced by a satyr and Athena by Dionysos, suggesting a theatrical source for both scenes – perhaps plays by Aeschylus. On a few 4th-century South Italian vases, Jason attacks the dragon in the presence of Medea.

Only one of the many adventures of the Argonauts on their way home is a subject of ancient art, the death of Talos. Talos was a man of bronze, given to King Minos of Crete by Hephaistos, who kept guard by running around the island three times each day. When Talos tried to prevent the Argonauts from landing, Medea, according to one version, devised his death, and this is the version depicted on a late-5th-century red-figure krater [279]. The Dioskouroi catch the falling Talos as Medea stands to the side, in front of the *Argo*, holding an embroidered sack (presumably containing her magic potions and drugs).

On his return to Iolkos, Jason discovered that while he was away, Pelias had caused the death of his father, Aison. Feigning reconciliation, Jason gave the fleece to Pelias, but at the same time he plotted revenge with Medea. She went to the daughters of Pelias and convinced them that she could, with her magic, make their father young again, and she offered proof by cutting up a ram and turning it into a lamb by boiling it in a cauldron. The daughters proceeded to cut up their father and boil the pieces, but, of course, to no avail.

The death of Pelias at the hands of his innocent daughters was a popular subject with Attic black-figure vase-painters at the end of the 6th century and with red-figure painters during the first half of the 5th. Often the ram is shown in the cauldron as Medea and the daughters look on, and sometimes a white-haired Pelias also observes [280]. On one red-figure vase just the daughters appear. One leads the way, one with a phiale hesitates, and a third with a sword urges her on.

In heroic times (and perhaps sometimes later), funeral games where young nobles competed for prizes, were held in honour of great men. The funeral games of Pelias are a subject that appears on several Archaic works, where inscriptions make certain the identification (funeral games for Patroklos are also depicted in ancient art, see Chapter 9). The earliest depiction is probably that on a fragment of an Attic black-figure vase from the Acropolis, c. 570, where one of two runners is named Phalareus, a participant mentioned by Pausanias in his description of the games as depicted on the Chest of Kypselos. On a shield band from Olympia [281] a boxer is named Mopsos, as on the Chest, and the games

are treated in some detail on a Corinthian krater of *c.*560 already mentioned (Chapter 7) for its connection with the Chest.

One particular contest from the games was popular with Attic black-figure vase-painters during the second half of the 6th century – the wrestling match between Peleus and the virgin huntress (athlete) Atalanta, who is discussed in more detail in connection with the Calydonian boar hunt. This match, which is mentioned only by Apollodorus, first appears on a shield band from Perachora, *c.* 575, and then on several Attic black-figure vases from the middle of the 6th century and several from the end, on a Chalcidian hydria, *c.* 540 *[282]*, and on early 5th-century gems. It is rarely depicted on Attic red-figure vases, but it is the subject of a Melian relief. Most depictions show the beginning of the fight where Peleus and Atalanta still stand, grasping each other's arms.

After the death of Pelias, Jason and Medea were, not surprisingly, forced to leave Iolkos, and they settled in Corinth. After ten years, however, Jason abandoned Medea for Glauke, the daughter of King Creon of Corinth. Maddened by his treachery, Medea sent Glauke a poison robe which stuck to her skin and burnt her and her father, when he came to her aid. Then Medea killed her own children by Jason and escaped to Athens in a chariot drawn by dragons to marry Aigeus. Though there are other versions of the story, this is the one used by Euripides in his *Medea* (and told by Apollodorus) and it is the version illustrated by South Italian vase-painters. On a Lucanian krater of *c.* 400, Glauke has put on the poisoned robe in the presence of Creon and servants, and on a Lucanian hydria and krater from the same date, Medea rides her chariot drawn by dragons above the altar on which her dead children lie *[283]*. Details of the actual murders appear on later Campanian and Apulian vases.

Meleager, son of Oineus, the King of Calydon is the focal figure in the myth of the Calydonian boar hunt. According to Homer (*Iliad* 9.529–99), Oineus neglected Artemis when he was sacrificing to the gods and the angry goddess sent a monstrous boar that ravaged the countryside. Meleager assembed a group of men with dogs to fight the animal and kill it. Later authors named the assembled hunters and usually include the Dioskouroi, Theseus, Peirithoos, Jason, Peleus and Atalanta, among others, and they add a romantic attachment between Meleager and the virgin huntress. According to Apollodorus, Atalanta was the first to shoot the boar, but it was Meleager who killed it and then gave her the skin. Homer tells nothing of a connection between a burning log and the length of Meleager's life, as later writers do, but he does connect his death with his mother's anger at the loss of her brothers.

Boars and boar hunts are popular subjects in Archaic art, and it is not possible to be certain that a hunt is for the Calydonian boar unless participants are named or a female is included. One of the early certain depictions is on the neck of the François Vase *[284]*, opposite the frieze with Theseus and the Athenian youths, where most of the participants (including dogs) are named. The huge boar is in the center, attacked front and back, and a disemboweled man and dog lie

186

beneath it. Peleus and Meleager lead the attack from the front and are followed by Atalanta and Melanion. According to Pausanias, Melanion was also shown together with Atalanta on the Chest of Kypselos and these clearly point to a different and probably earlier version of the story where he, rather than Meleager, is Atalanta's companion or lover. On fragments of a slightly earlier Attic dinos where the hunt was depicted, Atalanta stands beside a man whose name was inscribed, but only the first two letters remain – ME!

Similar depictions of the hunt, with the hunters and dogs variously arranged about the central boar, appear on several other Attic black-figure vases, mostly from before the last quarter of the 6th century, on a Chalcidian amphora, and on Caeretan hydriai. Whether or not hunters attacking a boar on a Laconian cup, c. 560, [285] are to be seen as the Calydonian hunt depends on one's interpretation of the sex of the second hunter. The Calydonian boar in a metope from the Treasury of the Sicyonians at Delphi, c. 560, survives.

Certain depictions of the Calydonian hunt are rare on Attic red-figure vases, but they do appear on 5th-century Melian reliefs. Most of a depiction of a hunt on a frieze from the heroon at Trysa (c. 400) survives, and Pausanias (8.45.3) tells that it was the subject of Skopas' east pediment of the mid-4th-century Temple of Athena at Tegea, which he describes in some detail. There, Atalanta seems to have fought beside Meleager.

Meleager and Atalanta are shown together conversing on several Attic red-figure vases from the end of the 5th century, perhaps illustrating Euripides' play *Meleager* produced in 416, and a depiction of the 4th century may have the same source. There, Tydeus and Meleager's sister Deianeira help him to a kline as a woman, probably a repentant Althaia, rushes in and Peleus and Thetis sit outside the house mourning. There is no hint of the burning log.

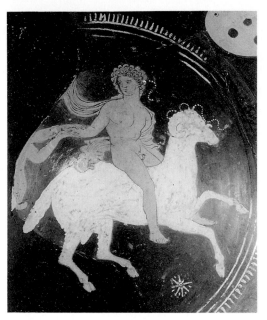

271 Gold ring. Phrixos and the Ram. 4th Century. L. 1.5 cm

272 (*right*) Apulian red-figure dish. Phrixos and the Ram. Helle grasps at Phrixos' arm as she slides from the back of the ram. *c*. 320

273 Limestone relief, metope from the Sicyonian Treasury at Delphi. Argonauts. The Dioskouroi on horseback (one mostly missing) frame the ship, Argo, where Orpheus and another, both with kitherai, stand. *c*. 560. 58 cm

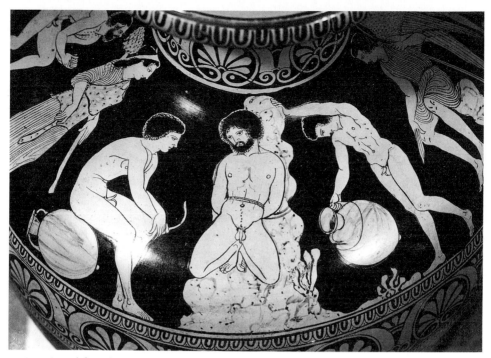

274 Lucanian red-figure hydria. Amykos is tied to a rock while two youths (Dioskouroi?) collect water. One of them, sitting on his jar, holds a strigil, a reference to the boxing match in which Polydeuces defeated Amykos. To the far right Nike(?) sits on a rock. To the left stand a maenad wearing a fawn-skin and holding a thrysos, and a satyr. *c.* 400

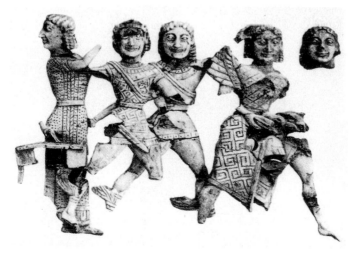

275 Ivory relief attachments, from Delphi. A woman looks back at Phineus, whose hand can be seen on the table, while the two Boreads chase off two Harpies. *c.* 570. 7 cm

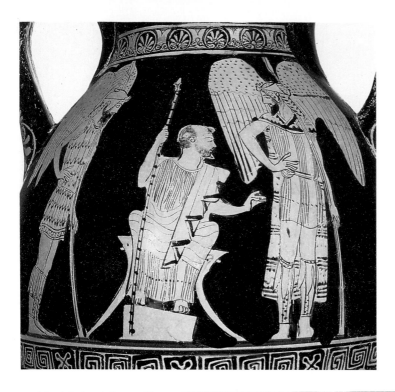

276 (*above*) Attic red-figure pelike.
Phineus and the Boreads. Blind
Phineus holding a sceptre sits on
his throne flanked by winged
Zetes and Kalias in Thracian dress.
c. 450. 21.5 cm

277 Attic red-figure cup by Douris
from Cervetri. Jason and the
dragon. The bearded dragon
disgorges Jason while Athena,
holding an owl and leaning on her
spear, watches. Note the
gorgoneion on her aegis and the
sphinx on her helmet. The golden
fleece hangs on a tree behind the
dragon. *c.* 470

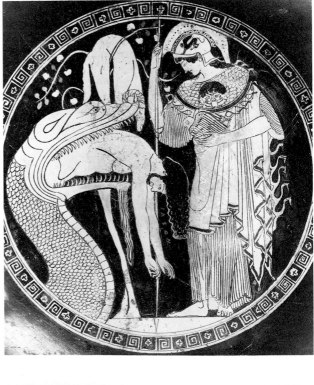

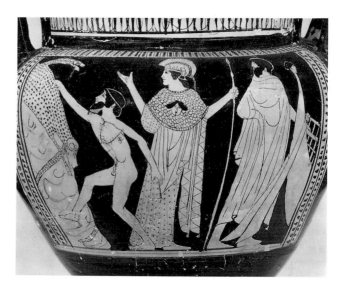

278 Attic red-figure column-krater by the Orchard P. Jason and the dragon. Jason reaches out for the fleece, which is guarded by a small dragon. Athena and another god (?) observe. To the right is the stern of the Argo with a small head at the top of the stern-post, a reference to the ship's ability to speak. *c.* 460

279 Attic red-figure volute-krater by the Talos P., from Ruvo. Death of Talos. Medea in Oriental garb stands to the left in front of the Argo holding her box of magic potions while the Dioskouroi catch the falling Talos. Poseidon with his trident sits to the right with Amphitrite observing. *c.* 400

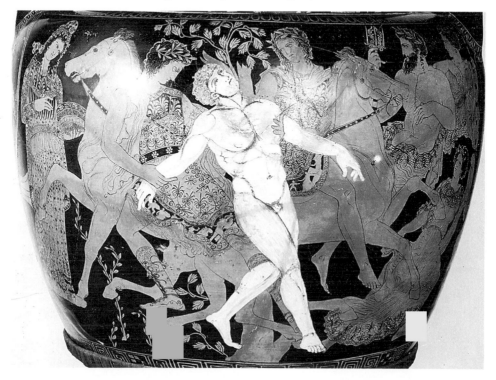

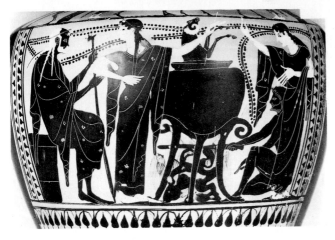

280 (*above*) Attic black-figure hydria, from Vulci. Medea and
the Ram. White-haired Pelias holding his sceptre sits watching
as Medea demonstrates her rejuvination technique with a ram in
a boiling cauldron. A man stokes the fire beneath the cauldron
and one of the daughters of Pelias to the right seems to
encourage her father, but the gesture is ambiguous. *c*. 510

281 (*right*) Bronze relief, shield band panel from Olympia.
Funeral games of Pelias. Mopsos and another box over a tripod-
cauldron. *c*. 570. 68 cm

282 (*below*) Chalcidian hydria from Vulci. Peleus and Atalanta.
Peleus and Atalanta wrestle in front of a boar-skin. Named
among the onlookers are Mopsos and Klytios. The woman
observing may be a goddess. This scene links the myth of the
Calydonian boar hunt (through the boar-skin) with the funeral
games for Pelias. *c*. 530

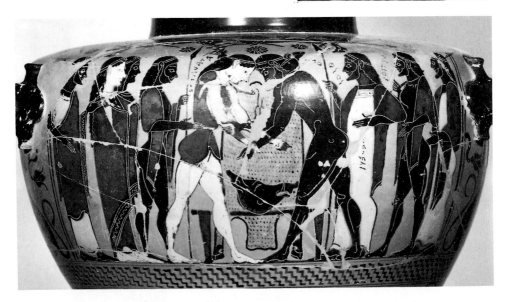

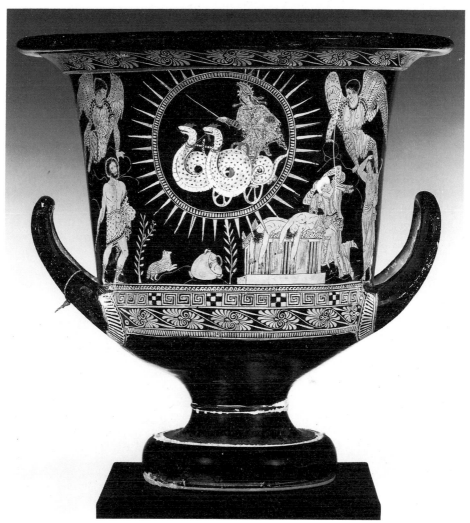

283 Lucanian red-figure calyx-krater. Medea wearing a Phrygian helmet drives a chariot drawn by dragons and surrounded by rays, which refer to her grandfather Helios, whose chariot it is. Below, an old nurse and tutor mourn the children dead on an altar, and to the left Jason looks up at his departing wife. Above, two winged Furies observe. c. 400. 51.4 cm

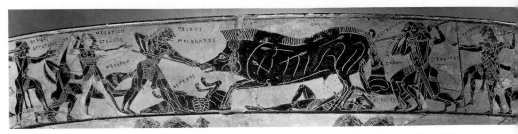

284 François Vase (see *1*). Calydonian Boar Hunt. Peleus and Meleagros attack the boar from the front followed by Melanion and Atalanta. A dog and a hunter lie disembowelled beneath the beast. Note the archer dressed in Scythian clothing to the far right, and the arrows in the side of the boar

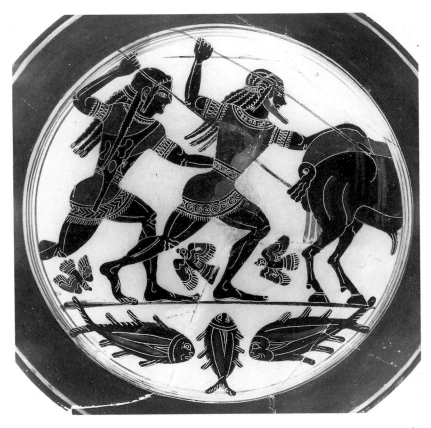

285 Laconian cup. Boar Hunt. This may be a generic boar-hunting scene, but some have argued that the beardless hunter is a women, thus Atalanta, which would make it the Calydonian hunt. *c.* 560

Chapter Nine

THE TROJAN WAR

The Trojan War was the central event in the historic past for all Greeks, and in the *Iliad* it was the subject of the literary work that above all others defined their perception of the heroic and the divine. The *Iliad*, however, deals only with one of the war's ten years, the *Odyssey* with the return of only one of the heroes after the war, and both poems must depend on much older oral traditions. Poets after Homer, drawing on the same traditions, wrote poems that dealt with the other years of the war and with other returns after the war, and together these have come to be known as the epic cycle, though only summaries of the non-Homeric works survive.

Apart from their literary forms, many of the stories that formed the epic cycle must have been part of the common heritage of Greeks during the Archaic and Classical periods, and as with stories of other heroes, conflicting details and even different versions could exist side by side. To treat the question of precisely which source a vase-painter or a gem-cutter drew on is far beyond the scope of this book. In any case, it would almost always be wrong to say that an artist, particularly during the Archaic period, was illustrating a text. Rather he narrated a story he knew with images instead of words.

This chapter is an attempt to look at the stories of the Trojan War, its causes and consequences, through the eyes of vase-painters, bronze-workers, sculptors and gem-cutters who worked during the Archaic and Classical periods. The organization of the material is based roughly on the chronology of events gleaned from Proclus' summaries of the lost poems of the epic cycle and, of course, on the *Iliad* and the *Odyssey*, but only those events depicted in ancient art are discussed.

An account of the war must start here with the wedding of Peleus and Thetis, an event already touched on in Chapter 3. According to the *Cypria*, the poem that dealt with the causes and early stages of the war, it was at the feast after the wedding that the seeds of the war were planted when Eris (Strife) started a dispute between Hera, Athena and Aphrodite as to which was fairest. This in turn, led through the judgement of Paris to the abduction of Helen, and it was through the union of Peleus and Thetis that Achilles, the greatest of the Greek heroes, was born.

Thetis, a Nereid, or sea nymph, daughter of Nereus, was loved by both Zeus and Poseidon. Probably because of their discovery that she was fated to have a

son greater than his father, they both withdrew their suits and arranged her marriage with Peleus, a mortal grandson of Zeus. First, however, Peleus had to catch Thetis, who had her father's gift of changing shapes, and, as Herakles had with Nereus, he succeeded by clinging to her throughout her metamorphoses. The subsequent wedding and feast was attended by all of the gods.

Pausanias says that on the Chest of Kypselos, Peleus was shown taking hold of Thetis from whose hand a snake darted. The snake here can be understood through depictions on a large number of Attic black-figure vases from the second half of the 6th century, and red-figure vases primarily from the first quarter of the 5th, where Thetis' transformations are represented by snakes and felines that wrap around her limbs and stand on her shoulders and arms. On a Melian relief from the middle of the 5th century [286] they are represented by a single lion. Though these transformations are not always indicated, the scene can nonetheless usually be distinguished from the wrestling match between Peleus and Atalanta by Thetis' modest dress and obvious desire to escape.

A slightly different version of the subject where Peleus comes out from hiding behind an altar and pursues the fleeing Nereids appears on a Corinthian krater, c. 560, and the pursuit rather than the fight appears on Attic vases during the second half of the 5th century [287], all but replacing the other by about 450. The subject appears on only a few Apulian vases, mostly early.

The procession of deities coming to the wedding of Peleus and Thetis on Attic vases by Sophilos and Kleitias have already been examined in some detail (Chapter 3). On both vases Peleus stands in front of the house greeting the guests, and on the François Vase Thetis can be seen seated inside.

A frieze on the Chest of Kypselos certainly depicted the wedding, though Pausanias misunderstood it and called the couple Odysseus and Circe. According to this description, a man and a woman lay in a grotto in front of which women cooked; then there was a centaur followed by chariots drawn by winged horses in which women rode; then a crippled man, followed by an assistant with tongs, gave armour to one of the women. Chiron must be the centaur, as on the Attic vases, but here the emphasis is on the gift of the armour which was presented to Peleus on his wedding day (Iliad 18.85). Hephaistos must, of course, be the crippled man.

Thus there were two contemporary but quite different depictions of the wedding feast of Peleus and Thetis from Corinth and Athens and there is no clear iconographic link between them. Curiously the subject is popular only briefly and neither the Corinthian nor the Attic models appear again. However, Peleus and Thetis are the named couple on an Attic black-figure hydria from the second half of the 6th century [288] and on a slightly earlier Eretrian black-figure amphora. Similar scenes in which an unnamed wedding couple rides in a chariot accompanied by a few deities (usually Hermes, Apollo, Dionysos and a goddess) are popular on Attic vases throughout the second half of the 6th century, and it is possible that an Athenian would have understood this couple always to be Peleus

and Thetis. It is also possible that the scene was, or became, a generic wedding scene with various deities playing symbolic roles.

The wedding couple in a chariot occasionally appears on Attic red-figure vases from the 5th century as do a few more detailed scenes with Peleus leading Thetis to a chariot in the presence of deities, or leading her to his house but, surprisingly, this wedding does not appear in the more romantic art of the 4th century in either Greece or South Italy.

The centaur Chiron, who has a prominent place in the early depictions of the wedding, was to be the tutor of the young Achilles. Depictions of Peleus entrusting Achilles to Chiron appear on many Attic black-figure vases throughout the second half of the 6th century [289] and on a few red-figure vases on into the first quarter of the 5th, when Achilles is sometimes shown as a youth rather than a child. The earliest occurrence of the scene is on a Proto-attic neck-amphora from the middle of the 7th century. It also appears on a Corinthian plate, c. 600, where both Chiron and his wife Chariklo are named, and Pausanias (3.18.9) says that it was carved on Bathykles' throne at Amyklai near Sparta, dated to the late-6th century.

To return to the wedding celebration, it was there that Eris (Strife), for whatever reason, started a dispute between Hera, Athena and Aphrodite as to which was fairest. In some versions Eris tosses a golden apple inscribed 'for the fairest' but both the literary and iconographic evidence for this detail are from long after our period. Zeus ordered Hermes to lead the three goddesses for judgement on the issue to Alexander (or Paris as he is more often called), a handsome son of King Priam of Troy. Each goddess offered him a bribe, Hera power, Athena success at war, and Aphrodite the hand of Helen, the most beautiful of women. Paris chose Aphrodite, thereby earning the eternal enmity of Hera and Athena. Sometime later, Paris went to Sparta accompanied, at Aphrodite's command, by Aineias to claim his prize though Helen was already married there to Menelaos, the king. After presenting gifts and being royally entertained by Menelaos, Paris absconded with the not unwilling Helen (and with substantial treasures) and returned with her to Troy, thus providing the immediate cause for the war.

The judgement of Paris was a popular subject in Greek art from soon after the middle of the 7th century on through the 4th. The earliest depiction is on a Proto-corinthian olpe (called the Chigi Vase) from about 640, where Hermes leads the three goddesses to Paris, a beardless youth who stands waiting for them. The next depiction is on an ivory relief on a Laconian comb from about 600 [291] and here a bearded Paris sits on a throne as the goddesses approach. In neither scene do the goddesses have attributes.

The subject is popular with Attic black-figure painters from the second quarter of the 6th century on into the 5th. On these Paris stands waiting, or more often flees [290], as the procession led by Hermes approaches. Paris is usually shown as an unexceptional, bearded adult, and after the middle of the 6th

century Athena often wears a helmet and aegis. On some vases the goddesses led by Hermes are shown without Paris. The processional scenes also appear on Chalcidean vases and on an Eretrian amphora, and Pausanias (5.19.1; 3.18.7) tells that this was the version depicted on both the Chest of Kypselos and Bathykles' throne at Amyklai.

On a few black-figure vases Paris sits on a throne as on the ivory relief, and on a few he sits on a rock with a lyre, but this version is more common on Attic red-figure vases from the first half of the 5th century. On these, Paris is usually a youth and is sometimes surrounded by goats.

In another version, popular with red-figure painters during the second half of the 5th century and on into the 4th when South Italian painters also adopt it, the goddesses gather about Paris as he prepares to make his decision, and by the end of the 5th century Paris is often shown in this dressed as an Oriental prince in ornate trousers and a Phrygian cap [292].

A scene on a geometric krater, c. 730, and on an ivory relief, c. 600, where a warrior leads a woman onto a ship (or takes his leave of her) have sometimes been identified as the abduction of Helen by Paris, but the first certain depictions of the abduction appear about 480 on two Attic red-figure vases [293]. On them, Paris grasps Helen by the wrist and leads her away with Aineias while Eros flutters above and Aphrodite and Peitho, goddess of persuasion, see her off. On later vases he is sometimes shown driving Helen away in a chariot. Not surprisingly, romantic depictions of Paris with Helen before the abduction are popular with Attic red-figure painters during the second half of the 5th century and are carried on into the 4th by Lucanian and Apulian red-figure painters. On the South Italian vases he usually wears a Phrygian cap and often the ornate trousers. On a Corinthian krater from about 580, Paris and Helen are shown as a wedded pair in a chariot amidst other named Trojans [294].

Before proceeding with the war as it appears in ancient art, a digression on Helen's birth is in order. In the best-known version she is the daughter of Leda by Zeus who came to her in the form of a swan. Tyndareus, Leda's husband, also slept with her on the same night, and the children born (hatched from an egg, or eggs, in some versions) were of mixed paternity. Helen is almost always a daughter of Zeus, Clytemnestra of Tyndareus, and the twins Kastor and Polydeuces (the Dioskouroi) are usually sons of Tyndareus and Zeus respectively. In another version, that told in the *Cypria*, Zeus pursued Nemesis and when she turned herself into a goose in her attempt to escape, he turned himself into a swan and mated with her. When she laid the egg from which Helen was later born, it was given to Leda who then raised Helen as her own.

The earliest depiction of Leda and the swan, as mentioned in Chapter 3 is from about 400. Part of the other story, however, is depicted on more than a dozen Attic red-figure vases from 450 to 400, most of which were painted during the last third of the century. On these, a large white egg sits on the altar of Zeus while Leda looks on [295]. Tyndareus is often present, as are the Dioskouroi. A similar

scene appears on some Campanian and Apulian red-figure vases from the 4th century, where Helen is sometimes shown emerging from the egg.

According to Pausanias (1.33.8) Leda leading Helen to Nemesis was the subject of sculpture on the base of the cult statue of Nemesis by Agorakritos, a pupil of Pheidias, at her temple at Rhamnous, which would have been sculpted at approximately the same time Attic red-figure painters took up the subject of the egg.

On learning of Helen's flight with Paris, Menelaos went to his brother Agamemnon, the great king of Mycenae, and together they enlisted the support of the leaders of the many Greek cities for an expedition to recover Helen. The length of time it took to muster the forces is unclear, but it was certainly several years. An oracle had told that the aid of Achilles was essential for success. Thetis knew this and also knew what his fate would be if he fought at Troy. So, according to one version, she dressed him as a girl when he was nine and sent him to live with the daughters of Lykomedes on Skyros (where he eventually fathered a son, Neoptolemos, by one of them). Eventually Odysseus uncovered the ploy and Achilles joined the expedition.

Achilles amongst the maidens on Skyros was the subject of a painting by Polygnotos (c. 450) in the Propylaia to the Acropolis in Athens, according to Pausanias (1.22.6), and according to Pliny (35.134) Odysseus recognizing the disguised Achilles was the subject of a painting by Athenion of Maronia (c. 350). These are the only known depictions of this version from our period, though several survive from later periods.

According to the *Iliad*, Achilles lived in Phthia with his father prior to the war, and before he left Peleus gave him the armour he had received from the gods at his wedding. Achilles was accompanied in the Trojan expedition by Patroklos, his friend since childhood, and Phoenix, his old tutor. According to another tradition, which survives in Euripides' *Elektra* (442–450) Nereids presented Achilles in Phthia with armour made for him by Hephaistos.

Achilles' departure from his father's house appears on a few Attic black-figure vases from the second quarter of the 6th century. On a kantharos Achilles and Patroklos, in the presence of Odysseus and Menelaos, take their leave of Thetis who has come to see them off. On a fragmentary kantharos by Nearchos, Achilles harnesses his chariot while Thetis or another Nereid holds his armour, and on a plate by Lydos [296] Peleus and Thetis watch Achilles arm – as does his son Neoptolemos, whose presence in the scene is, to say the least, puzzling.

A warrior arming, often in the presence of a woman, is a very common subject on Attic black-figure vases from the middle of the 6th century, but unless inscriptions appear, it is not possible to identify the figures. The inclusion of Boeotian shields on Attic vases often hints at an heroic meaning, since such shields never actually existed but are reminiscent of the Mycenaean figure-of-eight shields. The Boeotian shield, however, is not the property of any one hero [297].

Depictions of Achilles receiving his armour from Thetis appear on vases from about 670, on a 'Melian' neck-amphora from Mykonos, on through the 6th century on Attic black-figure vases [298], through the 5th on Attic and Boeotian red-figure, and on into the 4th on South Italian red-figure. But Achilles received two sets of armour – the first before his departure from Phthia (from Peleus or Thetis), and the second after its loss through the death of Patroklos at Troy, and it is often difficult to be certain which scene is being shown. When Peleus is present it is surely the first, and it is likely that all of the depictions from before the middle of the 6th century are also of the first. Red-figure scenes usually depict the second, as is discussed below.

After a first voyage during which the fleet was unable to find Troy, the forces gathered a second time at Aulis ready to depart, this time with a guide. Agamemnon, however, offended Artemis with a boast, and she sent weather that made their sailing impossible. The seer Kalchas told them that the weather would not change until they sacrificed Iphigenia, daughter of Agamemnon, to Artemis. Thus they summoned her under the pretence that she was to wed Achilles, but when they were about to sacrifice her, according to one version, the goddess snatched her away, substituting a deer, and made her a priestess at her sanctuary at Tauris.

The sacrifice of Iphigenia appears on an Attic white-ground lekythos, c. 480, [299] where Teukeros with a sword in one hand leads Iphigenia to an altar. On an Apulian red-figure vase from the middle of the 4th century a deer beside Iphigenia indicates the substitution, as a priest at an altar reaches out with a knife, and Apollo and Artemis look on. According to Pliny (35.73) the sacrifice was also the subject of a painting by the 4th-century artist, Timanthes, where Iphigenia stood at an altar in the presence of Menelaos, Agamemnon and others whose grief was wonderfully shown.

The Greeks remained outside the walls of Troy for the next nine years during which various skirmishes took place (including the murder of Troilos), but all were inconclusive.

One scene common on Attic vases during the second half of the 6th century, but for which not even a hint of a literary source has survived, must refer to this time before the start of the *Iliad*. In the earliest version, probably invented by Exekias in *c.* 540, Ajax and Achilles fully armed sit playing a board game. In later versions (there are more than 150 occurrences of the scene) an excited Athena sometimes stands in front or behind the table rousing them to action [300]. The implication is that while playing a game to pass the time near the battle field, they became so involved they missed the alarm. The same scene was probably the subject of a late 6th-century sculptural group on the Acropolis, from which fragments survive, and it also appears on shield bands, later though than the earliest Attic depictions. The reason for the great popularity of the subject remains something of a mystery, though it has recently been suggested that it may have been a reference to a contemporary political event.

A unique scene on an Attic red-figure cup, c. 500, where Achilles dresses a wound on Patroklos' arm must refer to the time before the start of the events in the *Iliad* [301].

It is with the tenth year of the war that the *Iliad* begins, one of the two surviving poems from the epic cycle. In what follows here it is assumed that the reader is (or will become) familiar with the *Iliad*, so only the barest of outlines is included to connect the various depictions that refer to elements narrated in the poem. Readers may find it of some interest to compare details in the poem with the details chosen for depictions.

The *Iliad*, as Homer says in the opening lines of the poem, is about the anger of Achilles and its dreadful effect on the Achaeans. Agamemnon, the leader of the Achaeans, provoked this anger when he required Achilles to give up Briseis, a woman he had taken as a prize for himself during a skirmish. Achilles responded by retiring to his tent, refusing to fight, and asking his mother, Thetis, to persuade Zeus to bring about the defeat of the Achaeans.

References to Agamemnon's seizure of Briseis are rare in ancient art. On one side of an Attic red-figure cup from about 480 [302], heralds lead Briseis away from Achilles who sits mourning in his tent, his head covered with a cloak, his right hand raised to his brow. On one side of a contemporary skyphos, Agamemnon leads Briseis away while on the other side a heavily draped Achilles sits on a stool while Ajax, Odysseus and Phoenix stand on either side of him. This second scene depicts the Mission to Achilles (9.182*ff*) sent by Agamemnon when he realized that he had to have Achilles' help to win the war. He offered extravagant gifts in addition to the return of Briseis untouched, but Achilles refused, his anger still controlling him.

The earliest depiction of the Mission to Achilles probably appears on a bronze relief from a tripod at Olympia, c. 620 [303], where three men, one with a kerykeion, should probably be identified as Ajax, Odysseus and Phoenix. On a Caeretan hydria, c. 520, the ambassadors prepare for their journey, but it is on Attic red-figure vases that the scene most frequently appears, mostly during the first quarter of the 5th century. The repetition of several elements in the Attic scenes suggests a common prototype for them: Achilles sits on a stool mourning while Odysseus sits (or occasionally stands) in front of him, and Ajax and Phoenix then frame the scene when they are included [304].

The battle scenes in the *Iliad* almost always focus on duels between two heroes, and several of these take place during Achilles' absence from the field. One of the first was between Menelaos and Paris (3.340*ff*). It had been agreed that this fight would terminate the war, the winner keeping Helen, and the armies from both sides stood by and watched. But just as Menelaos was about to vanquish Paris, Aphrodite intervened and carried her favorite from the field.

On an Attic cup, c. 480 [305], Menelaos pursues a fleeing Paris, and the scene is framed by Aphrodite with a flower held to her nose and Artemis with a bow, the presence of both hinting at divine intervention. In a similar scene on the other

side of the cup Ajax and Hektor fight between Athena and Apollo. This duel, another watched by the opposing armies (7.206ff), was the result of a direct challenge from Hektor, and the two fought furiously until heralds intervened and stopped them; the two warriors then exchanged gifts out of admiration for each other.

Pausanias tells that the fight between Ajax and Hektor was depicted on the Chest of Kypselos where a hideous figure of Eris (Strife) stood between them. The duel is also the subject of Corinthian vases from the late 7th and early 6th centuries. On at least two Attic red-figure vases, c. 480, Phoenix and Priam are shown leading the warriors away, and though each seems to glare angrily at the other, each holds the gift mentioned in the *Iliad* [306].

Of the various duels described in the *Iliad*, the fight between Diomedes and Aineias (5.297ff) was one of the most popular with Archaic artists. The two warriors fought over the body of Aineias' companion, Pandaros, and just as Diomedes crushed Aineias' hip with a huge rock, Aphrodite appeared and intervened to save her son. With Athena's encouragement, Diomedes attacked the goddess, wounding her in the hand, and Apollo took her place in protecting Aineias.

The earliest depiction is on a fragment of a Corinthian plaque from Penteskouphia of c. 560, where Athena stands in the chariot while Diomedes, on foot, fights with Aineias over the body of Pandaros (Aineias and most of the body are missing). On fragments of an Attic black-figure krater, c. 540, Athena stands behind Diomedes while Aphrodite, again with a flower to her nose, stands behind Aineias. Then, the duel is the subject of several Attic red-figure vases from the first quarter of the 5th century, and on one of these Apollo is to be seen rushing to the aid of the fallen Aineias as Diomedes pursues Aphrodite [307].

One cannot help but be struck, in reading the descriptions of the battles in the *Iliad*, by the detail in which Homer describes ghastly wounds, while on glancing at depictions of those fights on Attic vases, one is equally struck by the lack of gore – only a drop of blood here and there on the always beautiful (and hairless) bodies of heroes.

One night, after the Achaeans had taken a particularly brutal battering (*Book 10*), Diomedes and Odysseus went out on a kind of guerilla expedition to harrass the Trojans. At the same time Hektor sent an unfortunate youth named Dolon on a scouting mission. Dressed in a wolf-skin and a weasel-skin for a helmet, he was to learn what he could of the Achaean plans. The paths crossed, however, and Dolon was captured by Odysseus and Diomedes, who pumped him for information before Diomedes cut off his head.

Dolon, named, appears under the handle of an early 6th-century Corinthian cup. On several Attic vases from the first quarter of the 5th century the capture of Dolon is shown, as it is on Lucanian vases a century later [308]. The death of Dolon under Diomedes' sword only appears on 4th-century Campanian vases.

In all of the depictions except the earliest, reference is made to Dolon's costume of animal skins.

Even as the Trojans began to burn the Achaean ships, Achilles refused to join the battle but he sent Patroklos, his comrade, dressed in his armour to take his place. Patroklos lead the troops in pushing back the Trojans from the ships, and among others he killed the Lycian Sarpedon, a son of Zeus and one of the great defenders of Troy, whose body once stripped of its armour, was removed from the battlefield by Hypnos and Thanatos. But Patroklos, pushing on too far toward the walls of Troy, was killed by Hektor with the aid of Apollo. Though Hektor took from him the armour of Achilles, the Achaeans, led by Ajax and Menelaos, recovered the body after a long and bloody fight.

Hypnos and Thanatos lifting the body of Sarpedon from the battlefield (16.666ff) appear on a few Attic red-figure vases from the end of the 6th century and first quarter of the 5th [310]. On a Lucanian hydria and an Apulian krater, both from about 400, Hypnos and Thanatos fly through the air with the body, and on the latter they bring it to Sarpedon's mother, Europa – a scene perhaps inspired by a production of a tragedy by Aeschylus which dealt with the subject. As mentioned in Chapter 3, this heroic subject on Attic vases becomes a generic funerary scene later in the 5th century.

Warriors fighting over the body of a fallen comrade is not an unusual subject in Archaic art, and unless the figures are named, identification of a particular fight is seldom possible. On a Rhodian plate from the end of the 7th century Menelaos and Hektor fight over the body of Euphorbos [311], the Trojan who first tried to strip the armour from Patroklos' body. Exekias painted the fight over the body of Patroklos on a krater, c. 540, but it is very fragmentary and of the six warriors fighting only the names of Hektor and Diomedes survive. On a red-figure cup from the end of the 6th century, Ajax and Diomedes fight Aineias and Hippasos over the body of Patroklos and again only the inclusion of the names distinguish this from the many genre scenes. The most interesting depiction of the subject is on a metope from the Heraion at Foce del Sele near Paestum, c. 550, where Patroklos runs holding up his corselet as a warrior (Euphorbos?) plunges a spear into his back [312].

With the death of Patroklos, Achilles transferred his anger from Agamemnon to Hektor and vowed revenge. Before he could go back into battle, however, he needed new armour, and this Thetis persuaded Hephaistos to make for him.

On a Corinthian oinochoe, c. 550, Thetis comforts Achilles who lies on a kline, his hand to his forehead in the traditional gesture of mourning, while Odysseus and Phoenix (and two unnamed women) observe. On several Attic red-figure vases from the first half of the century, scenes of Thetis comforting Achilles are combined with the presentation of his new armour [313], and Nereids are often shown carrying it. During the second half of the century, Nereids with the armour are sometimes shown riding various forms of sea-life

across the ocean, and this scene appears on a few South Italian vases as well, all perhaps inspired by Aeschylus' lost *Nereids*. Thetis collecting the arms from Hephaistos appears on a few vases from the second quarter of the 5th century *[88]*. As mentioned earlier, the previous arming in Phthia is depicted on black-figure vases.

In his new armour, Achilles sought out Hektor, whose parents begged him, to no avail, to stay within the walls of Troy. Achilles then chased him three times around the walls of Troy before Athena tricked Hektor into facing him in a duel, and then aided Achilles in quickly killing him. Achilles then tied the body to his chariot and dragged it, feet first, back to the Achaean ships where the body of Patroklos was then burnt on a great pyre and funeral games were held in his honour. Still mad with anger and grief, Achilles then dragged Hektor's body around Patroklos' tomb each morning until the gods intervened. The *Iliad* ends with Priam's successful mission to Achilles to ransom the body of his son.

Hektor arming or departing from his anxious parents is the subject on a few vases – Corinthian, Chalcidian and Attic – from the second quarter of the 6th century through to the second half of the 5th, but in most cases names have simply been attached to generic scenes.

On the outside of an Attic red-figure cup, *c.* 480, the walls of Troy are shown *[314]*. Below them, on one side Achilles chases Hektor past guarded gates while, on the other, Priam and Hecuba stand within a gate greatly perturbed. The actual fight is shown on several Attic red-figure vases from the last quarter of the 6th century and first quarter of the 5th.

Of the cremation of Patroklos, nothing is shown in Greek art, but it is instructive to note that in Etruscan art, the sacrifice of the twelve Trojans by Achilles on the pyre of Patroklos is not an uncommon subject, pointing to the very different tastes of the Etruscans.

The funeral games of Patroklos, on the other hand, appear on two early Attic black-figure vases, by Sophilos and Kleitias. The best preserved is the depiction on the neck of the François Vase, opposite the Centauromachy, where chariots race past a turning post toward Achilles who stands in front of a bronze tripod which, along with a dinos and another tripod in the field, were, no doubt, meant as prizes. On a fragment of a dinos by Sophilos *[315]*, found in Thessaly, tiny men sit in bleachers as huge chariot-horses race toward them. Achilles' name appears, though he is missing, and an unusual inscription identifies the scene as the funeral games of Patroklos.

Depictions of Achilles dragging, or preparing to drag, the body of Hektor behind his chariot appear on a sizeable group of Attic black-figure vases, all from the years before and after 500 *[316]*. On all of them Hektor's body is dragged on its back, on some Iris is included, presumably conveying news of the gods' displeasure, and the omphalos-shaped tomb of Patroklos appears on some with an *eidolon* (spirit of the warrior) running through the air above it. The tomb points to Achilles' mad attempts to mutilate the body in *Book 24*, but the

inclusion of Priam and Hecuba before the gates of Troy on one suggests that a conflation of the incident at the end of *Book 22* with that in *Book 24* has taken place.

On a fragment of a black-figure Clazomenian vase, *c.* 550, Achilles drags the body face down (only the feet remain) but there are no other early depictions nor are there any on Attic red-figure vases. On Apulian vases from the 4th century the subject appears rarely.

Priam before Achilles appears on a series of bronze reliefs, mostly shield bands, from about 570 to near the end of the century *[317]*. On each, Hektor's body lies in the foreground while a bent old Priam leaning on his staff supplicates Achilles, who stands in front of him to the left, and Hermes with is kerykeion stands behind him. On several Attic black- and red-figure vases from *c.* 570–480, a different scene appears *[318]*. On each Achilles, feasting, reclines on a kline beneath which the body of Hektor lies, while Priam approaches from the left, sometimes followed by servants bearing the ransom he will pay for the body and sometimes accompanied by Hermes.

Yet a third version of the ransom of Hektor appears on a Melian relief, *c.* 440, based on Aeschylus' lost *Phrygians* in which Priam ransomed the body for its weight in gold *[319]*. On the relief, the body lies in front of scales while Achilles and Priam stand on opposite sides of it and a youth holds a bowl with which, presumably, he has been weighing out gold.

In the epic cycle, the *Iliad* was followed by the *Aithiopis*. There, according to Proclus' summary, the Amazon Penthesilea, a daughter of Ares, came to aid the Trojans as did the Ethiopian king, Memnon, and both were killed by Achilles, who was himself killed by Paris aided by Apollo. Ajax rescued Achilles' body and carried it from the battlefield.

As we have seen, Amazonomachies are popular subjects in Greek art during the Archaic and Classical periods, and it is often difficult to tell which particular battle is being depicted. Only inscriptions allow a certain identification of the fight between Achilles and Penthesilea, and one of the earliest is on a terracotta relief, *c.* 600, where only Achilles and part of a fallen Amazon (with inscriptions) remain. Achilles and Penthesilea fight on shield bands from the end of the 7th century on through to the middle of the 6th *[320]*, and their fight is the subject of several Attic black-figure vases, the finest being the earliest, *c.* 540, signed by Exekias *[321]*, where Achilles plunges his spear into a falling Penthesilea. The fight is also the subject of several Attic red-figure vases, mostly from the first half of the 6th century.

In one version of the story, Achilles fell in love with Penthesilea as he killed her – a motif some have seen reflected even on Exekias' vase. On a few South Italian vases from the 4th century, the romantic element is stressed as the grieving Achilles supports the body of the dying Penthesilea, and according to Pausanias (5.11.6) a similar scene was painted by Panainos on the throne of Zeus at Olympia.

Memnon was the offspring of Eos (Dawn) and Tithonos, a brother of Priam who had been carried away to Ethiopia by the goddess when he was still quite young. A winged Eos pursuing or carrying off a young man is a very popular subject with Attic red-figure vase-painters, particularly during the second and third quarters of the 5th century (there are nearly two hundred) but, in addition to Tithonos, she pursued a young hunter named Kephalos, who is sometimes the youth pursued, identified by the spears he carries, his hunting clothes, or even an inscription. Tithonos is probably the school-boy she pursues who carries a lyre or a writing tablet [322]. On Melian reliefs, c. 460, she carries a youth without attributes [323]. Memnon's African home is sometimes indicated on Archaic vases by squires with negroid features who accompany him [324].

Depictions of a *psychostasia*, or weighing of souls, in which Hermes holds the scales appear on a few Attic black- and red-figure vases from about 540 to 450 [325]. These are connected with Achilles' fight with Memnon rather than with Hektor (as in *Iliad* 22.208–13) and the divine mothers, Thetis and Eos, are usually present. This was obviously the subject of Aeschylus' lost play, *Psychostasia* and may have been the subject of a play by Sophocles, though the depictions first appear long before the plays could have been written.

The actual fight between Achilles and Memnon was a popular subject in Archaic art. Pausanias tells that they were depicted fighting on the Chest of Kypselos with their mothers beside them, and the presence of Thetis and Eos is, in fact, one of the common features in most depictions on the subject. The fight appears on several 6th-century Corinthian vases [326], on East Greek and Chalcidian vases, and on a number of Attic black- and red-figure vases from c. 570 down to about 450. It has recently been shown that this is the fight depicted on the east frieze of the Siphnian Treasury [309]. Pausanias (3.18.12) also says that it appeared on Bathykles' throne at Amyklai along with Kephalos being carried off by Day (which must be his misunderstanding of a depiction of Eos and Tithonos). Eos lifts up the body of her dead son on a few Attic vases from about 500 [327].

The death of Achilles may be the subject of two Proto-corinthian vases – a lekythos and an aryballos – from the 7th century where an archer crouches with his bow drawn as warriors fight in front of him. On one, an arrow is about to strike one of the warriors in the lower leg. On a Chalcidian amphora, now lost [328], Achilles lay dead with an arrow in his heel as Ajax defended his body, and on a few red-figure vases Paris aims an arrow at Achilles, but the subject is otherwise quite rare in Archaic and Classical art.

A warrior carrying a dead warrior over his shoulder is a popular subject in Greek art from the end of the 8th century to the end of the 6th. The scene appears on an early ivory seal from Perachora, on shield bands [329], and on dozens of Attic black-figure and on a few early red-figure vases. Achilles and Ajax are identified by inscriptions on a few vases, including the François Vase, and while it is likely that many of the other scenes are intended to represent them, it is rarely

possible to be certain without an inscription (at least one other hero is identified by an inscription).

The *Aithiopis* ended with the death of Ajax and the *Little Iliad*, the next poem in the cycle, began with the same subject and recounted the events on through the fall of Troy. After the death of Achilles, Ajax and Odysseus quarrelled over his armour, and according to one common version, a vote was taken as to which should have it, and Odysseus won with Athena's support. Ajax, maddened with disappointment (or through divine meddling) slaughtered a flock of sheep, thinking them to be the Achaeans who had cheated him of his prize. On regaining his senses he killed himself by falling on his sword.

The quarrel between Ajax and Odysseus is depicted on a few Attic red-figure vases from the first quarter of the 6th century where the two rush at each other but are restrained by fellow warriors [330]. Quarrelling heroes being restrained by fellow warriors is a common scene on Attic black-figure vases during the last third of the 6th century, but none of these scenes can be safely identified as Odysseus and Ajax. It is the presence of the armour, a king, or related scenes on the same vase, that allows the identification of the few red-figure scenes.

Depictions of the vote appear on a few red-figure vases from the same period, some on the same vases [330]. There, the Achaeans cast their ballots in the presence of Athena while Odysseus and Ajax stand to the sides, one pleased, the other despondent. On fragments of a red-figure cup from the same period a unique depiction of the Achaeans discovering the slaughtered sheep may also appear, and it seems possible that this sudden interest in various aspects of Ajax may have been prompted by an early production of a tragedy on the subject.

The earliest depiction of the suicide of Ajax is probably from the beginning of the 7th century on a Proto-corinthian aryballos. It appears on several Corinthian vases from the first quarter of the 6th century as well as on an ivory comb from Sparta, shield bands from Olympia [331] and a metope from the Heraion of Foce del Sele. In each case, Ajax is impaled on a sword, the handle of which is buried in the ground. Though the subject rarely appears in Attic art, one of the most moving depictions of it is on a black-figure amphora by Exekias where, alone, Ajax buries the handle of the sword in the earth [332].

From the Trojan prophet Hellenus, captured by Odysseus, the Achaeans learned that Troy would fall if they had the bones of Pelops, if Neoptolemos, the son of Achilles, fought with them, and if they stole the Palladion, an image that had fallen to Troy from the heavens.

The departure of Neoptolemos from Skyros, where he had been fathered by Achilles, appears on a few Attic red-figure vases from the first half of the 5th century, but these are conventional departure scenes to which names have been added. Neoptolemos receives the armour of Achilles from Odysseus on the inside of one of the cups mentioned above, with the quarrel and the vote on the outside, bringing the cycle of the arms to a tidy close.

The theft of the Palladion first appears during the first quarter of the 5th century on Attic red-figure vases in two puzzling scenes where both Diomedes and Odysseus hold palladia (the two palladia also appear on an Apulian vase a century later) and on one of these the scheme of quarreling heroes is used. In a few other red-figure scenes (Attic and South Italian) Diomedes usually carries the Palladion accompanied by Odysseus.

Pausanias (1.22.6) tells that Diomedes stealing the Palladion was the subject of a painting in the Propylaia of the Acropolis in Athens, and from the end of the 5th century Diomedes alone with the Palladion appeared on Attic vases, on gems, on coins [333], and in a statue of which copies survive.

The actual fall of Troy as a direct result of the Achaean ploy of the wooden horse, seems to have been told in both the *Little Iliad* and the next book of the cycle, the *Ilioupersis*. The Achaeans built a great wooden horse in which they hid warriors, and leaving it outside the walls of Troy, they sailed off as if abandoning the siege. The Trojans, after much debate, pulled the horse inside their walls where, of course, the warriors dismounted at night and, with the Achaeans who had sailed back, sacked the city.

There are only a few depictions of the Trojan horse in Greek art and those few are distributed across the centuries from the end of the 8th to the beginning of the 4th. The earliest is incised on a bronze fibula, *c.* 700, already mentioned here in connection with Herakles' fight with the hydra, which also appears depicted on it. Much of the horse is missing, but the wheels at the ends of its legs can be clearly seen. The scene on a 7th-century relief amphora from Mykonos [334] is well-preserved and the heads of warriors can be seen through square portholes in the side of the great wheeled horse. This recalls Pausanias' scornful description (1.23.8) of a bronze horse on the Acropolis (for which the inscribed base has been found) with the faces of Menestheus, Teucer, Akamas and Demophon peeping out. On a Corinthian aryballos from before the middle of the 6th century, warriors jump down from a great horse, and on a fragment of an Attic black-figure vase from after the middle of the century, warriors climb down onto the shoulders of others below them. The last example, *c.* 400, is on a fragment of an Attic red-figure vase where warriors climb out of the horse in front of a temple.

Depictions of individual scenes from the sack of Troy appear frequently in Archaic and Early Classical art, and on several red-figure vases from the last quarter of the 6th century and first quarter of the 5th, scenes from the sack are grouped together. One of the finest of these is a hydria by the Kleophrades Painter, *c.* 480 [335], and the depictions on that vase can serve here as a guide through the various acts of heroism and carnage that are a part of the *Ilioupersis*. We move through the scenes from left to right.

First, Aineias lifts his old father Anchises onto his back, as his young son Askanios precedes him off to the left and out of the scene, indicating their successful escape from Troy. Aineias escaping with Anchises on his back,

sometimes accompanied by Askanios and sometimes by a woman (Aphrodite once, Kreousa? Eurydike?) is the subject of nearly a hundred Attic black-figure vases from the last quarter of the 6th century [336], but it is rare in red-figure, even amongst the contemporaries of the black-figure painters.

Next in the hydria picture, Ajax, son of Oileus (the Lesser Ajax) prepares to drag a nearly-naked Kassandra away from a statue of Athena to which she clings. The violation of Kassandra in the Sanctuary of Athena, which outraged the other Achaeans, was a popular subject for both Archaic and Classical Greek art, and essentially the same scene is shown throughout. Kassandra is often naked, or nearly so, and clings to the image of Athena which is usually in the Promachos pose discussed in Chapter 3. The depiction on the hydria is one of the first in which Athena is clearly shown as a statue (i.e. on a base).

The earliest depictions of the subject are on shield bands from Olympia and Delphi from the first half of the 6th century [337], and Pausanias says that Ajax dragging Kassandra from the image of Athena was shown on the Chest of Kypselos. On Attic black-figure vases the subject appears from about 560 on through the end of the century; red-figure painters carry it on through the 5th, and during the 4th it is a popular subject with South Italian vase-painters.

According to Pausanias (5.11.6), the rape was the subject of a painting by Panainos inside the Temple of Zeus at Olympia, and he tells of two other paintings depicting different moments after the incident. In Polygnotos' painting from the Lesche of the Cnidians at Delphi (10.26.3), Ajax stood beside an altar taking an oath and Kassandra sat near him holding the image of Athena that had fallen when he raped her. In a painting from the Stoa Poikile in Athens (1.15.3), the Achaean kings were shown consulting about the outrage Ajax had committed, while Ajax, Kassandra and other captured women, were shown nearby.

The next group on the hydria comprises Priam seated on an altar by a palm tree with the dead Astyanax on his lap while Neoptolemos grabs his shoulder and swings his sword at him. This episode has already been discussed in Chapter 2 [36, 37], but here it is worth noting that this painter has given a variant on the usual scene on Attic vases where Neoptolemos swings Astyanax by the foot at the seated Priam [36].

Beyond Neoptolemos a Trojan woman attacks a warrior with a pestle. She is not named here, but on another slightly earlier *Ilioupersis* vase she is Andromache, the wife of Hektor. To the right Akamas and Demophon rescue their grandmother Aithra, a subject already mentioned in Chapter 7. The identity of the woman grieving to the far right is unclear.

Two other scenes mentioned in Proclus' summary as part of the *Ilioupersis* are the sacrifice of Polyxena and the recovery of Helen by Menelaos, and both appear in ancient art. The first has already been discussed in Chapter 2. Of the second, several versions appear on Attic vases.

In Proclus' summary the simple statement is made that Menelaos found Helen

and led her to the ships and from the *Odyssey* we know that he returned with her to Sparta. According to another version he intended to kill her when he found her but threw away his sword when he saw her exposed breasts. Some scenes on black-figure vases in which a warrior with a drawn sword approaches a woman, or leads her by the wrist, probably show Menelaos recovering Helen *[36]*. Inscriptions on a few red-figure vases show that some scenes where he escorts or pursues her certainly do, and in several of the pursuit scenes Menelaos is shown dropping his sword *[338]*. In some Helen flees toward an altar, and in some Eros flutters above, confirming the erotic motif.

286 (*left*) Melian (terracotta) relief from Camiros. Peleus and Thetis. Peleus clings to Thetis whose many transformations are symbolized by the single lion. *c.* 460. 17 cm

287 (*centre*) Attic red-figure calyx-krater. Peleus grasps Thetis around the waist while Nereids rush about in disarray. The civilized centaur, Chiron, who was Peleus' adviser and later Achilles' tutor, stands to the right observing the struggle. *c.* 460

288 (*below*) Attic black-figure hydria from Orvieto. Wedding of Peleus and Thetis. Peleus and Thetis ride in a chariot followed by Dionysos with his mother Semele (called Thyone here) and accompanied by Apollo playing his kithara, Athena and Herakles, Hermes, Aphrodite and other goddesses. *c.* 520

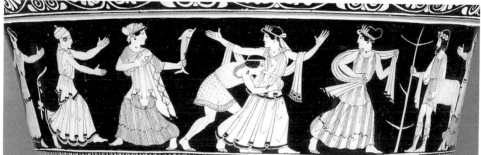

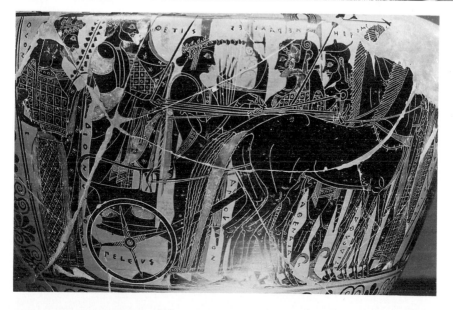

289 Attic black-figure amphora. Peleus delivers the young Achilles to the centaur Chiron. Note that Chiron, unlike most centaurs, wears a chiton. The deer beside him indicates the rural setting. *c.* 540

290 (*below*) Attic black-figure hydria from Vulci. Judgement of Paris. A bearded Paris holding a sceptre moves away from Hermes and the goddesses who greet him. Hera and Aphrodite are not differentiated. Athena wears her snaky aegis and holds her helmet. The deer beside her would more appropriately accompany Artemis. *c.* 540

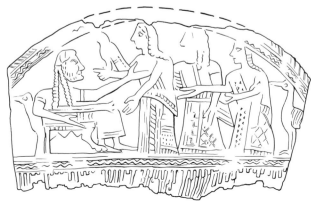

291 Ivory relief, comb from Sparta. Judgement of Paris. A bearded Paris sits on a throne as the three goddesses approach him. The first, with a bird on her arm, could be Hera with her cuckoo, the second is Athena who may be wearing a helmet and the third, followed by a bird could be Aphrodite with her goose. *c.* 600. L. 8 cm

292 Attic red-figure hydria from Ruvo. Judgement of Paris. An Eros leans on the shoulder of Paris, who is dressed in oriental garb, while Hermes stands in front of him. Hera and Athena stand to the left of him. Aphrodite accompanied by an Eros sits to the right. Zeus, seated with sceptre and thunderbolt, and Muses observe. In the centre, above Paris, Eris (Strife) stands behind a hill and to the far right Helios (Sun) drives his chariot up into the sky. The painter has abandoned the traditional ground-line and has placed his figures at various levels on the vase in an unsuccessful attempt to give the illusion of space and depth. c. 400

293 Attic red-figure skyphos from Suessula. Abduction of Helen. Paris preceded by Aineias leads a willing Helen while Eros and Peitho (Persuasion) crown her and Aphrodite encourages them. c. 480

294 Corinthian krater from Italy. Wedding of Paris and Helen. Paris and Helen ride together in a chariot in the presence of Trojans including Hektor (named). *c.* 580

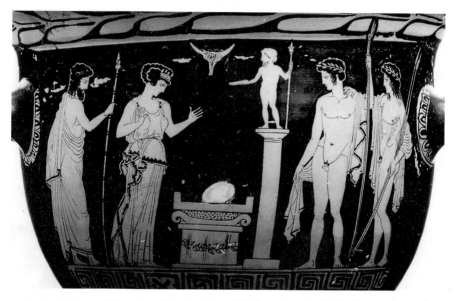

295 Attic red-figure bell-krater from Egnatia. Leda and the Egg. A surprised Leda discovers the egg from which Helen will be born, on an altar in front of a statue of Zeus, while Tyndareus, her husband, and the Dioskouroi (Kastor and Polydeuces) her sons, look on. Above the altar hangs a bukranion (bull skull) draped with a garland. *c.* 420. 26 cm

Opposite

296 (*top*) Attic black-figure plate from Attica. Armour of Achilles. Thetis holds a shield and spear while Achilles puts on a greave. The man to the left is Peleus, making the setting Pthia. The youth to the right is labelled Neoptolemos, Achilles' son, but his presence here makes no sense at all. *c.* 550. D. 26.7 cm

297 (*centre*) A, Hunter with a 'figure of eight' shield from a dagger of Cretan manufacture from a shaft grave at Mycenae. *c.* 1550. B, Warrior with 'Dipylon' shield from a geometric krater. *c.* 750. C, Warrior with 'Boeotian' shield from an Attic black-figure vase. *c.* 540

298 (*below*) Attic black-figure amphora. Armour of Achilles. Achilles receives his shield, corselet, greaves and helmet from Thetis and three Nereids. Note the gorgoneion device on the Boeotian shield. The old man behind Achilles is probably Peleus

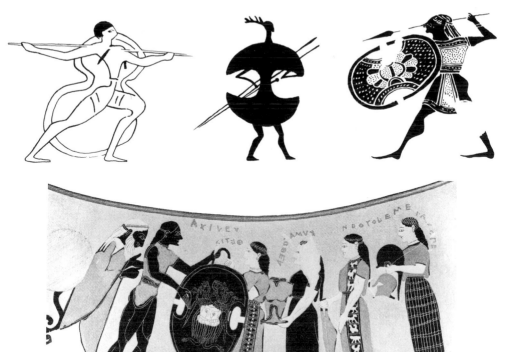

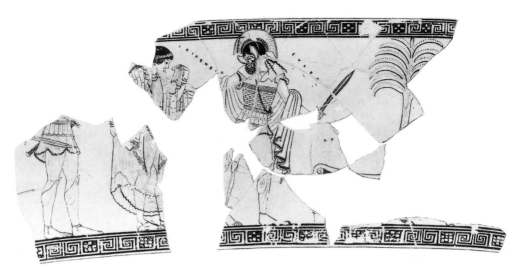

299 Attic white-ground lekythos from Selinus. Sacrifice of Iphigenia. A warrior, labelled Teucer, leads Iphegenia, who is dressed as a bride, to an altar of Artemis and is followed by another warrior whose name is lost. *c.* 490

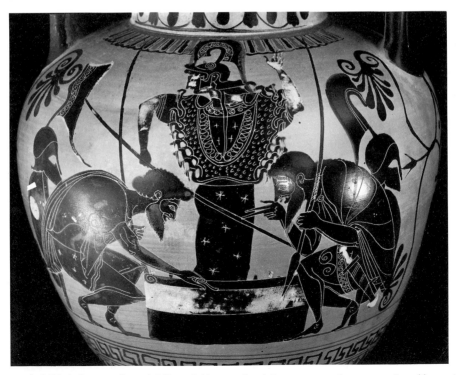

300 Attic black-figure amphora. Achilles and Ajax, wearing their armour, crouch over a gaming table, absorbed in a board game with dice while Athena warns them of an impending enemy attack. Their shields and helmets are behind them. *c.* 510

301 Attic red-figure cup from Vulci.
Achilles crouches beside his companion,
Patroklos, who sits on his shield (note the
tripod device) and binds his wounded arm
after removing an arrow. Patroklos bares
his teeth in pain. *c*. 500. D. 18 cm

302 (*above*) Attic red-figure cup from Vulci. Heralds, one
with a kerykeion, lead Briseis away from Achilles who
sits on a stool in his tent, wrapped in his himation, sulking
over his loss. Achilles' helmet and sword hang beside him.
c. 470

303 Bronze relief on a tripod from Olympia. Mission to
Achilles. A man with a kerykeion leads two others who
carry spears. The hat on the central figure may identify
him as Odysseus and the other two are probably Ajax and
Phoenix. *c*. 620

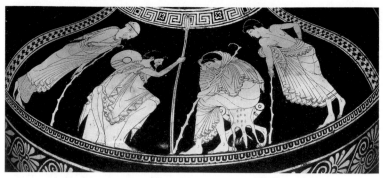

304 Attic red-figure hydria. Mission to Achilles. Achilles, wrapped in his himation sits on a stool draped with a fawn-skin and sulks as Odysseus, a petasos hanging at his back, sits in front of him and talks. Old Phoenix stands behind Odysseus, and the youth behind Achilles must be Patroklos. *c.* 480

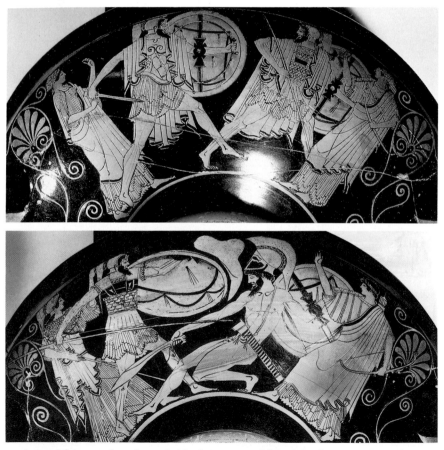

305 Attic red-figure cup from Capua. A, Menelaos, accompanied by Aphrodite, pursues Paris who runs toward Artemis who holds a bow. B, Ajax, urged on by Athena, attacks Hektor to whose aid Artemis rushes. Note the rock between Ajax's shield and Hektor's face, which clearly refers to the boulder thrown by Ajax in the *Iliad*, which knocks Hektor from his feet. *c.* 490

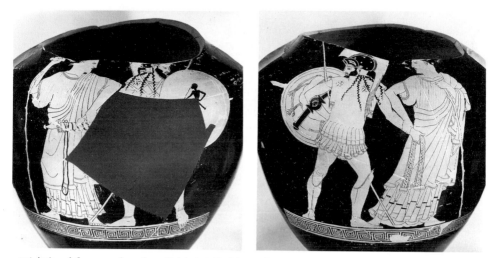

306 Attic red-figure amphora from Vulci. A & B, After exchanging gifts, Ajax and Hektor are led away by Phoenix and Priam. Ajax carries Hektor's sword, Hektor Ajax's belt. *c.* 480

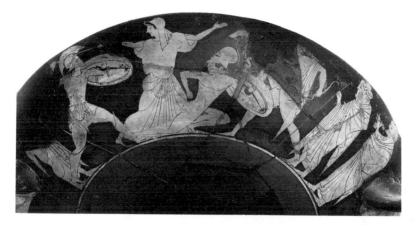

307 (*above*) Attic red-figure cup. Diomedes and Aineias. Diomedes, with spear raised, pursues Aphrodite as Apollo rushes to the aid of Aineias. *c.* 520

308 Lucanian red-figure calyx-krater from Pisticci. Ambush of Dolon. The unfortunate Trojan youth Dolon, carrying a bow and spear and wearing an animal skin and a fur cap and spats, is ambushed in a forest by Odysseus, wearing a pilos and carrying a sword, and Diomedes with a spear. Note the elaborate crest on Diomedes' helmet. 4th Century. 48 cm

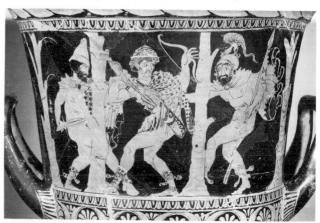

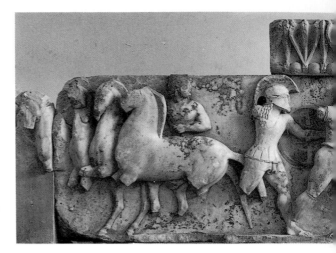

309 Marble relief, east frieze of the Siphnian Treasury at Delphi. Fight over the body of Antilochos. Aineias and Memnon fight Achilles and Ajax (?) over the body of Antilochos. Behind the warriors Lykos and Automedon wait with chariots and Nestor approaches from the far right. Inscriptions name figures. *c.* 525. 64 cm

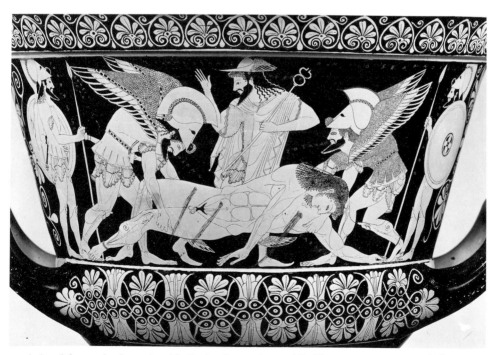

310 Attic red-figure calyx-krater signed by Euphronios as painter and Euxitheos as potter. Hypnos and Thanatos with the body of Sarpedon. The winged and bearded twins, Hypnos (Sleep) and Thanatos (Death) lift the body of Sarpedon as Hermes, with his kerykeion, winged boots and a winged hat, supervises. *c.* 510

311 (*opposite*) Rhodian plate from Camiros. Menelaos and Hektor fight over the body of Euphorbos (all three warriors are named). The filling devices around the figures are common on Rhodian pottery and are unrelated to the scene. Note the naturalistic eyes and eyebrows painted as part of the design. *c.* 600. D. 38.5 cm

312 (*above*) Sandstone metope from Foce del Sele. Death of Patroklos. Euphorbos plunges his spear into the back of Patroklos who has fallen to his knees and reaches for his corselet which Apollo (not included) has knocked from him. *c.* 550. 77 cm

313 Attic red-figure pelike from Camiros. Armour of Achilles. Achilles sits in his mourning pose as Thetis comforts him and two Nereids hold his new armour. Athena stands to the far left, and the old man to the right could be Phoenix or Nereus. *c.* 460

314 Attic red-figure cup from Cervetri. Achilles pursues Hektor around the walls of Troy. Note the battlements above (which continue around the whole lip of the cup) and the two archers in Scythian dress guarding gates. *c.* 480

315 Attic black-figure dinos fragment from Pharsalos signed by Sophilos as painter. Funeral Games of Patroklos. Horses pulling a missing chariot gallop toward stands in which cheering men sit. Achilles' name to the far right shows that he presided over the games. The inscription below Sophilos' signature names the scene, a very rare occurrence in Attic vase-painting. c. 580

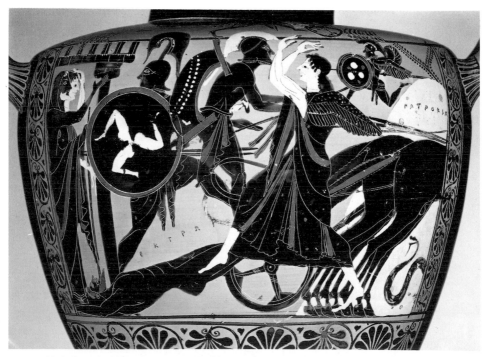

316 Attic black-figure hydria. Achilles mounts his chariot in which the charioteer already stands and to which the body of Hektor has been attached. He looks back at Priam and Hecuba who stand beneath a doric entablature as Iris rushes toward him to stop him and the eidolon of Patroklos flies away from his omphalos-shaped tomb. The device on Achilles' shield, called a triskeles, is a common one, composed of three legs joined together. The painter has compressed both time and space to show this story. c. 520. 49.6 cm

317 (*left*) Bronze relief, shield band (?) from Olympia. Ransom of Hektor. Priam in the centre stands by Hektor's body and reaches up to touch Achilles' chin in supplication. Hermes, with his kerykeion, stands behind him. *c.* 570. 5 cm

318 (*below*) Attic red-figure cup from Vulci. Ransom of Hektor. Holding a drinking cup and looking at a woman who places a wreath on his head, Achilles reclines on a kline beneath which is the body of Hektor. Priam approaches followed by a servant carrying a hydria and three phialai. Having led Priam to Achilles' tent, Hermes departs. Note the food (bread and meat) on the table beside Achilles. On the other side of the vase youths and a woman carry more gifts. *c.* 520

319 (*below*) Melian (terracotta) relief from Melos (?) Ransom of Hektor. The body of Hektor lies by a scale as youths hold bowls, presumably for measuring out an equivalent weight of gold. Priam stands to the right mourning, with his hand to his head. *c.* 440. 19.5 cm

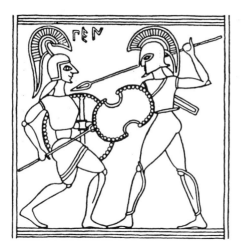

320 Bronze relief, shield band panel from Olympia. Achilles and Penthesilea. The first letters of the Amazon's name are inscribed above her head. *c.* 550

321 (*below*) Attic black-figure amphora from Vulci signed by Exekias as potter. Achilles and Penthesilea. The Amazon, who wears a leopard-skin over her short chiton, looks up at Achilles as he drives his spear through her neck. Note the conventional use of white for female flesh. *c.* 530. 41.3 cm

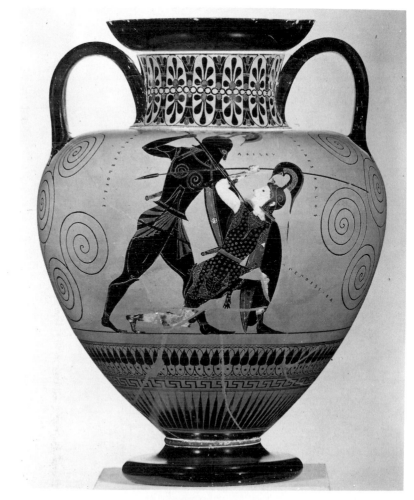

322 Attic red-figure cup by the Telephos Painter from Vulci. Eos and Tithonos. Eos pursues the young Tithonos who resists her advances

323 (below) Melian (terracotta) relief from Camiros. Eos abducting a youth (Tithonos or Kephalos?) c. 460. 15.8 cm

Opposite

324 (top) Attic black-figure amphora. Memnon stands with his black squires, one of whom, holding a pelta and club, is named Amasis. c. 530. 41.8 cm

325 (centre) Attic red-figure cup. Psychostasia. Hermes with his petasos and boots holds a set of scales in one hand, his kerykeion in the other. Eidola of Memnon and Achilles stand on the trays while their mothers, winged Eos and Thetis, rush to the left and right. c. 450

326 (below) Corinthian hydria. Achilles and Memnon. Achilles with a gorgoneion on his shield attacks Memnon who has fallen in front of him. The chariots, which have presumably brought the warriors to the battlefield, wait at either side of the scene. Achilles' charioteer Automedon is named in the chariot to the left (most of the name of the other charioteer is missing). c. 530

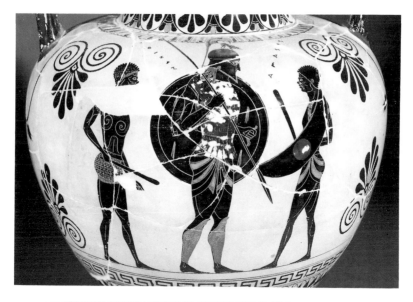

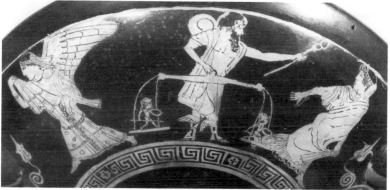

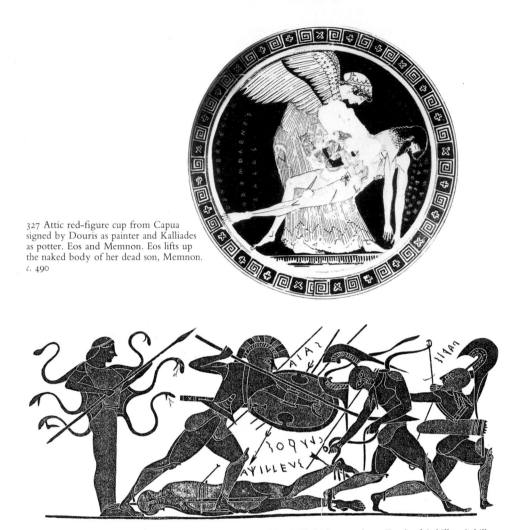

327 Attic red-figure cup from Capua signed by Douris as painter and Kalliades as potter. Eos and Memnon. Eos lifts up the naked body of her dead son, Memnon. c. 490

328 (above) Chalcidian amphora. Death of Achilles. Achilles lies dead on the ground with an arrow through his ankle and another in his back. Ajax, guarding the body, spears Glaukos, and Paris, his bow drawn, runs off to the right. Athena in her snaky aegis, stands behind Ajax. c. 540

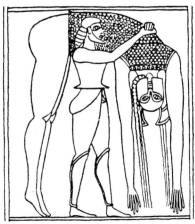

329 (left) Bronze relief, shield band panel from Olympia. Warrior (Ajax?) carrying the body of a dead hero (Achilles?) Note the heroic proportions of the dead warrior. c. 600. W. 7.8 cm

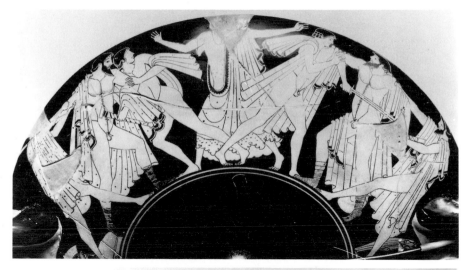

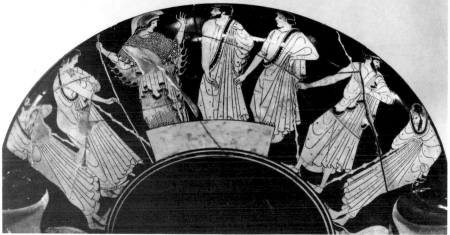

330 (*above*) Attic red-figure cup from Vulci. Armour of
Achilles. A, Ajax and Odysseus are restrained by their
comrades as they quarrel over who should have the armour
of Achilles. The armour under the handles of the cup and
the scene on the other side allow the identification of the
specific (as opposed to generic) scene. B, Athena watches as
the Achaeans cast their ballots to determine who will have
the armour. Odysseus stands to the far left, the winner,
while a despondent Ajax stands to the far right. *c*. 480

331 (*right*) Bronze relief, shield band panel from Olympia.
Suicide of Ajax. Two warriors discover Ajax who has fallen
on his sword. *c*. 575. W. 7 cm

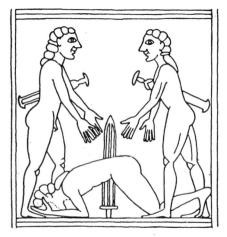

332 (*above left*) Attic black-figure amphora by Exekias. Suicide of Ajax. Ajax buries his sword in the earth near a palm tree, which indicates the foreign setting. His helmet rests on a Boeotian shield with a gorgoneion for a device, and his spears lean against it. *c.* 540

333 (*above right*) Attic red-figure cup from Apulia. Diomedes with the Palladion approaches an altar on which a fire burns. *c.* 380

334 (*below*) Clay relief pithos from Mykonos. Trojan horse. The faces of Achaeans can be seen through square portholes on the side of a great wheeled horse. Some warriors have already climbed out of the horse, while others hand out their armour. *c.* 670

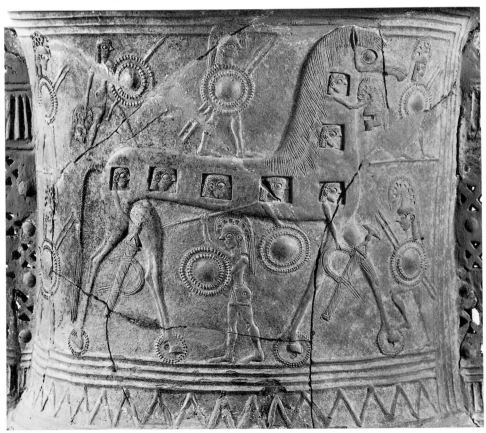

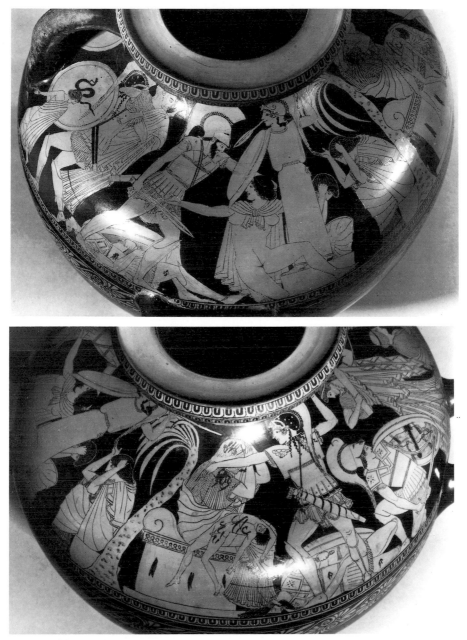

335 Attic red-figure hydria from Nola by the Kleophrades P. Ilioupersis. l to r: Aineias lifts his father
Anchises onto his back while his son Askanios leads the way; Ajax (Lesser) prepares to drag the naked
Kassandra away from a statue of Athena where she has sought sanctuary; Priam sits on an altar by a palm
tree with the body of his grandson Astyanax on his lap as Neoptolemos prepares to strike him with a sword
and women wail; a woman (Andromache?) attacks a warrior with a pestle; Akamas and Demophon rescue
their grandmother Aithra. *c.* 480

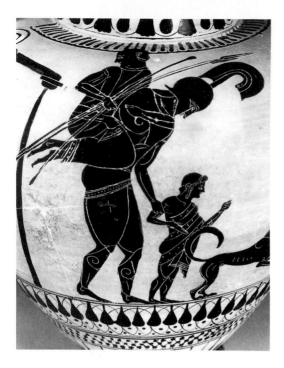

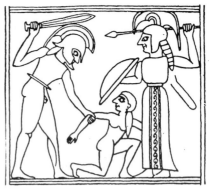

336 (*left*) Attic black-figure amphora from Vulci. Aineias and Anchises. *c.* 510

337 (*above*) Bronze relief, shield band panel from Olympia. Ajax and Kassandra. *c.* 580. W. 7.2 cm

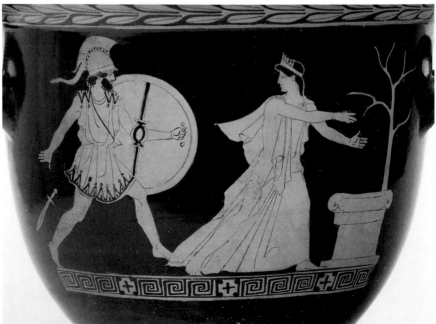

338 Attic red-figure bell-krater. Recovery of Helen. Menelaos, intent on killing Helen for her treachery, has pursued her, but at the sight of her naked breast he is overcome by passion and drops his sword. Note how the painter has revealed part of Helen's body as she rushes toward an altar for sanctuary. *c.* 440. 32.5 cm

Chapter Ten

THE AFTERMATH OF THE WAR

The last three poems of the epic cycle (*Nostoi*, *Odyssey*, *Telegony*) follow the lives of some of the Achaean heroes after the end of the war. Of the three, we have only the *Odyssey*, which deals with Odysseus' ten-year journey from Troy back to Ithaca, and several episodes from that journey are the subject of ancient art. As with the *Iliad*, it is assumed here that the reader is familiar with the *Odyssey* so only the barest of outlines is presented for the stories.

Shipwrecked, Odysseus was washed up naked on the shore of the Phaeacian's land where he revealed himself to Nausikaa, the daughter of the king, Alcinous, who took him to her father. Well-received, Odysseus recounted his adventures during the five years since he had left Troy. Of these, his encounters with the Cyclops, Circe, and the sirens are depicted in the art of our period.

Odysseus surprising Nausikaa and her companions as they wash clothes, is the subject of at least two Attic red-figure vases [*339*]. Though separated by at least a quarter of a century, the imagery on both of them is very similar and suggests that they depend on the same model. A naked Odysseus urged on by Athena approaches young women who start to flee, while one, who has not yet noticed him, continues to wring clothes. Pausanias (1.22.6) tells that a painting by Polygnotos in the Propylaia to the Acropolis in Athens showed the same subject.

The encounter with the Cyclops Polyphemos is the most popular subject from the *Odyssey* in Greek art and has the longest life. Odysseus landed on the island of the Cyclops and went with twelve men to the cave of the one-eyed giant Polyphemos, who inhospitably ate six of the men before Odysseus made him drunk, and with his remaining men, put out his one eye. They then escaped through the mouth of the cave tied to the underside of sheep (except Odysseus who clung beneath a great ram).

The blinding of Polyphemos with a long pole carried by several men first appears during the 7th century on a Proto-attic amphora [*340*] and an Argive krater fragment. From later in that century, similar depictions appear on the Aristonothos krater, probably made by a Greek artisan in Etruria, and on a fragmentary bronze relief from Samos. During the 6th century, the same subject appears on several different types of vases including Corinthian, Chalcidian, Laconian (where the scene is combined with Polyphemos' feast) and Caeretan, and on a shield band from Olympia, but it rarely appears on Attic black-figure vases and virtually never on Attic red-figure.

On an early Lucanian krater of *c.* 410 *[341]* Odysseus directs his men as they carry a tree-trunk toward the drunken Polyphemos while satyrs frolic nearby, quite probably an illustration of Euripides' satyr play, *Cyclops*.

The earliest depiction of the escape from Polyphemos is on a 7th-century Proto-attic vase *[342]*, where men are bound or cling to the underside of rams, but the subject's greatest popularity is with the Attic black-figure vase-painters. Kleitias painted it, but the majority of the vases on which it appears are lekythoi and oinochoai from the last quarter of the 6th century and first quarter of the 5th. Sometimes only one figure is shown strapped or clinging to the underside of a ram or sheep, sometimes several. On some the blinded Polyphemos reaches out trying to find the escaping men. The escape is also the subject of a few Archaic Attic red-figure vases where Odysseus, strapped beneath a ram, wields a sword.

After several more adventures and the loss of all his ships except his own, Odysseus landed on the island Aeaea, home of the witch Circe (Medea's aunt). He sent out a scouting party, which Circe entertained with elegant food and drink before turning the men into swine. On learning of this from Eurylochos, the one scout who escaped, Odysseus went to the rescue of his men with the help of Hermes who gave him an herb that protected him from Circe's magic and told him that to succeed he must first threaten to kill Circe and then sleep with her. This he did, the men were saved, and they all remained on the island with Circe for a year.

Two Attic black-figure cups from before 550 have similar depictions of Circe on them *[343]*. She hands a cup to a man who already has the head of a boar. Behind him and behind her are other men in stages of transformation. From the left Odysseus rushes in with a drawn sword, and on one a man rushes off to the right. This scene is a particularly good example of the compression of time and space in Archaic narratives. Three or four successive episodes are shown in a single scene. Circe hands the man a cup, but before he takes it he has started to turn into a boar, and Odysseus, hearing of the outrage, comes to the rescue. The figure rushing off to the right may be Eurylochos, who goes to tell Odysseus what has happened.

Somewhat simpler depictions of the story, with Circe offering the cup or Odysseus pursuing her, appear on a few late black-figure vases and on a few 5th-century red-figure vases. On a series of Boeotian skyphoi from the end of the 5th century, caricatures of Odysseus and Circe act out their usual roles *[344]*. She stands in front of her loom mixing a potion, while he has drawn his sword.

After the year with Circe, Odysseus and his crew decided to leave but learned that before returning home they would have to travel to the underworld to ask advice from the seer Teiresias. Polygnotos' painting at Delphi of Odysseus' visit to the underworld has already been discussed in some detail in Chapter 4.

Later, as they sailed on, they came to the island of the sirens, creatures who bewitched mortals with their songs and led them to destruction. Following

Circe's instructions, the men plugged their ears with wax and tied Odysseus to the mast of the ship, since he wanted to hear the song. They then rowed safely past the island, ignoring Odysseus' pleas to be freed.

The name siren is used for creatures half-human and half-bird (sometimes male, but later usually female) that appear in animal friezes, having come to Greece from the East during the orientalizing period. In Attic art only the head is human while in East Greek and Laconian art they can also have arms. These creatures are first associated with the story from the *Odyssey* early in the 6th century on Corinthian vases where Odysseus is shown tied to the mast as the sirens stand on a cliff and presumably sing. On a few Attic black-figure vases showing a similar scene, the sirens play instruments – pipes and lyres. On a fine red-figure stamnos of *c.* 450 [*346*], two sirens watch the ship sail by while a third, dead, plumets into the sea. This certainly refers to a version of the story in which the sirens were fated to die when a ship successfully passed them by, though the earliest surviving literary reference to this detail is from the Hellenistic period.

The sea-monster Scylla, with whom Odysseus had to contend, is depicted on a few Attic and South Italian vases from the late 5th and 4th centuries, and on 5th-century coins from Cumae and Akragas [*345*]. Odysseus seldom appears with her; rather, she is simply a type of marine life, like tritons and hippocamps, depicted as a mermaid with a girdle of dog protomes.

During the twenty years of Odysseus' absence from Ithaca, his faithful queen, Penelope, waited for him in his palace, fending off persistent suitors who lived off Odysseus' wealth while they waited for her answer as to which of them she would choose. When Odysseus finally returned to Ithaca, disguised as a beggar, he first revealed his identity to his son, Telemachos, and together, with the help of Athena, they eventually routed the abusive suitors.

The mourning Penelope, seated and veiled with her head bowed, appears on a number of Melian reliefs from the 5th century, where Odysseus, still disguised, converses with her. Penelope is shown in a similar pose on an Attic red-figure skyphos of *c.* 440 [*347*], where she sits in front of a loom as Telemachos talks with her. It is likely that this is the pose Zeuxis of Herakleia, *c.* 400, chose for her in his painting which Pliny (35.63) says seemed to portray morality itself.

On the other side of this skyphos, Eurykleia, Odysseus' old nurse, washes his foot, and is about to recognize him by a scar on his thigh [*347*]. This scene of recognition (*Odyssey* 19.361ff) also appears on a slightly earlier Melian relief. The conical felt cap Odysseus wears in both of these scenes, often called a *pilos*, becomes his regular attribute after about 400 (though, of course, others too may wear it).

Finally, Odysseus' vengeance on the suitors is depicted on another skyphos of *c.* 440 [*348*]. On one side two women stand behind Odysseus as he draws his bow, while on the other a suitor on a kline has been struck in the back and two others try to shield themselves. On a relief from the Heroon at Trysa of *c.* 400 [*349*], a similar scene appears with suitors on several klinai and Odysseus

accompanied by Telemachos. Pausanias says (9.4.2) that in the Temple of Athena at Platea there was a painting by Polygnotos of Odysseus after he had killed the suitors.

The *Telegony*, the last book of the epic cycle, followed Odysseus from his revenge on the suitors to his own death, but episodes from that work have not been recognized in art from our period.

The murder of Agamemnon on his return to Mycenae and the vengeance of Orestes were recounted in the *Nostoi* (Returns) but in Proclus' summary both are disposed of in a single sentence. Rather, it is from passages in the *Odyssey*, from tragedies, and from depictions in ancient art, that we know many of the details of those stories.

The dark and barbarous behavior of Atreus and his brother Thyestes, which cast a shadow over both of their houses, is not a subject in ancient art, but the murder of Agamemnon by his wife Clytemnestra, and his cousin Aigisthos, appear on 6th-century shield bands and on an Attic red-figure krater of *c*. 470. On the shield bands *[350]* Clytemnestra plunges a sword into his back while Aigisthos holds him from the front. On the krater *[351]* Aigisthos wields the sword while Agamemnon falls back, caught in a net-like garment, and Clytemnestra with a small axe runs in from the left. Each of these is earlier than Aeschylus' trilogy of 458.

A relief on a terracotta plaque from Crete, *c*. 620, shows a woman who seems to be stabbing a seated man while another man holds him down from behind. This scene is usually interpreted as the death of Agamemnon, but some have seen it as the death of Aigisthos, a more common subject in later art where the victim is often shown seated.

When Agamemnon was killed, his son Orestes, who was still a child, was smuggled out of Mycenae by his sister Elektra, according to some versions, and was raised in Phocis by Stropios with his own son Pylades. Later, prompted by Apollo, Orestes returned to avenge his father's death and killed Aigisthos and Clytemnestra.

The meeting of Orestes and Elektra at the tomb of Agamemnon is the subject of several Melian reliefs from the second and third quarters of the 5th century and of an Attic red-figure vase of *c*. 440, but its greatest popularity is with South Italian painters throughout the 4th century *[352]*. The tomb of Agamemnon, usually represented by a stele or column, is a common element in all the depictions, and Pylades usually accompanies Orestes. Some show the moments before Elektra recognizes Orestes, some later moments, and it is safe to assume that almost all of the depictions show influences of dramatic productions. If the traditional date for the earliest Melian relief were lowered by just a few years, all of the depictions would date from after Aeschylus' *Oresteia*.

The death of Aigisthos at the hands of Orestes is the subject of bronze shield bands from the first quarter of the 6th century *[353]* where Orestes grabs the seated Aigisthos by the hair and prepares to stab him with a spear as he struggles

236

to unsheath his sword. On a metope from the Heraion at Foce del Sele, Orestes plunges his sword into the back of Aigisthos who clings to a column with one arm and raises his other hand to Orestes' chin in supplication.

The period of greatest popularity for this subject is from about 510 to about 460, perhaps explained by strong anti-tyrannical feelings current in Athens, when it appears on nearly twenty Attic red-figure vases. On the majority of these Orestes grabs the hair of the seated Aigisthos [354], as on the shield bands, and plunges his sword into him, but on many of these Clytemnestra comes to the rescue of her lover swinging an axe. The subject does not appear after about 460 on Attic vases, and it is rare on South Italian vases. Pausanias, however, says (1.22.6) that a painting in the Propylaia on the Acropolis at Athens showed Orestes killing Aigisthos, and Pylades killing the sons of Naupios, who came to the rescue of Aigisthos, which clearly reflects Euripides' tragedy, *Orestes*.

Unlike the murder of Aigisthos, the death of Clytemnestra is rarely depicted in Archaic or Classical Greek art. It may be the subject of a relief on a bronze tripod leg from Olympia, *c.* 570, where a youth stabs a woman as a man rushes off to the right, but other identifications for this scene are also possible. On a 4th-century Paestan amphora the identification of the scene is made certain by the presence of a Fury who observes the act [355].

After killing Aigisthos and Clytemnestra, Orestes was pursued by the *Erinyes* or Furies, spirits of punishment, provoked by his matricide. Trying to be freed of them, Orestes went first to Delphi, to be purified by Apollo, and then to Athens for a judgement by the Areopagus.

The earliest certain depictions of Orestes and the Furies are on several Attic red-figure vases, *c.* 440. On most of them Orestes kneels on a pile of rocks as Apollo protects him from a pursuing Fury (or Furies). The Furies on most are winged, some carry snakes, and some have snakes in their hair. Pausanias (1.28.6) says that Aeschylus was the first to represent Furies with snakes in their hair.

The setting for the Attic scenes is presumably Delphi, and on a large group of South Italian vases from the 4th century, the setting is certainly Delphi, confirmed by the presence of tripod and omphalos [356]. Lucanian, Campanian, Apulian and Paestan painters all depict the subject in varying degrees of detail.

339 (*above*) Attic red-figure amphora from Vulci. Odysseus and Nausikaa. Watched by Athena, a naked Odysseus ineffectually covering himself with a branch, approaches a group of young women washing clothes, some of whom start to flee when they see him. Clothes have been hung to dry in the tree beside him and one girl, who has not yet seen him, continues to wring a garment. *c.* 440

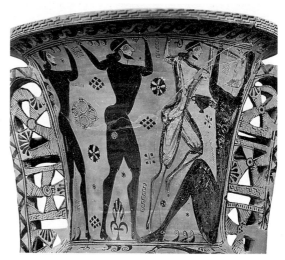

340 (*right*) Proto-attic amphora from Eleusis. Blinding of Polyphemos. Odysseus and two of his men blind the Cyclops Polyphemos with a long pole they carry on their shoulders. Proto-attic vase-painters were experimenters with new techniques and here one of the men has been painted in white (a colour usually reserved for female flesh) to distinguish him from the others. Note the cup in Polyphemos' hand and the filling devices in the field around the figures. *c.* 670

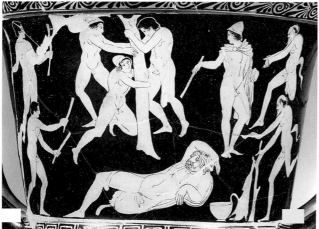

341 Lucanian red-figure calyx-krater. Blinding of Polyphemos. Odysseus, wearing his pilos, directs his men as they carry a sharpened tree-trunk toward a sleeping Polyphemos beside whom is a cup and a half-empty wine-skin hanging from a tree. The satyrs to the right suggest that this scene may have been inspired by a satyr play, perhaps Euripides' *Cyclops*. *c.* 410

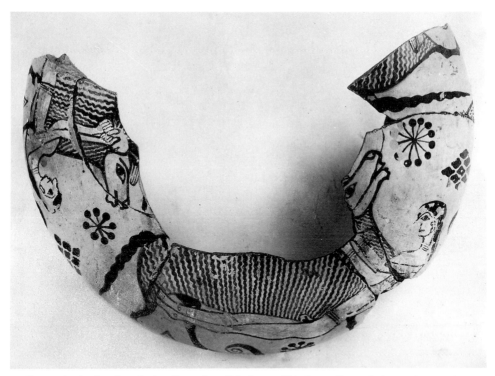

342 Proto-attic oinochoe from Aegina. Escape from Polyphemos. Naked men cling to the horns of rams and ride beneath their bodies. There is no indication that the men are tied in place. *c.* 670

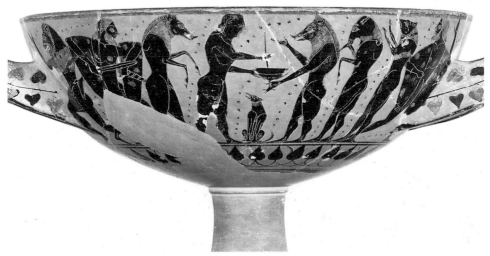

343 Attic black-figure cup. Circe and Odysseus. In the centre, Circe stirs a potion in a cup as she hands it to a man who has already begun to turn into a boar. Other men are in various stages of transformation as Odysseus rushes in from the left with his sword drawn. The figure rushing off to the right may be Eurylochos, who goes to warn Odysseus. This scene is a particularly good example of the compression of time and space. The inscriptions are nonsense words. *c.* 550

344 Boeotian black-figure skyphos from Thebes. Odysseus and Circe. In a burlesque version of the story, Circe stirs her potion in a skyphos as Odysseus rushes in with his sword drawn. Behind Circe is a loom. Late 5th Century. 15.4 cm

345 (right) Silver tetradrachm from Acragas. Below a crab is the monster Scylla who has the head and torso of a woman attached to a serpent or 'ketos' tail and the foreparts of two dogs. c. 420

346 (below) Attic red-figure stamnos from Vulci. Odysseus and the Sirens. Odysseus, tied to the mast of his ship, hears the siren song while his crewmen, their ears plugged with wax, row safely past the island. Two sirens (one named Himeropa or song of desire) stand on cliffs watching, while a third plummets to her death, presumably because Odysseus and his crew have escaped. Note the eye painted on the bow of the ship. c. 450. 35.2 cm

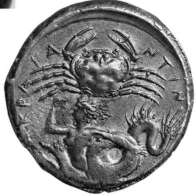

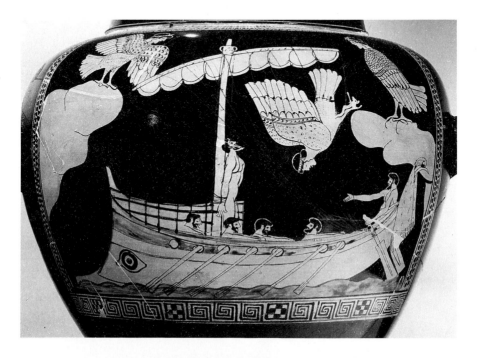

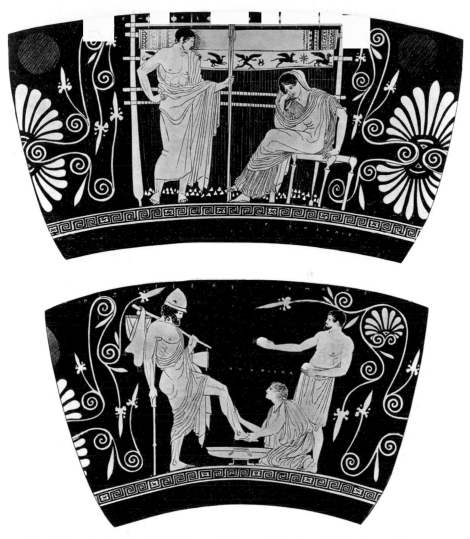

347 Attic red-figure skyphos from Chiusi. Return of Odysseus. A, Penelope sits by her loom as her son Telemachos talks with her. Note the delicate embroidery on the unfinished cloth. B, Odysseus' old nurse (named Antiphata here) recognizes his scar as she washes his foot, while Eumaios offers him a gift. Odysseus wears his pilos and carries a basket on a stick over his shoulder. *c.* 440. 20.3 cm

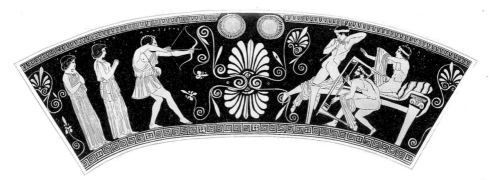

348 Attic red-figure skyphos from Tarquinia. A, Odysseus draws his bow as two servants look on. B, The suitors futilely try to defend themselves from Odysseus' arrows. Two of them are on a kline where, presumably, they have been feasting, and a third holds up a table as a shield. *c.* 440

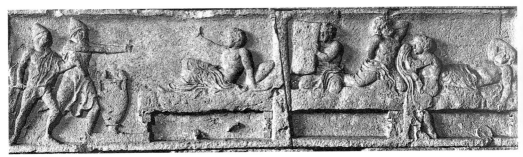

349 Limestone relief from Tyrsa. Odysseus killing the suitors. Early 4th Century

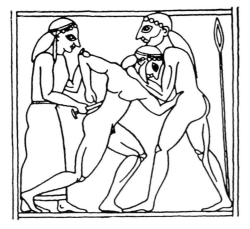

350 Bronze relief, shield band panel from Olympia. Death of Agamemnon. Clytemnestra plunges a short sword or dagger into Agamemnon's back while Aigisthos grasps him around the neck in a wrestling hold. *c.* 560. W. 7.2 cm

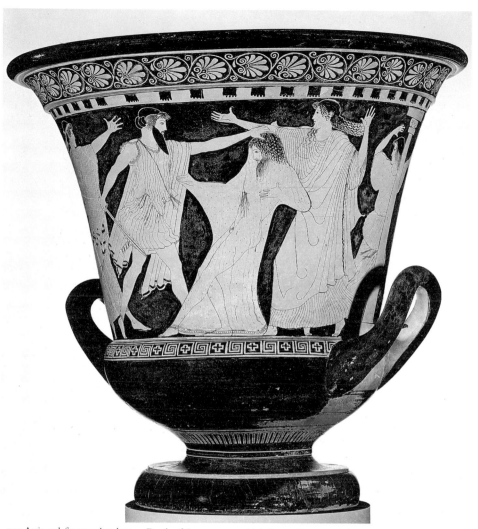

351 Attic red-figure calyx-krater. Death of Agamemnon. Aigisthos, with a sword, has stabbed Agamemnon, who is caught in a net-like garment and Clytemnestra rushes in from the left with a small axe in her hand. The two other women near Clytemnestra and Agamemnon (only one shown here) are probably their daughters Elektra and Chrysothemis. At the far right another woman, probably Kassandra, runs away. *c.* 470

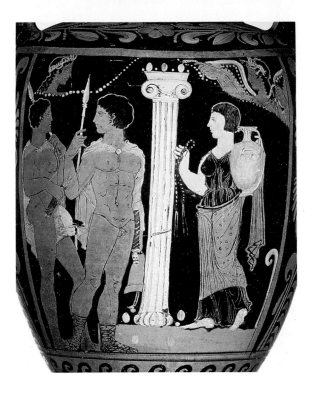

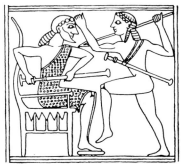

352 Paestan red-figure amphora from Nola. Pylades and Orestes, having just arrived, stand by the tomb of Agamemnon which is indicated by an ionic column, as Elektra, her hair cut short in mourning, approaches it with a hydria and a fillet. This is the moment just before the brother and sister recognize each other. Two Furies look down from above. *c.* 320. 51.3 cm

353 (*below*) Bronze relief, shield band panel from Olympia. Death of Aigisthos. Orestes grabs by the forelock Aigisthos, who is seated on a throne, and is about to stab him with a spear, as the latter tries to unsheathe his sword. *c.* 580. W. 7.2 cm

354 (*below*) Attic red-figure stamnos from Vulci. Death of Aigisthos. Orestes stabs the seated Aigisthos while Elektra, running in from the right, warns him that Clytemnestra is behind him swinging an axe. *c.* 470

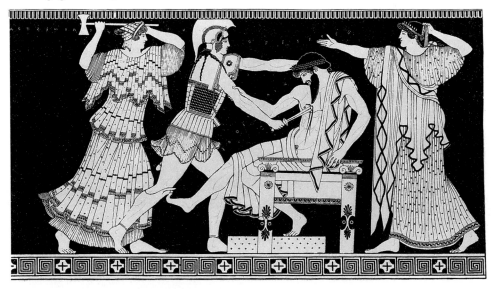

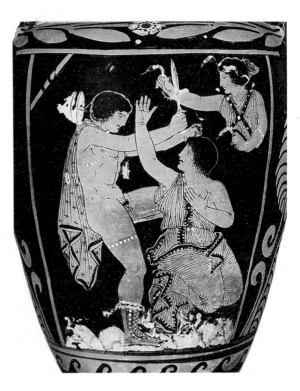

355 Paestan red-figure amphora. Death of Clytemnestra. Orestes grabs his mother's hair and prepares to strike her with his sword as she, having fallen to her knees, bares her breast with one hand and reaches up to him in supplication (or to defend herself). Above, a Fury with snakes in her hair and in her hands looks down. *c.* 340. 47.7 cm

356 Apulian volute-krater from Ruvo. Orestes at Delphi. Orestes clings to an ornate omphalos as Apollo wards off a Fury flying in from above and the huntress Artemis stands to the right shading her eyes and looking off into the distance for more of them. The horrified priestess (Pythia) rushes off dropping her key. Two helmets and two chariot wheels above are dedications in the temple. The ionic columns indicate a temple and the omphalos and tripod make the identification of the setting certain. *c.* 370. 90 cm

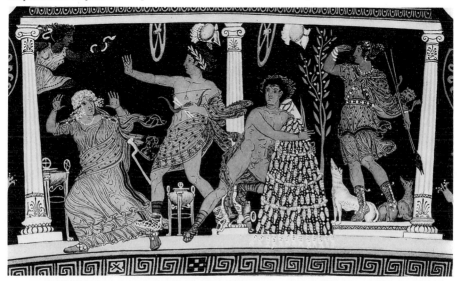

ABBREVIATIONS

AA	*Archäologischer Anzeiger*	Jacobsthal	P. Jacobsthal, *Die Melischen Reliefs* (Berlin, 1931)
ABV	J.D. Beazley, *Attic Black-figure Vase-painters* (Oxford, 1956)	JdI	*Jahrbuch des Deutschen Archäologischen Instituts*
AJA	*American Journal of Archaeology*	JHS	*Journal of Hellenic Studies*
AK	*Antike Kunst*	Kraay	C. Kraay & M. Hirmer, *Greek Coins* (London, 1966)
Amyx	D.A. Amyx, *Corinthian Vase-Painting of the Archaic Period* (Berkeley, 1988)	Kunze	E. Kunze, *Archaische Schildbänder* (Berlin, 1950)
ARV	J.D. Beazley, *Attic Red-figure Vase-painters*, 2nd edition (Oxford, 1963)	Langlotz	E. Langlotz & M. Hirmer, *Ancient Greek Sculpture of South Italy and Sicily* (New York, 1965)
AthMitt	*Mitteilungen des Deutschen Archäologischen Instituts, Athenische Abteilung*	ÖJh	*Jahreshefte des Österreichischen Archäologischen Instituts in Wien*
BABesch	*Bulletin van de Vereeniging tot Bevordering der Kennis van de Antieke Beschaving tes Gravenhage*	Para	J.D. Beazley, *Paralipomena* (Oxford, 1971)
BCH	*Bulletin de Correspondance Hellénique*	Pipili	M. Pipili, *Laconian Iconography of the Sixth Century B.C.* (Oxford, 1987)
BMFA	*Bulletin of the Museum of Fine Arts, Boston*	RA	*Revue Archéologique*
Boardman, GA	J. Boardman, *Greek Art* (London, 1985)	Robertson, HGA	M. Robertson, *History of Greek Art* (Cambridge, 1975)
Boardman, GGF	J. Boardman, *Greek Gems and Finger Rings* (London, 1970)	RömMitt	*Mitteilungen des Deutschen Archäologischen Instituts, Römische Abteilung*
Boardman, GSAP	J. Boardman, *Greek Sculpture, the Archaic Period* (London, 1978)	Rumpf	A. Rumpf, *Chalkidische Vasen* (Berlin, 1927)
Boardman, GSCP	J. Boardman, *Greek Sculpture, the Classical Period* (London, 1985)	Trendall, LCS	A.D. Trendall, *The Red-figured Vases of Lucania, Campania and Sicily* (Oxford, 1967)
BonnJb	*Bonner Jahrbücher*	Trendall, RFVA	A.D. Trendall & A. Cambitoglou, *The Red-figure Vases of Apulia* (Oxford, 1978–82)
CVA	*Corpus Vasorum Antiquorum*	Trendall RVP	A.D. Trendall, *The red-figured Vases of Paestum* (British School, Rome, 1987)
Eye of Greece	D. Kurtz & B. Sparkes, *The Eye of Greece* (Studies Robertson, Cambridge, 1982)		
Hemelrijk	J.M. Hemelrijk, *Caeretan Hydriae* (Mainz, 1984)		

A SELECTED LIST OF FURTHER READING

The most comprehensive study of ancient Greek, Roman and Etruscan iconography is the *Lexicon Iconographicum Mythologiae Classicae* (Zurich and Munich, 1981–97), an international undertaking (articles are in English, German, French or Italian) the first four volumes of which appeared between 1981 and 1988 and covered mythological figures to 'Herakles'.

Less comprehensive but more accessible surveys of Greek iconography are: K. Schefold, *Myth and Legend in Early Greek Art* (London, 1966), *Götter- und Heldensagen der Griechen in der spätarchaischen Kunst* (Munich, 1978), *Die Göttersage in der klassichen und hellenistischen Kunst* (Munich 1981) and with F. Jung, *Die Urkönige Perseus, Bellerophon, Herakles und Theseus in der klassischen und hellenistischen Kunst* (Munich, 1988). Also, H. Metzger, *Les représentations dans la céramique attique du IVe siècle* (Paris, 1951). J. Henle, *Greek Myths, a Vase Painter's Notebook* (Indiana, 1973) includes useful discussions of several myths. For intensive studies of the earliest depictions, see H. von Steuben, *Frühe Sagendarstellungen in Korinth und Athen* (Berlin, 1968), K. Fittschen, *Untersuchungen zum Beginn der Sagendarstellungen bei den Griechen* (Berlin, 1969) and J. Carter, *Annual of the British School at Athens* 67 (1972) 25–58; M. Pipili, *Laconian Iconography of the Sixth Century B.C.* (Oxford, 1987) is a thorough study of that area and includes an appendix on 7th-Century art.

F. Brommer has published indispensible lists of representations of myths in ancient art: *Vasenlisten zur griechischen Heldensage*, 3rd ed. (Marburg, 1973) and *Göttersagen in Vasenlisten* (Marburg, 1980) for vases; *Denkmälerlisten zur griechischen Heldensage* (Marburg, 1976) for other media.

1. INTRODUCTION

The indexes in Martin Robertson's masterly *History of Greek Art* (Cambridge, 1975) are useful for mythological subjects as well as for forms, specific objects and periods. For iconographic indexes and bibliographies for sources of illustrations of Attic vases, see: J.D. Beazley, *Attic Black-figure Vase-painters* (Oxford, 1956), *Attic Red-figure Vase-painters*, 2nd ed. (Oxford, 1963) and *Paralipomena* (Oxford, 1971). For updated references to these works, see T. H. Carpenter, *Beazley Addenda*, 2nd ed. (Oxford, 1989). For well-illustrated studies of Attic vase-painting, see: J. Boardman, *Athenian Black Figure Vases* (London, 1974), *Athenian Red Figure Vases, Archaic* (London, 1975) and *Athenian Red Figure Vases, Classical* (London, 1989).

For iconographic indexes and bibliographies of sources for illustrations of South Italian vases see: A.D. Trendall, *The Red-figured Vases of Lucania, Campania and Sicily* (Oxford, 1967) with supplements, and *The Red-figured Vases of Apulia* (Oxford, 1978–82). Both also include many illustrations. For Paestan vases, see A.D. Trendall, *The red-figured Vases of Paestum* (1987). For a well-illustrated survey of South Italian vase-painting see A.D. Trendall, *Red-Figure Vases of South Italy and Sicily* (London, 1989).

For illustrations of Greek drama, see A.D. Trendall and T.B.L. Webster, *Illustrations of Greek Drama* (London, 1971). L. Séchan, *Études sur la tragédie grecque dans ses rapports avec la céramique* (Paris, 1926) should be used with caution.

For Corinthian vases see D. Amyx, *Corinthian Vase Painting* (Berkeley, 1988), though H. Payne, *Necrocorinthia* (Oxford, 1931) is still a very useful study. For Laconian vases, C.M. Stibbe, *Lakonische Vasenmaler* (Amsterdam, 1972) and M. Pipili, *Laconian Iconography* (see above); For Chalcidian, M. Iozzo, *Ceramica 'Calcidese': Nuovi documenti e problemi riproposti* (Rome, 1994); for Caeretan, J.M. Hemelrijk, *Caeretan Hydriae* (Mainz, 1984).

For coins see: C. Kraay, *Archaic and Classical Greek Coins* (London, 1976) and C. Kraay and M. Hirmer, *Greek Coins* (London, 1966). For gems, J. Boardman, *Archaic Greek Gems* (London, 1968) and *Greek Gems and Finger Rings*, 2nd ed. (London, 2001). For shield bands, E. Kunze, *Archaische Schildbänder* (Berlin, 1950). For Melian reliefs, P. Jacobsthal, *Die Melischen Reliefs* (Berlin, 1931).

For sculpture, see J. Boardman, *Greek Sculpture, the Archaic Period* (London, 1978), *Greek Sculpture, the Classical Period* (London, 1985) and *Greek Sculpture, the Late Classical Period and Sculpture in Colonies and Overseas* (London, 1995); R.R.R. Smith, *Hellenistic Sculpture* (London, 1991).

A recent translation of Pausanias by P. Levi (Harmondsworth, 1979) includes useful notes.

2. A DEMONSTRATION OF METHOD: THE RETURN OF HEPHAISTOS/TROILOS AND ACHILLES

H.J. Rose, *Handbook of Greek Mythology*, 6th edition (London, 1958) is still the most comprehensive and reliable survey of Greek myths. In addition, Frazer's notes in the Loeb edition of Apollodorus are invaluable.

François Vase: Arias, Hirmer and Shefton, *History of Greek Vase Painting* (London, 1963); *Bollettino d'Arte*, serie speciale 1 (Rome, 1980) has photos of most recent cleaning.

Dionysos: see below, chapter 3. Return of Hephaistos: F. Brommer, *JdI* 52 (1937) 198–219 and *Hephaistos* (Mainz, 1978); A. Seeberg, *JHS* 85 (1965) 102–9 and *Corinthian Komos Vases* (London, 1971); M. Cremer, *AA* 1981, 317–28; M. Halm-Tisserant, *AK* 29 (1986) 8–22; T.H. Carpenter, *Dionysian Imagery in Archaic Greek Art* (Oxford, 1986) 13–29. Satyrs: F. Brommer, *Satyroi* (Würzburg, 1937), *Satyrspiele* 2nd ed. (Berlin, 1959); E. Buschor, *Satyrtänze und frühes Drama* (Munich, 1943); E. Simon, *Eye of Greece* 123–48.

Troilos: M. Wiencke, *AJA* 58 (1954) 285–306; C. Mota, *RA* 50 (1957) 25–44, K. Schauenburg, *BonnJb* 161 (1961) 218–21; D. Kemp-Lindemann, *Darstellungen des Achilleus in griechischer und römischer Kunst* (Frankfurt, 1975), 90–127; A. Cambitoglou & J. Wade, *AK* 15 (1972) 90–94; I. Krauskopf, *AA* (1971) 13–37.

3. PORTRAITS OF THE GODS

For a thorough survey of the gods, including iconography, see E. Simon, *Die Götter der Griechen* (Munich, 1969). For the loves of the gods, see S. Kämpf-Dimitriadou, *Die Liebe der Götter in der attischen Kunst des 5. Jhs. v.C.* (Berne, 1979).

Iris: G. Schwarz, *ÖJh* 51 (1976–77) 1–17.

Chiron/Centaurs: P. Baur, *Centaurs in Ancient Art* (Berlin,

1912); B. Schiffler, *Die Typologie des Kentauren in der antiken Kunst* (Frankfurt, 1976).
Demeter: A. Peschlow-Bindokat, *JdI* 87 (1972) 60–157. For the rape of Persephone, see below, chapter 4.
Leto and Tityos: Greifenhagen, *Jahrbuch der Berliner Museen*, n.s. 1 (1959) 5–32.
Dionysos: K. Kerenyi, *Dionysos, Archetypal Image of Indestructible Life* (New York, 1976); C. Houser (ed.), *Dionysos and His Circle* (Harvard, 1979); T.H. Carpenter, *Dionysian Imagery in Archaic Art* (Oxford, 1986). Infant Dionysos: J. Oakley, *AK* 25 (1982) 44–47. Ariadne: T. Webster, *Greece and Rome* 13 (1966) 22–31.
Zeus: A.B. Cook, *Zeus* (Cambridge, 1914–40); D. Aebli, *Klassischer Zeus* (Munich, 1971). Thunderbolt: P. Jacobsthal, *Der Blitz* (Berlin, 1906). Europa: W. Bühler, *Europa* (Munich, 1968). Ganymede: H. Sichtermann, *AK* 2 (1959) 10–15; P. Bruneau, *BCH* 86 (1962) 193–228; G. Schwarz, *ÖJh* 51 (1976–77) 1–17; K. Schauenburg, *Fest Jantzen* (Wiesbaden, 1969) 131–40; S. Kämpf-Dimitriadou, *AK* 22 (1979) 49–54. Statue of Zeus at Olympia: B. Shefton, *Eye of Greece* 160–65. Poseidon: U. Heimberg, *Das Bild des Poseidon in der griechischen Vasenmalerei* (Freiburg, 1968); J. Anderson & R. West (eds) *Poseidon's Realm* (Sacramento, 1982). Amymone: A. Trendall, *Fest Brommer* (Mainz, 1977) 281–87.
Ares: I. Beck, *Ares in Vasenmalerei, Relief und Rundplastik* (Frankfurt, 1984). Kyknos: H. Shapiro, *AJA* 88 (1984) 523–29.
Aphrodite: E. Langlotz, *Aphrodite in den Gärten* (Heidelberg, 1954); E. Simon, *Die Geburt der Aphrodite* (Berlin, 1959).
Apollo: (struggle for tripod) J. Boardman, *RA* 1978, 227–34; D. von Bothmer, *Fest Brommer* (Mainz, 1977) 51–63.
Artemis: C. Christou, *Potnia Theron* (Thessalonike, 1968).
Niobe: H. Hoffmann, *Archaeology* 13 (1960) 182–85; C. Clairmont, *AK* 6 (1963) 23–32; R.M. Cook, *Niobe and Her Children* (Cambridge, 1964); C. Vogelpohl, *JdI* 95 (1980) 197–226.
Hermes: P. Zanker, *Wandel der Hermesgestalt in der attischen Vasenmalerei* (Bonn, 1965). Io: E. Simon, *AA* 1985, 265–80; N. Yalouris *BCH* Suppl. 14 (1986) 3–21.
Athena: for birth, see below, Chapter 4. Promachos: H. Niemeyer, *Promachos* (Waldsassen, 1960); Beazley, *Development of Attic Black-figure* 3rd edition Berkeley, 1986) 81–92. Parthenos: N. Leipen, *Athena Parthenos* (Toronto, 1971); B. Shefton, *Eye of Greece* 159–60.
Nereus: R. Glynn, *AJA* 85 (1981) 121–32.
Hephaistos: F. Brommer, *Hephaistos* (Mainz, 1978).
Okeanos: F. Brommer, *AA* 1971, 29–30.
Eileithyia: S. Pingiatoglou, *Eileithyia* (Würzburg, 1981).

4. THE ASCENDANCY OF THE OLYMPIANS

Eros: A. Greifenhagen, *Griechische Eroten* (Berlin, 1957); W. Albert, *Darstellungen des Eros in Unteritalien* (Amsterdam, 1979).
Birth of Athena: F. Brommer, *Jahrbuch des Römische-Germanischen Zentralmuseums, Mainz* 8 (1961) 66–83; E. Simon, *AK* 25 (1982) 39–43.
Apollo and Pytho: L. Kahil, *Melanges Michalowski* (1966), 481–90.
Erichthonios: J. Oakley, *JHS* 102 (1982) 220–22; *AK* 30 (1987) 123–30.
Gigantomachy/Titanomachy: F. Vian, *Répertoire des gigantomachies figurées dans l'art grec et romain* (Paris, 1951); J. Dörig & O. Gigon, *Der Kampf der Götter und Titanen* (Lausanne, 1961); M. Moore, *AJA* 83 (1979) 79–99

(Siphnian Treasury); V. Brinkmann, *BCH* 109 (1985) 7–130.
Prometheus: J. Beazley, *AJA* 43 (1939) 618–39; K. Kerenyi, *Prometheus, Archetypal Image of Human Existence* (New York, 1963).
Rape of Persephone: F. Hölscher, *Fest Hampe* (Mainz, 1980); (R. Lindner, *Der Raub der Persephone in der antiken Kunst* (Würzburg, 1984).
Eirene and Ploutos: E. LaRocca, *JdI* 89 (1974) 112–36.
Underworld: K. Schauenburg, *JdI* 73 (1958) 48–78; W. Felten, *Attische Unterweltsdarstellungen des VI und V Jh.V.Chr.* (Munich, 1975); E. Keuls, *The Water Carriers in Hades* (Amsterdam, 1974). Ixion: E. Simon, *ÖJh* 42 (1955) 5–26; J. Chamay, *AK* 27 (1984) 146–50.
Aktaion: K. Schauenburg, *JdI* 84 (1969) 29–46; E. Leach, *RömMitt* 88 (1981) 307–27.
Pentheus: L. Curtius, *Pentheus* (Berlin, 1929).
Marsyas: J. Boardman, *JHS* 76 (1956) 18–20; C. Clairmont, *Yale Classical Studies* 15 (1957) 161–78; K. Schauenburg, *RömMitt* 65 (1958) 42–66 and *RömMitt* 79 (1972) 317–22.
Orpheus: F. Schoeller, *Darstellungen des Orpheus in der Antike* (Freiburg, 1969); M. Schmidt, *AK* 15 (1972) 128–37 and *Fest Bloesch* (Bern, 1973), 95–105; H. Stern, *Mélanges Lafaurie* (Paris, 1980) 157–64.

5. PERSEUS, BELLEROPHON

Heroes: O. Stumpfe, *Die Heroen Griechenlands* (Münster, 1978).
Perseus: C. Clairmont, *AJA* 57 (1953) 92–94; K. Schauenburg, *Perseus in der Kunst des Altertums* (Bonn, 1960); J. Oakley, *AJA* 86 (1982) 111–15, (Graiai) *AJA* 92 (1988) 383–91. Medusa: R. Hampe, *AthMitt* 60/61 (1935/36) 269–99. Gorgoneion: H. Besig, *Gorgo und Gorgoneion in der archaischen griechischen Kunst* (Berlin, 1937); J. Belson, *AJA* 84 (1980) 373–78; M. Halm-Tisserant, *RA* 1986, 245–78. Andromeda: K. Phillips, *AJA* 72 (1968) 1–23. Bellerophon/Pegasos: K. Schauenburg, *JdI* 71 (1956) 59–96; M. Schmitt, *AJA* 70 (1966) 341–47; S. Hiller, *Bellerophon* (Munich 1970); J.-M. Moret, *AK* 15 (1972) 95–106; N. Yalouris, *Pegasus, the Art of the Legend* (1977).

6. HERAKLES

F. Brommer, *Herakles* (Münster, 1953) for a survey of the labours; *Herakles II* (Darmstadt, 1984) for other sources. See also R. Flacelière & P. Devambez, *Héraclès, Images et Récits* (Paris, 1966); G. Galinsky, *The Herakles Theme* (Oxford, 1972). See J. Boardman, *RA* 1972, 57–72; *JHS* 95 (1975) 1–12; *RA* 1978, 227–34; *Eye of Greece*, 1–28 and H. Brijder, *Ancient and Related Pottery* (Amsterdam, 1984) 239–47 for political implications of Heraclean imagery.
Infant Herakles and the snakes: S. Woodford, *Image et Ceramique* (Rouen, 1983) 121–29. Herakles as musician: K. Schauenburg, *JdI* 94 (1979) 49–76.
Lion: (early sources) J. Carter, *BSA* 67 (1972) 25–58.
Hydra: D. Amyx & P. Amandry, *AK* 25 (1982) 102–16; J. Boardman, *Oxford Journal of Archaeology* 1 (1982) 237–38.
Pholos: K. Schauenburg, *AthMitt* 86 (1971) 43–54. Centaurs: see above, chapter 3.
Horses of Diomedes: D. Kurtz, *JHS* 95 (1975) 171–72.
Amazons: D. von Bothmer, *Amazons in Greek Art* (Oxford, 1957); K. Schauenburg, *Philologus* 104 (1960) 1–13; J. Boardman, *Eye of Greece* 1–28.
Hesione: Brommer, *Marburger Winckelmann-Programm* 1955, 4ff.

Geryon: M. Robertson, *Classical Quarterly* 19 (1969) 207–21; P. Brize, *Die Geryoneis des Stesichoros und die frühe griechische Kunst* (Würzburg, 1980) and *AthMitt* 100 (1985) 53–90.

Nereus/Triton: R. Glynn, *AJA* 85 (1981) 121–32; G. Ahlberg-Cornell, *Herakles and the Sea-Monster in Attic Black-figured Vase Painting* (Stockholm, 1984).

Kerkopes: P. Zancani-Montuoro, *Heraion alla Foce del Sele* ii (Rome, 1954) 185 ff.

Geras: J. Beazley, *BABesch* 24–26 (1949–51) 18–20; Brommer, *AA* 1952, 61–64.

Alkyoneus: B. Andreae, *JdI* 77 (1962) 130–210.

Acheloos: H.P. Isler, *Acheloos* (Berne, 1970).

Nessos: K. Fittschen, *Gymnasium* 77 (1970) 159–70.

Death of Herakles: J. Boardman, *Fest Schauenburg* (Mainz, 1986) 127–32. Apotheosis: J. Boardman, *RA* 1972, 60–72.

7. THESEUS

Theseus: C. Dugas & R. Flacelière, *Thésée: images et récits* (Paris, 1958); F. Brommer, *AA* 1975, 487–551, *AA* 1982, 69–88 and *Theseus* (Darmstadt, 1982); C. Sourvinou-Inwood, *Theseus as Son and Stepson* (London, 1979); J. Neils, *AJA* 85 (1981) 177–9; H. Shapiro, *AA* 1982, 291–7.

Kaineus: E. Laufer, *Kaineus, Studien zur Ikonographie* (Rome, 1985).

Oedipus and the sphinx: E. Simon, *Das Satyrspiel Sphinx des Aischylos* (Heidelberg, 1981); K. Schauenburg, *Fest Hausmann* (Tübingen, 1982), 230–35; J.-M. Moret, *Oedipe, la Sphinx et les Thébains* (Rome, 1984). Sphinx: H. Demisch, *Die Sphinx* (Stuttgart, 1977).

Amphiaraos: I. Krauskopf, *Fest Hampe* (Mainz, 1980), 105–116. Alkamaion: J. Small, *RömMitt* 83 (1976) 113–144. Seven Against Thebes: G. Richter, *AJA* 74 (1970) 331–33; M. Tiverios, *AthMitt* 96 (1981) 145–61.

8. ARGONAUTS, CALYDONIAN BOAR HUNT

Phrixos: K. Schauenburg, *RhM* 101 (1958) 41–50. Jason/Medea: V. Zinserling-Paul, *Klio* 61 (1979) 407–36. Argonauts: M. Vojatzi, *Frühe Argonautenbilder* (Würzburg, 1982). Funeral games: L. Roller, *AJA* 85 (1981) 107–19. Calydonian Boar hunt: G. Daltrop, *Die Kalydonische Jagd in der Antike* (Hamburg, 1966); F. Kleiner, *AK* 15 (1972) 7–19.

9. THE TROJAN WAR

K. Friis Johansen, *The Iliad in Early Greek Art* (Copenhagen, 1967).

Peleus and Thetis: X. Krieger, *Des Kampf zwischen Peleus und Thetis in der griechischen Vasenmalerei* (Münster, 1973). Judgement of Paris: C. Clairmont, *Das parisurteil in der antiken Kunst* (Zurich, 1951) I. Raab, *Zu den Darstellungen des Parisurteils in der griechischen Kunst* (Frankfurt, 1972); J.-M. Moret, *AK* 21 (1978) 76–98.

Achilles: K. Schauenburg, *BonnJb* 161 (1961) 215–35; D. Kemp-Lindemann, *Darstellungen des Achilleus in griechischer und römischer Kunst* (Frankfurt, 1975) (Arming): D. von Bothmer, *BMFA* 7 (1949) 84–90. Ajax and Achilles gaming: J. Boardman, *AJA* 82 (1978) 18–24; S. Woodford, *JHS* 102 (1982) 173–85.

Death of Sarpedon: D. von Bothmer in S. Hyatt, ed. *The Greek Vase* (New York, 1981) 63–80.

Ransom of Hektor: J. Beazley, *BABesch* 29 (1954) 12ff.

Ajax with body of Achilles: S. Woodford & M. Loudon, *AJA* 84 (1980) 25–40.

Return of Helen: L. Gahli-Kahil, *Les enlèvements et le retour d'Hélène* (Paris, 1955); P. Clement, *Hesperia* 27 (1958) 47–73; M. Davies, *AK* 20 (1977) 73–85.

Patroklos; K. Stahler, *Grab und Psyche des Patroklos* (Münster, 1967). Vengeance of Achilles: E. Vermeule, *BMFA* 63 (1965) 35–52.

Dolon: F. Lissarrague, *RA* 1980, 3–30.

Ilioupersis: J.-M. Moret, *L'Ilioupersis dans la céramique Italiote* (Rome, 1975); J. Boardman, *AK* 19 (1976) 3–18.

Aeneas with Anchises: K. Schauenburg, *Gymnasium* 67 (1960) 176–91 and /6 (1969) 42–53, S. Woodford & M. Loudon, *AJA* 84 (1980) 25–40.

Arms of Achilles: D. Williams, *AK* 23 (1980) 137–45.

Suicide of Ajax: M. Davies, *AK* 16 (1973) 60–70; K. Schefold, *AK* 19 (1976) 71–78; M. Moore, *AJA* 84 (1980) 417–34.

10. THE AFTERMATH OF THE WAR

Odyssey: O. Touchefeu Meynier, *Thèmes odysséens dans l'art antique* (Paris, 1968); B. Fellman, *Die antiken Darstellungen des Polyphemabenteuers* (Munich, 1972); F. Brommer, *Odysseus* (Darmstadt, 1983).

Circe: F. Canciani, *Fest Hampe* (Mainz, 1980) 117f; A. Snodgrass, *Narration and Illusion in Archaic Greek Art* (London, 1982).

Oresteia: A.J.N.W. Prag, The *Oresteia* (Warminster, 1985).

LIST OF ILLUSTRATIONS

The publisher and the author are grateful to the many museums and collectors named in the List of Illustrations for their kindness in supplying photographs and granting permission to publish them. The following other sources of illustrations are also gratefully acknowledged:

American Journal of Archaeology 4 (1900) *[163]*, 15 (1911) *[178]*, 83 (1979) *[112]*; *Archeologia Nella Tuscia* II *[233]*; *Arts of Mankind [21, 95a, 110, 140, 185]*; *Ath-Mitt* 100 (1985) *[201]*; Aurigemma, *Spina [18]*; *AZ* (1859) *[214]*, (1861) *[219]*, (1884) *[246]*; Benndorf, *Heroon [240, 349]*; Boardman, *GSAP [17, 95a, 217]*, *GSCP [101, 136, 173, 256]*; *Bulletin of the Metropolitan Museum* 23 (1928) *[294]*; *Bulletin of the Museum of Fine Arts, Boston* 47 (1949) *[298]*; Herbert Cahn *[227]*; Caskey and Beazley *[314]*; *Clara Rhodos* III *[11]*; Drawings by Marion Cox *[45, 69, 129, 175, 291, 297, 312]*; Furtwängler and Reichhold *[2, 20, 47, 71, 73, 88, 171, 207, 234, 244, 255, 261, 266, 267, 292, 293, 339, 347, 348, 356]*; Furtwängler, *Kleine [245]*; Gerhard, *EKV [36, 249, 354]*; Gerhard, *Trinkschalen [24, 73]*; Graef and Langlotz I *[91]*; Hirmer Archive *[42, 50, 51, 55, 58, 60, 62, 70, 82, 104, 122, 130, 133,* *177, 183, 184, 193, 196, 206, 217, 221, 257, 258, 269, 270, 273, 279, 282, 305, 310, 311, 335, 345]; JHS* 14 (1894) *[37]*; Kunze, *Archaische Schildbänder [31, 87, 96, 98, 126, 156, 164, 202, 246, 281, 320, 329, 331, 337, 350, 353]*; *MonPiot* 16 (1920) *[32]*, 40 (1944) *[179]*; *Monumenti Antichi* 32 *[299]*; Mylonas, *Protoattikos [149, 340]*; *Olympia Bericht* i *[268]*, vii *[303]*; Richter and Hall *[168]*; Rumpf, *Chalkidische [328]*; Thiersch, *Tyrrhenische [267]*; Trendall, *RFVA [19]*.

The author would like to express his thanks to Elie Borowski, Maria Brouskari, Herbert Cahn, Margaret Mayo, Maria Pipili, Marion True, Michael Vickers, Malcolm Wiener, Bob Wilkins, Dyfri Williams, and to the staff of the Ashmolean Library, Oxford where much of this book was researched and written. He is particularly indebted to John Boardman without whose continued help the book might never have appeared.

Dimensions given in the captions refer to the height of complete vases unless stated otherwise.

INDEX OF MYTHOLOGICAL SUBJECTS

Illustration numbers are in italic

INDEX OF COMMON ATTRIBUTES

Illustration numbers are in italic